Women Writers of Meiji and Taishō Japan

For my children
Tomas and Sashya

WOMEN WRITERS OF MEIJI AND TAISHŌ JAPAN

Their Lives, Works and Critical Reception, 1868–1926

by
Yukiko Tanaka

McFarland & Company, Inc., Publishers
Jefferson, North Carolina, and London

Library of Congress Cataloguing-in-Publication Data

Tanaka, Yukiko, 1940–
 Women writers of Meiji and Taishō Japan : their lives, works and critical reception, 1868–1926 / by Yukiko Tanaka
 p. cm.
 Includes bibliographical references and index.
 ISBN 0-7864-0852-9 (softcover : 50# alkaline paper) ∞
 1. Women authors, Japanese. 2. Japanese literature — Meiji period, 1868–1912 — History and criticism. 3. Japanese literature — Taishō period, 1912–1926 — History and criticism. I. Title.
PL725.T36 2000
895.609'9287'09034 — dc21 00-41869
[B]

British Library cataloguing data are available

©2000 Yukiko Tanaka. All rights reserved

No part of this book may be reproduced or transmitted in any form or by any means, electronic or mechanical, including photocopying or recording, or by any information storage and retrieval system, without permission in writing from the publisher.

Cover image ©2000 Photodisc

Manufactured in the United States of America

McFarland & Company, Inc., Publishers
 Box 611, Jefferson, North Carolina 28640
 www.mcfarlandpub.com

Contents

Acknowledgments vi
Preface 1
Introduction 5

1 — Meiji's Pioneering Literary Women: Tanabe Kaho, Kishida Toshiko, Kimura Akebono, Wakamatsu Shizuko, and Shimizu Toyoko 13
2 — The Ethos of Reactionary Conservativism and Women Writers: Kitada Usurai, Higuchi Ichiyō, and Tazawa Inafune 51
3 — The Romantic Movement in Poetry: Yosano Akiko 89
4 — Women Writers of the Naturalist School: Mizuno Senko, Shiraki Shizu, Ojima Kikuko, and Tamura Toshiko 103
5 — Taishō Liberalism and Women 137

Epilogue: Toward the New Era of Literary Women: Nogami Yaeko 161
Notes 167
Selected Bibliography 181
Index 183

Acknowledgments

Bringing this book to completion has been a long and arduous process that involved not only rewriting but also alteration in some of its original conception. In this process I received a great deal of help and support from more than a few individuals. Nori Hirai assisted me in locating hard-to-find materials in Japanese; Mirium Silverberg and Christina Mullen gave me invaluable suggestions. I also want to thank Arlene Corey for her help in the beginning phase. Without her encouragement and faith in this project, I might not have persisted.

Preface

This book is a study of creative women writers of Japan's Meiji and Taishō eras, roughly from the 1880s through the 1920s. It examines how these women started writing for publication and how their work was received. By placing their works, and their lives, in a historical context, it will also look at how the sociocultural climate of the time affected their endeavor.

Despite the country's golden tradition of writers of the tenth and eleventh centuries, when such works as *The Tale of Genji* by Lady Murasaki and *The Pillow Book* by Sei Shōnagon were produced, Japanese women kept silent during the years prior to the period under consideration. Under the shogunate, with its official doctrine of Neo-Confucianism, women's role was rigidly defined as wife and mother, nothing more; their place was the home, or *oku*, the back chambers of the estate. This circumstance was altered dramatically when Japan opened its doors to the West. Under the new sociopolitical system, and aided by new knowledge and awareness, many changes were implemented, some successfully, others as mere tokens and soon vanishing. Women participated in this process, voicing their views in their writings as well as in public speeches. The first chapter will examine these activities.

The initial enthusiasm for things new did not last very long (as Japan shifted its interest toward imperialistic endeavor), and women's position in society was pushed back to the old. Although women went on with their activities in the public arena, this setback is clearly reflected in their writings. Referred to as *keishū sakka*, or "beautiful" writers of the *kei*, the women's chamber, these women concentrated on the theme of women's victimization under the reinforced patriarchy. Conscious of their vulnerable position — authorship was, after all, a man's prerogative — these writers were careful in choosing their style as well as content. How their awareness was manifested in the stories and novellas they wrote will be the focus of chapters two, three, and four.

Of course there were a few who resisted, even rebelled against patriarchal definition. This book will also examine how these women attempted this

task both individually and as a group. In the beginning of the Taishō period, when greater freedom was enjoyed by the Japanese in general, a group of young women got together and published a magazine called *Seitō* (roughly translated "Blue Stockings"). Under Western influences, including feminism, women were finding their lives less confining, and the term *keishū* was now used much less frequently. As women's social and literary activities became more clearly recognizable phenomena, they began to see themselves as a group in their own eyes, not by outsiders' labeling. As shown in the last chapter, these women in fact tried to redefine the name — "New Women" — that was given to them.

Literary historians in Japan — exclusively male until recently — have always approached women writers with their own notions, which are one-sided and gender-specific. Once they grouped all women together as *keishū* (later *joryū*) writers, they applied a different set of critical standards instead of evaluating women's work in terms of its inherent value. It seems as if these historians were not aware of this practice, and herein lie some interesting questions: Why did they do this, and why were they unaware of doing so, or at least unwilling to admit to it?

While the historians grouped all women writers together, giving them a term to connote their separateness from the dominant groups of male writers, literary critics singled out Higuchi Ichiyō as representing all other literary women of her time. Likewise, only Yosano Akiko, the critics believed, made substantial contributions to the new literary trend. It is true that what these two women produced is of exceptional quality, but close examination reveals that each had strategies that worked favorably and warranted a favorable critical response. This study will examine those strategies, as they are again related to the gender dynamics operating in the minds of the Meiji men and women.

This book is not a biographical study of a dozen or so individual creative women, nor is it purely a critical analysis of their work. Rather, it tries to see these writers along a continuum, with the idea that if it were not for other women publishing earlier, Ichiyō and Akiko could not have achieved what they did. Aided by some scholarly works in English, such as *A Literature of Their Own* (Elaine Showalter) and *The Madwoman in the Attic* (Sandra Gilbert and Susan Gubar), I will attempt to identify something that can be called a literary tradition of their own along this continuum.

"When I take a quick glance at all the major studies produced over the past several decades on Higuchi Ichiyō, a particular scene comes to my mind," wrote a Japanese feminist scholar. In that scene Ichiyō is situated in the center, "as if she were a protective goddess," and surrounding her are various male scholars and researchers.[1]

It is true, women scholars and critics have not given their own readings based on their understanding of gender dynamics. This situation is now changing, and a few scholars have published their studies, adding to an already impressive number of books on Ichiyō. One result of such efforts is an interpretation of Ichiyō as "her father's daughter"—as one who wrote by indentifying herself with patriarchy.

In addition to resisting the "male interpretation" of women's work, what has been needed was to see them in their own connectedness. Examination of Ichiyō's work should not focus solely on her gender, but neither should her work be seen as existing in a vacuum. As I studied several better-known authors, it became clear that there were many more women who wrote and published than we have been led to believe. And yet, in ninety volumes of *Meiji Bungaku Zenshū*—a collection of works by Meiji literati—only two volumes are devoted to women. In order to consider the historical continuum of women writers of the period, this book focuses on a dozen literary women and refers to others as well.

These authors were selected from the slightly larger body of published authors of the time with two considerations in mind: the quality of their work and the messages embedded there. With a few exceptions, the women discussed here are now virtually forgotten by all but the specialists in *joryū* literature. With only scant information available, it is difficult to trace their lives closely. Because most of them died young and left a rather small body of work—mostly short stories—there are few texts to go by. Furthermore, their works were published almost exclusively in magazines, all but a few of which have ceased publication, so getting access to their entire work is quite difficult. Even when, on rare occasions, collections of their stories are published, it is hard to find them in bookstores or even college libraries.

My first task, therefore, was to go to the National Diet Library in Tokyo and read the stories, essays, and other writings these women have left behind. Some of their writings seemed insignificant and often difficult to get excited about, as their style, particularly those written in the Meiji period (discussed in the first two chapters), is antiquated. Some reviews were published in contemporary magazines, but finding them was a painstaking task. Critical studies and essays have been written about these works over the years, but there is little or no systematic or in-depth study.

To my knowledge, the writings of these women—with the exception of Higuchi Ichiyō—have not yet been translated. I have supplied brief translations of the works under discussion. Regrettably, the nuances of the traditional literary style in which many stories were written are hard to convey in translation, but I hope that the passages at least will give the reader a grasp of what is being discussed.

Discussions of important social and political activities and trends of the era are included in this study. In order to better understand what these women were writing about, it is necessary to see their lives and work in the sociocultural environment of their respective eras. Although that environment has changed over the years, the system of *ie*, the patriarchal domination of women, has remained constant. Studying women in the Meiji patriarchy inevitably leads our attention to the then widespread practice of "buying women" at houses of prostitution, a lucrative business operation for which licenses were issued. Efforts to abolish this system — which amounted to a form of slavery — went on during the entire time period examined here. The effects of this pervasive practice must have been injurious to the female psyche, and although it is difficult to identify its precise impact, the relationship between this practice and women's writings cannot be ignored.

A few words on the names. Authors' names are given in Japanese order, that is, family name first. It has been a common practice, however, to call them — especially better-known authors — by their first name, and I have followed this practice. It was also a traditional practice for literati to adopt a *nom de plume*, and many women in this book followed this custom. Both given names and pseudonyms were used in the text, and sometimes it is rather confusing. I have devised a system, not always consistent, to use the given names to talk about their personal lives, and the other names to discuss their work. For easier reading I have translated the names of stories, magazines, and books into English, but this does not mean they are available in translation.

Some ambiguity surrounds the terms *story* and *novella*. To date, the common practice in Japan has been not to separate the two or to define them clearly. I used the terms loosely, based on the length of the work.

Introduction

In December 1895, the twenty-eighth year of the Meiji period (1868–1912), a literary magazine called *Bungei Kurabu* (*Literary Club*) issued a special edition. Calling it *keishū sakka tokushu,* or a special issue on *keishū sakka,* *Literary Club* published short stories, novellas, and poetry in the traditional form, as well as translations from English and German, by twelve women writers. Since it started its publication in January of the same year, this commercial magazine, one of the earliest in the Meiji period, had come to focus more on the works of newcomers in the literary world. This special issue on women writers proved to be a successful venture, and it sold an unprecedented thirty thousand copies. The result was another special on *keishū sakka* thirteen months later. The works collected in these two issues showed great diversity in theme, style, and tone; it was the authors' gender that was the organizing principle of this publishing event. That readers were also interested in the authors' gender can be seen in the fact that the magazine printed pictures of the women, something it did not do with male authors.

Symbolic of the status of women in general in a patriarchal society, which Meiji Japan was, women writers then were referred to as *keishū sakka*. *Kei* (from a Chinese word *kuei*) means "the women's chamber," a room in the back of the estate where wealthy men kept their women separate; *shū* means "beautiful"; and *sakka* means "writers"—hence the meaning of the term is roughly "the beautiful lady writers of the back chambers." As the existence of such a term points out, women writers were seen as separate from the mainstream, their male counterparts. Although the term does convey a hint of condescension toward women, conveying such an attitude was most likely not the intention of the publisher and critics.

Behind the commercial success of *Literary Club*'s *keishū* special was a rapid progress in Japan's industrialization. Improved printing technology supported the publishing business, which prospered because of an increased interest in literary and other cultural activities. The more essential factor, however, was the increase in the number of women who wrote with publication

in mind; although still not many, they were an identifiable group in the eye of the publisher.

Seeing all women authors as belonging to one group merely because of their gender was a common practice in the Meiji era. This grouping caused the reviewers, all male, to use a set of critical standards that was different from those applied to works by men: gentle, feminine sentiment conveyed in a highly polished style with flowing language was considered essential for good writing by women. Because it satisfied this standard, Higuchi Ichiyō's *Jūsanya* ("The Thirteenth Night"), a piece published in the first *keishū* special, was highly praised; likewise, because their style and tone conveyed feminine qualities, translations by Wakamatsu Shizuko and Tanabe Kaho (also Koganei Kimiko, who translated from German) were praised by critics as "not to stand below those done by men."[1]

The critics of the time, furthermore, thought that women's writing ought to appeal to the emotions, not to the intellect. For this reason, two stories in the *keishū* special, *Kuromegane* ("Dark Spectacles") by Kitada Usurai and *Shirobara* ("The White Rose") by Tazawa Inafune, received negative reviews. The highly contrived plots and absence of lyrical quality in these works were given as the reasons for negative responses, but more essentially, critics were reacting to the basic message embedded in these stories. Characterization of Inafune's sharp-tongued heroine, in particular, was in clear contrast with that of the woman in Ichiyō's highly praised story.

These women's endeavors at writing and publishing are particularly remarkable because, unlike male authors, they had few immediate predecessors of their own sex. For a few centuries preceding this era, women were muted publicly. The arrival of the Meiji era earlier, however, was a new start for Japanese women in their renewed attempt at self-definition and self-expression. It went hand in hand with their social consciousness, and from the very beginning of the period studied here, some exceptional women did attempt, with considerable zeal, to bring changes in various patriarchal practices. Among their early political activities was an effort to bring a stop to the practice of polygamy and the keeping of concubines; denouncing the practice of men's treating women as sexual commodities, these women joined men in writing polemics and fiction on the issue. However, altering the common perception in Japanese society that women are the inferior sex, that they are meant to be subjugated by men, was a difficult task.

Even within the four decades considered in this study, definite changes are evident in women's individual and collective creative endeavors. Shortly after Ichiyō died at the peak of her fame, at the beginning of the twentieth century, Yosano Akiko emerged as a poet with a commitment to her art to a degree not seen earlier. She, among the minority who managed to maintain

a relatively long creative life, even led a group whose membership was primarily male. Introduction of the Naturalist School approach to fiction writing in the early 1900s further stimulated women's interest in writing. Aspiring women were greatly encouraged by the notion that fiction was a record of the author's experiences in real life, and that writing fiction could be a means to liberate one from various constraints. This school's approach was particularly helpful for women because it enabled them to break through their inhibitions and helped them achieve liberation from the patriarchal *ie* (family) system. At about the same time, women — mostly young and still few in number — began uniting together, and they voiced more openly their objections to sexual oppression, as well as to various forms of male hypocrisy. Women writers were no longer so isolated by then.

When this new interest in women was stirred up at the beginning of the Taishō period (1912–1926), it was largely due to the more liberal social and political climate of the time, but it was also a response to the suffrage crusade and other feminist activities in England and the United States. For the first time, Japanese women tried to identify directly with the West, to learn about women's emancipation and other important issues. This affected women's literary, as well as social and political, activities and initiated more aggressive attempts at self-definition and self-assertion in writing.

At the very end of the Meiji period, when a group of young women got together and published a magazine called *Seitō* (roughly translated as "Blue Stockings"), the term *keishū* was used much more infrequently. The first wave of the feminist movement in the West reached Japan shortly afterwards; women's social and literary activities were now a clearly recognizable phenomenon, not merely a rebellion by "outsiders." In the more liberal climate of the Taishō era, when an interest in writing as a means of self-exploration went hand in hand with campaigns for social and political emancipation, women were not only encouraged to write and publish, thanks to a growing mass culture and journalism, but also supported each other in their endeavors. During this period, a group of young women would start writing, armed with socialist or other revolutionary ideologies.

By the time Nogami Yaeko published *Kaijin-maru* (*The Neptune,* 1922), an epoch-making novella that treats neither the unfortunate lot of a woman nor an inconsequential domestic incident, but rather morality and the human condition, a new stage of women's fiction had clearly arrived. Yaeko's long and productive career and her self-assurance are indeed symbolic of the new upswing among women in creative careers, as well as of the prestige they would gain in a few decades. Other women writers seemed to have also reached the point where they made their first decisive steps away from their old morality with a new self-perception. Writing on diverse topics, including that of

female sexuality, they wrote more explicitly as well. Women writers no longer belonged to an insignificant sex, or were the residents of the back chambers.

While the term *keishū* was no longer in use, however, another word, *joryū,* emerged. Meaning literally "the female school," it is used in combination with *sakka* (writers) or *bungaku* (literature), and this term is still in use to some extent.[2] In view of the absence of a male counterpart for the term, and judging from other examples where the word *ryu* (school) is used (*Sogetsu-ryū* in flower arrangement and *Yagyu-ryū* in swordsmanship, for instance), one has to assume that the *joryū* represents a subcategory of writers (or literature); it is still a term that has its root in genocentricity. So far as one can see in the use of this term, women writers in Japan are still a separate subgroup.

The literary women who tried to lead creative lives in much of the period studied in this book, between 1885 and 1925, were not many in number. Furthermore, most of them died young, having enjoyed only minor success during their lifetimes. As they were quickly forgotten after their death, they have rarely been the subjects of scholarly studies until very recently, when some painstaking work uncovering their forgotten lives and work has began. Except for their limited pedagogical relations with their male mentors, they did not form groups (the Seitō Society was an exception) to support each other, and this left them, by and large, isolated. This isolation was a disadvantage one cannot overestimate, because during much of the period under consideration (as well as later), Japanese writers in general tended to develop their careers primarily through their affiliation with a coterie. Although these women's situation was hardly unique, their isolation and exclusion from larger literary groups influenced *keishū* writers' views of themselves and deterred them from developing a self-confidence necessary for successful career development. This is reflected in the gender dynamics shown in their stories.

Beyond some basic biographical facts, little is known about the majority of the literary women studied in this book. Unlike the Victorian women writers, many of whom began their careers after age thirty,[3] most of these women started writing early in their lives. With some exceptions, however, their creative lives were very short, often lasting only a few years; they either died young or became silent. Only a few were truly successful and able to support themselves financially by writing. They were all from middle-class families with either samurai or mercantile backgrounds, and while many grew up in homes with a strong authoritarian father and a submissive mother, there are also cases in which the father was absent during the daughter's adolescent years. The majority of the writers received nine years of formal education — the most women could attain then — at schools designated for girls. With the

single exception of Higuchi Ichiyō, all of the women were married either at the time they started publishing or shortly afterward; some were also mothers. Although getting married does not seem to have prevented them from continuing to write (an exception was Shimizu Toyoko), the point is difficult to establish, since many died a few years after marriage.

Meiji women writers did not employ conscious strategies to overcome their problems, as Western literary women did, by, for example, creating a "duplicitous" woman character or a "mad woman"[4] who rejects the submissive role; they more or less accepted the patriarchal definition of women. While they escaped from the "phallocentric" myth that plagued literary women of the Victorian era[5] (after all, the Japanese procreation myth centers around the goddess Amaterasu, and from the late tenth to the early twelfth century, women authored works that continued to be considered canonical even after the establishment of patriarchy), they suffered from various psychological inhibitions that had their roots in the entirely negative appraisal and devaluation of their gender, and thus their endeavors.

Having internalized the common view of women in general, many women writers accepted these definitions, along with limitations placed upon them, and wrote with themes and style considered appropriate to their gender. Aware of society's view on their "impertinence" in writing and publishing, most women writers delineated their heroines as benign and helpless. And knowing that they were venturing into a traditionally male domain, they practiced self-censoring in their choice of themes and characterization. Along with their recognition of general disapproval of any commitments outside the family, a fear of being labeled as presumptuous in the relatively small and insulated world they lived in was a powerful psychological inhibition indeed. In cases where women were successful in gaining recognition and respect (as Higuchi Ichiyō and Yosano Akiko did), it was because they were able to deal with this issue via specific circumstances or strategies. Ichiyō overcame her inhibitions through playing the role (out of necessity) of head of her household, responsible for the livelihood of her family, and thus needed to be serious in her endeavor. Akiko, on the other hand, exploited the female tradition by consciously identifying herself with the literary women of many centuries ago.

While engaged in the activity of serious writing, which required self-justification, most of the Meiji women writers, like the heroines they created, rarely had someone in whom they could confide; their endeavor, it would be clear upon examinations of their lives, was strenuous and taxing. In the face of many difficulties they encountered, gender-based subgrouping seemed a minor problem. In fact, *keishū* writers in general accepted it with its accompanying practice of a critical double standard; it in turn helped them limit

their choice of subjects and their characterization of their heroines. Only in the case of Higuchi Ichiyō do we know how they felt about being a *keishū* writer. "Pondering many things as I sit at my desk, I am made to realize that indeed I am a woman," she wrote in her journal. While this acceptance eliminated the temptation to use male pseudonyms, a tactic employed by their Western counterparts, "the beautiful lady writers of the back chamber" saw themselves as clearly separated from male writers. Although they were free from the stereotypical image by which the women writers of Victorian England were represented — spinsters or childless, unattractive and perhaps slightly mad[6] — they were viewed instead, as were all Japanese women, as frail and largely inconsequential.

By and large, Meiji women did not write stories of domestic felicity; their topics center around misfortunes in marriage and family life. Instead of being sweet, submissive women who are cherished by their men, as seen in some of the Victorian authors such as Dickens, the heroines in these stories are portrayed as selfless persons who yet can be easily betrayed and destroyed by men; sorrow, rather than joy, dominates their experiences. Clearly, it is the victimization of women that is the most prevalent theme. As the submissive heroine sacrifices herself in practicing the morality of the patriarchy, the dynamics of heterosexual relationships become evident; the story is extremely one-sided, with men assuming superiority and exercising dominance in every possible arena. If these stories convey a protest against men's mistreatment of women, it is most of the time too quiet to register as such.

Why was such crude victimization of one sex by the other perpetually treated as a fictional theme in an age when Japan was supposedly attempting to become a modern and egalitarian state? This unavoidable question comes to mind when one reads stories by Meiji women writers. In order to answer it, or to know why a sense of helplessness permeates the experience of these heroines, one has to consider the widespread and socially sanctioned practices of selling and buying women; such practices most definitely affected men's evaluation and treatment of women in general. Because licensed prostitutes, called *kōshō* (the term literally means "public prostitutes," while unlicensed street prostitutes were referred to as *shishō*, "private prostitutes"), were often indentured for life, the selling and buying of women propagated a system of slavery in people's minds, encouraging men to openly view women as exploitable objects. Along with the centuries-old indoctrination of Confucianism, with its basic disdain for women, the view of women as property influenced Meiji men's perception of the heterosexual relationship. Stories written by women writers are eloquent representations of and revelations about Meiji patriarchal society, where all women were in some danger of becoming men's victims.

While most women writers discussed in this book received little critical attention from their contemporaries, the literary accomplishments of two women, Higuchi Ichiyō and Yosano Akiko, were widely recognized during their lifetimes, as well as later, resulting in an impressive number of books and articles of both scholarly and more general interest. The dynamics behind these two women's successful careers warrant a close examination. The singular success of Higuchi Ichiyō in particular needs to be examined to see how, despite many restrictions and disadvantages, she was able to achieve a degree of success unmatched by any other women writers among her contemporaries.

In order to understand these who triumphed, however, we must study those who did not, those whose aspirations and efforts brought only minor successes. By including these minor women, as done in this volume, we can see the more successful case more completely and accurately. It is through studying both cases that we recognize clues as to what made some successful. By including minor authors, and only then, one also can identify a certain pattern, which might be called the female literary tradition, "a literature of their own."

1

Meiji's Pioneering Literary Women:
Tanabe Kaho, Kishida Toshiko, Kimura Akebono, Wakamatsu Shizuko, and Shimizu Toyoko

Yabu no uguisu (*Songbirds in the Grove*), a novella written by Tanabe Kaho, was the first work of fiction by a Meiji woman published by a major publishing house. It was in 1888, several years before the publication of *Literary Club*'s special on *keishū* writers, and the book fetched a handsome sum of money.

This epoch-making work describes the atmosphere of what is generally referred to as *Bunmeikaika,* or "Civilization and Enlightenment," a short-lived sociocultural phenomenon that took place shortly after Japan's opening up to the West. After two hundred years of Japanese isolation, the country's leaders were now urging people to Westernize, or at least to act as if they were. This policy provoked a flurry of activities among the upper class and the intellectuals, such as introducing Western culture — lifestyle and taste — as well as political theories and literary practices. An extension of this was the Rokumeikan, a two-story Western-style brick building the government built in 1883. Here nightly balls, dinner parties, bazaars, and even masquerades were held for foreign visitors and residents. This was part of an effort to show to Western nations how civilized Japan had become — more specifically, to lay the groundwork for rectifying the unfair treaty with England that Japan had been forced into at the opening of the country two decades earlier. Women — wives and daughters of high-ranking government officials — were recruited. Builders of the nation, men who had carried out the Restoration and were now in the key government positions, took a pleasure

in these frivolous activities, too. The several years in which superficial adoption of all things Western took place in a somewhat comical manner are called the Rokumeikan era.

In the opening scenes of *Songbirds,* the new social phenomenon of the Rokumeikan era and the influence of the Enlightenment advocates are introduced, first through a Western-style ball at a New Year's party, then with a dormitory room of female high school students. These students are primarily from families with money, and some of them are flippant and interested in pleasure-seeking activities more than study. The school was modeled after one the author had attended briefly; it was a public institution, but as tuition was expensive, only the privileged could attend. It is said that the school considered attendance at the Rokumeikan balls important, if not mandatory. One of the leading characters of the novella is a wealthy young heiress, Hamako, who worships, along with her indulging father, the ways of the West; they are superficial and blind worshipers of the new era. Hamako's father represents those who had built new wealth amid the huge economic changes that took place in the early years of the Meiji period.

Songbirds gives a glimpse of another, more positive aspect of the early Meiji era as well. Some of the female students have been influenced by the idea of "enlightenment," a position held earlier by a few government leaders. Some ambitious policies, such as establishing secondary schools aiming at higher education for girls, were the result of that position. Hamako's more serious classmates thus talk about their aspirations for independent lives, including having careers and choosing their own marriage partners — ideas totally new at that time even among educated women. These students also speak of the value of acquiring knowledge and skill.

The young women Tanabe Kaho depicted in *Songbirds* are those of Tokyo Kōtō Jogakkō, a secondary school for girls opened by the government in 1872 (though it would be closed rather quickly) to implement its policies represented by Enlightenment advocates such as Nakamura Masanao. It was conceived as the model school for girls' secondary education, and foreign languages, particularly English, were taught with the idea that they were essential tools for living in the modern age. In this year, the fourth year under the new government, compulsory education of four years was instituted with the philosophy that there should be no difference between sexes. This approach to education for girls during the first two decades of the Meiji era was indeed both ambitious and progressive.

The public schools were not created from whole cloth, since some of the schools of the old domain had existed from the seventeenth century and were being reorganized to meet the changing needs. New schools, of which Tokyo Kōtō Jogakkō was one, were also established specifically to educate

girls. Unfortunately, the school was closed down rather quickly because of the financial strain the government was under.

The new government's policy of enlightening the nation went hand in hand with one of the central activities among leading intellectuals — translating works of English (and sometimes French or Italian) in order to introduce Western manners and ideas. While curiosity about upper-middle-class life and political intrigue led to translations of the work of Bulwer-Lytton, fascination with modern science as the symbol of Western civilization welcomed Jules Verne's science fiction stories. Biographies of self-made men such as James Watt also had a strong appeal because of the worship of technology and knowledge. A Victorian creed of personal improvement and social progress through individual effort found enthusiastic acceptance among early Meiji intellectuals, although considering the ethos of the time, this was not surprising. Samuel Smiles's *Self Help* thus was among the best-sellers.[1] The same translator also introduced John Stuart Mill's *The Subjugation of Women*. Forming the theoretical foundation for the Popular Right Movement, Japan's first grassroots movement for democratic governance, were the liberal political concepts of Jean-Jacques Rousseau (introduced by Nakae Chōmin in the early 1870s), among others. Other favorites included such classics as the plays of Shakespeare and the novels of Sir Walter Scott; books by Dumas and Boccaccio were also translated.

Tanabe Ryūko, "Kaho"

Ryūko was twenty years old and a student at the Tokyo Kōtō Jogakkō when her novella *Songbirds in the Grove* was published by Kinkōdō Publishing House. The manuscript is said to have been first presented to Tsubouchi Shōyō, an influential writer and critic of the time, through an acquaintance of Kaho's father, and was subsequently recommended to a publisher. Reviews were generally positive, such as one in *Jogaku Zasshi* (*Women's Education Magazine*) which stated that the piece was written in an "elegant and smooth style" and that it "successfully conveys the strong emotion of indignation felt by the author." Another reviewer wrote that the author demonstrated an ability to construct a work based upon observations but also infusing in it ideas of her own.[2] At the same time, however, a rumor that the publisher bought the manuscript as a favor to Shōyō, and that it was heavily edited by him, circulated in the literary establishment.[3] This rumor reflected a generally unsympathetic reaction, mixed with curiosity, toward the first publication of a woman's work. As if to encourage condescending remarks about her indebtedness to Shōyō, Kaho herself made a public statement claiming

that she had written her novella using Shōyō's *Tōsei shosei katagi* (*Characters of Modern Students*, 1885) as a model.

Songbirds is indeed a female version of Shōyō's work, which is a portrait of students as a new social phenomenon observed in Tokyo during the 1870s and early 1880s. Like *Characters of Modern Students,* it strings various scenes together, each of which reads like a scene on the stage. Much of Kaho's novella, however, is about another important character, Hideko, whose story is an important aspect of the novella. Stories of the two characters — Hamako and Hideko — are loosely connected by Tsutomu. Having studied abroad, and among the nation's future leaders, Tsutomu is presented as one who can see both the positive and negative aspects of Japan's Westernization. He finds in Hideko an ideal woman and his future wife. Offering a contrast to Tsutomu is Yamanaka, a low-ranking government official who courts Hamako for her money; he is an opportunist and moral degenerate who cannot resist his golden opportunity to deceive Hamako and appropriate her money. Hamako, with her blind worship of the new (she also flirts with her English tutor while her fiancé is abroad), thus is shown to lack the ability to judge character.

Hamako and Hideko are meant to reflect two types of young women of the time: a newly emerging group of young women and a more traditional, familiar type. Likewise, Tsutomu and Yamanaka are types, as Shōyō's characters are. Kaho's depiction of her characters, however, is less superficial than Shōyō's. More than merely observing new social phenomena, *Songbirds* transmits certain messages, one of which concerns the government policy on "enlightening women." Namiko, Hamako's classmate, seems to represent Kaho's position on the matters of Westernization and women's enlightenment: "I've heard of an opinion lately that women shouldn't be educated, that it's best to keep us illiterate. The rationale I heard is that educated women might choose to work, taking up a job like teaching, and then they don't want to have a husband. This would cause a serious problem of population decrease and it is unpatriotic, they say."

In this statement we already see the rising conservative sentiment that would become dominant, greatly affecting the lives of women (as discussed in the following chapter). It is no doubt a reaction to the radically new and free atmosphere of the Enlightenment era. Namiko says: "Around the fifth and sixth year of the Meiji, women's manners are said to be quite deteriorated; they walked like men with their shoulders stiff up high and wearing men's hakama trousers; they also uttered many words, talking about half-baked ideas." These are accurate observations, as there were some women who were encouraged by the idea of gender equality expressed by the Enlightenment advocates. Namiko herself declares that she plans to marry a scholar but will develop a career so that she will have her own income. Written at the

time when Japan was changing its direction — coiling into its past if you will — *Songbirds* remonstrates against the excessive Westernization observed in the mannerisms and behavior of young women of the elite class and instead recommends the traditional womanly virtues of chastity, reticence, and self-sacrifice, as seen in Hideko.

The author, who did not hesitate to show disdain for the social ambition and appetite for material success of the nouveau riche in the first half of the novella, reveals that her sympathy lies with Hideko. Hideko puts her younger brother through school by working as a seamstress. A bright woman who respects education and manages to learn from her brothers' textbooks, Hideko is, however, distinctly a heroine of the Meiji era, not of Tokugawa fiction. She is resourceful, independent-minded, and free from the negative attributes of traditional Japanese womanhood, such as ignorance, passivity, and dependence. Placed against the backdrop of an emerging new type of pleasure-seeking woman, Hideko in fact is an indomitable character. Some optimism, as well as wishful thinking and a certain naiveté, is behind the creation of such a character as Hideko. The same features are observed in the work of another *keishū* writer, Kimura Akebono, who portrayed her ideal woman in *Fujo no kagami* (*Mirror of Womanhood*), a novella that appeared the following year.

Although the character of Hideko is idealized, the situation in which she finds herself — having lost both of her parents and penniless — was not so rare at the time. During the first few decades of the Meiji period, society was in great turmoil, and many families — particularly those of the old ruling class — found their lives being drastically altered. Kaho herself experienced the dramatic change from being the daughter of an upper-class family to being a young adult with no one but herself to depend upon. Kaho's mother, for instance, who is described in a memoir as "always sitting quietly next to her sewing box," somehow managed to keep the household together after the Tanabes' financial decline, "protecting [us] from being engulfed by the rough waves of life."[4] Hideko's perceptions of reality, as well as her characterizations, are not as unbelievable as they may appear to today's readers.

Tanabe Taichi, Kaho's father, was a fine Confucian scholar with highly polished taste in traditional aesthetics who had held a very high office in the Shōgun's government. Unwilling to cooperate with the new government, he chose to let himself slip into oblivion, showing his disapproval and resentment through immoderate behavior and causing the family's finances to be quickly drained during the years when Kaho, called Ryūko then, was growing up. A resourceful daughter who wanted to find a way to earn some money, she came up with an idea of writing fiction to publish.

The circumstances under which Kaho wrote *Songbird,* the first book

published by a woman, are frequently referred to by literary historians. While Ryūko was ill at home, she overheard her mother talking to a servant, lamenting over the fact that the Tanabes' financial decline was such that the eldest son's third-year memorial service, an important occasion for Buddhists, cannot be held properly. Ryūko had just read *Characters of Modern Students,* and thought she could write something similar — a remarkable idea indeed, considering the dearth of women writing at this time, as well as during the many decades in the preceding Tokugawa period.

Literary biographers and scholars who underscore Kaho's indebtedness to Shōyō call attention to her public statement that she wrote *Songbirds* in order to raise money for a memorial service for her older brother.[5] The author's own words, which might have been merely a disguise to hide her uneasiness, were thus taken at face value. Kaho's "confession" that she borrowed the idea from Shōyō and her rationale for publishing both reveal a certain nervousness about writing and publishing a book, something no other woman was doing then. This fact has not been considered by literary historians who have written about Kaho.

Growing up in close contact with first-class scholars, poets, and musicians, some of whom were her tutors, Ryūko was a precocious child; she is said to have produced *waka* poetry when she was five and, a little later, to have written a story with characters modeled on her friends at school. She was also an avid reader, mainly of Chinese and late Tokugawa literature, and along with Higuchi Ichiyō (discussed in the following chapter) she was the best student at Haginoya Conservatory, where *waka* was taught. Tanabe Ryūko, in other words, had both talent and an interest in writing, and revealed both early in her life. In view of other women who closely followed in her footsteps in producing works of fiction, however, what she did should not be so astonishing.

Kaho did have literary ambition, and like Ichiyō, she chose not to disclose it. Although the two *keishū* writers had quite different personalities, both knew that it was not a good idea to be open about their own thoughts in this regard. Kaho, the first published author among women, was in a double bind, as it were. Out of fear that she would be thought presumptuous, she played down her ambition, making gestures of self-effacement, a dangerous but not uncommon practice among women. By accepting Kaho's self-deprecating explanation at face value, the critics of the time, and later, revealed their own reluctance to take Kaho's literary endeavors seriously.

Kaho went on writing, and she published several more works of fiction in various magazines, including *Jogaku Zasshi* and *Miyakonohana* (*Flower of the Capitol*). In 1892 she had a collection of stories published, a rare achievement for a Meiji woman writer. This time, too, however, Kaho made it clear

that she had no serious intention in writing and that her motivation was monetary — even as mundane as to provide some clothes for her child's special birthday.

Kaho's perpetually noncommittal attitude and her reluctance to see herself as seriously engaged in writing require investigation. One of the factors here is her desire to pose as a dilettante, a trait that her father might have passed down to her. More fundamentally, she was reluctant to compete with others, particularly men. Yet her reluctance and lack of commitment were not hers only; in fact, they are viewed today as being shared widely among women as a result of social conditioning. The general view of the time toward the woman who had dared to publish is summarized in a remark said to have been made by a critic when Kaho married Miyake Setsurei, a renowned philosopher: "It [this marriage] was her best achievement."[6] Setsurei was the publisher of *Nihonjin* (*The Japanese*), a magazine stressing nationalism, a man known for his unorthodox and often peculiar behavior. Kaho continued writing after marriage — in fact, she wrote until her death in 1943 at the age of seventy-six. Her later writings, however, are mainly occasional essays and memoirs.

Kaho's public posture of self-belittling with regard to her writing and publishing is inseparable from the basic message conveyed in her work. Placing her in the midst of the fever to Westernize, Kaho made Hideko, who holds the traditional values of self-sacrifice and self-negation, a positive figure. The heroine of her next major piece, *Yaezakura* ("Double-Petaled Cherry Blossoms," April 1890), again a dutiful daughter of a once-respectable family now sunk into destitution, is even more self-effacing. In order to help her impoverished family, this woman, Yae, becomes the concubine of a well-to-do man while secretly loving another man, Hidetoshi, the fiancé of her patron's daughter. Yae bears a son to her patron, and when Hidetoshi proposes to take her as his legal wife, she declines. Then, to show her true devotion to him, she cuts her hair and announces her renunciation of worldly desires, a common practice of medieval Japan.

The ambiance of "Double-Petaled" is that of *Genji Monogatari* (*The Tale of Genji*), a medieval romance, rather than of the modern age. Languid and imbued with resignation and lack of will, it represents the life of a woman who has retreated back into the old morality. It is a similar to *Songbirds* in its subplot: the daughter of a well-to-do family rejects the man chosen by her parents in favor of another. Although this can be seen as the young woman's rebellion, it is presented as one of childish willfulness. A silly woman in "Double-Petaled" is not even punished in the end (as Hamako is) for her senseless indulgence. Not aspiration and hope for change, but deep sighs, tears, and suffering dominate the fictional world of this piece.

The portrait of Yae as a concubine is convincing nonetheless. Kaho personally knew the life of women like her, seeing them in her father's house: "My home was frequented by professional entertainers and geishas … and following the disgusting custom of those days, my father also had concubines living in our house," she wrote.[7] What is described in "Double-Petaled" was not so uncommon in real life at the time the story was written: men with money kept concubines in their houses, a practice that came back during the mid–Meiji years under the influence of reactionary conservatism. The days when "enlightenment" advocates wrote fervently on the concept of *joshi kairyō* (improvement of women), when a few women, like Shimizu Toyoko, petitioned to abolish the law permitting polygamy, were over, and now, with the reorganization of the social, political, and legal system under the patriarchal concept of *ie* (the family), the old Tokugawa practice of polygamy was revived. In the name of *hōkō* (meaning "service," it is an ambiguous term used since the Tokugawa era to refer to both domestic chores and sexual services for the head of the household), pretty young women in Yae's situation were recruited; and since the legal wife was made to feel (just as she was in the Tokugawa period) that her husband should take concubines in order to ensure a male successor, little guilt was felt by the man engaged in polygamous practices.

The reason for Yae's final act of self-denial — her rejection of a suitor whom she loves — is unclear, but when she consoles her rejected suitor she uses ambiguous words, saying that his responsibility is "to serve his country." These words are indicative of society's understanding of women's role as the self-sacrificing supporters of men's (and the nation's) worthwhile endeavors. In her role of a filial daughter and concubine, Yae symbolically represents a part not only of gender dynamics of the time but of the direction in which Japan was heading. "Double-Petaled Cherry Blossoms" reveals more clearly the mood that was to prevail in the fictional worlds of women writers during the next decade, around the mid–1890s; it reflects Japanese women's retreat from aspirations toward greater emancipation. We will see more evidence of this retreat in the following chapter.

Although "Double-Petaled" shows that its author has developed skill in creating a character with a more complex psychology, Kaho seemed to have little interest in pursuing fiction writing. In *Literary Club*'s *keishū* special she is represented with a piece entitled *Hagikikyō* ("A Bushclover and a Bellflower")[8]; it is a rough remake of Adelaide Proctor's short story about friendship between two women. Kaho stopped writing fiction after this piece.

Although she would continue to write and publish essays and memoirs, Kaho is primarily known to posterity as the first published female author. Her success at her venture encouraged other women who had an interest in

creative writing to publish. Although historians underscore her influence upon Higuchi Ichiyō, other women — such as Kimura Akebono and Wakamatsu Shizuko — were also inspired by her example.

Undeniably, Kaho got the idea for her first attempt at fiction from Shōyō's novel. Still, *Songbirds* is uniquely hers in the sense that it is based on her personal experiences. In the novella, she integrated her own understanding of life and her own perception of reality, which were vastly different from those of Shōyō. Moral issues, in which the author had a personal stake, were an underlying literary motif of "Double-Petaled" as well. What we see here (as will be shown in the case of Kimura Akebono and Kishida Toshiko discussed below) is fiction that represents, both symbolically and straightforwardly, what they saw, felt, and dreamed. In the case of male authors, on the other hand, this aspect of integrating personal experiences in fiction is absent by and large until the emergence of the Naturalist School writers during the first decade of the following century.

Kishida Toshiko

In 1889, a year after the publication of *Songbirds in the Grove*, another work of fiction by a woman appeared in a literary magazine called *Miyako no hana* (*Flowers of the Capital*, February–May 1889). The piece, *Sankan no meika* (*Splendid Flowers of the Valley*), was reviewed favorably by the magazine's young editor and writer Yamada Bimyō, who called it "a story of true love."[9] *Splendid Flowers* set an example for many women who were to write stories based on their own experiences, expressing their deep emotions.

The first half of the novella concentrates on presenting various evidence of corruption among high-ranking government officials told from the point of view of the heroine, Yoshiko, a woman activist who had been on the front line of the political scene. The second half is about three young women who look up to Yoshiko as their mentor. Since the novella treats the theme of women's political emancipation, it can be classified as a *seiji shōsetsu*, or "political fiction." It is based, at least in part, on its author's real experiences, and this separates it from other political fiction written by men and confirms its tie to Tanabe Kaho's work. As shown in the latter section of *Splendid Flowers* — where women's rights, specifically, of equality in the divorce laws for men and women and abolishing the concubine system are discussed — Kishida Toshiko (1863–1901; "Shōen," sometime used the name Nakajima Toshiko) becomes interested in the emancipation of women, but it was in the Popular Rights Movement where she got her political start.

Taking place for several years from the very end of the 1870s through

the early 1880s, the Popular Rights Movement opposed the new government and was the first grassroots political movement in Japan. In this movement, a group of former samurai (who had failed to obtain positions in the new central government) were joined by prosperous local merchants (who objected to the government's large subsidies to big business) and the farmers in remote regions (who were finding the new tax system more costly for them than for city people). It involved a few spirited women who were spurred into joining the men in voicing their demands for a wider distribution of political rights. A forty-five-year-old widow and tax-paying householder by the name of Kusunose Kita, for instance, wrote a letter to the local authorities, basing her complaint on the infringement of her right to vote: rights and duties should go together, she stated, yet her rights, "compared with those of male heads of households, were totally ignored."[10] Various local groups were organized, including one by women, in various parts of the country in support of the movement. As the result, two political parties emerged, in 1882, in preparation for the opening of the national assembly.

The daughter of a wealthy merchant in Kyoto, Toshiko had enjoyed a reputation as a child prodigy, and at age fifteen she was invited to become a tutor for the Empress, the first commoner to be given this role (she gave lectures on Chinese classics). By then she had briefly attended the newly established higher normal school for girls. Both the school and the job in the court, from which she resigned after a few years, did not hold her interest, however. Shortly after her resignation, Toshiko took an extended trip, mainly on foot and accompanied only by her mother. Such a trip, rare for two women to undertake alone in those days of inadequate transportation, was perhaps possible because the father was absent in the household; her mother, furthermore, was an exceptional woman who seemed to have dedicated herself to her daughter's education. It was during this trip to the southwestern part of Japan, where the Popular Rights Movement was most active, that Toshiko became exposed to the movement for the first time. For the next two years she delivered speeches in various cities on the movement's behalf, demanding political rights for a wider segment of the population.

Political speechmaking was the central activity of the Popular Rights Movement, and this was where Toshiko became involved. Her first public speech, delivered in 1882 in Osaka, was a great success and drew a great deal of public attention to the movement. Standing on the podium in a formal kimono and traditional coiffure, Toshiko was a striking figure, and the brilliance of her speech also made a definite impression upon the audience. Though most of those in the audience were male, her reputation as a child prodigy and her past association with the court contributed to gain her respectability on this unheard-of occasion. When newspaper reporters wrote about

the occasion, however, their remarks did not focus on the content of her speech or the manner in which it was delivered, but rather on how clear and pleasant her voice was and how "ladylike" she was.[11] In the end, it was the novelty of a young woman's speaking in public that caught the most attention. One has to conclude that Toshiko's message, which contained her criticism of men—"the dictator with harsh emotion," in her words—failed to reach the audience.

Toshiko let the men in the movement exploit her in a way, but if there was a woman fit to be the first to appear in public and do what was considered a man's prerogative, it was Toshiko; she had enough composure to handle rude comments and banter during her speeches. And her delivering of speeches did encourage other women, who had not dreamed of undertaking direct participation in men's activities, to open their eyes to the new challenge and new possibilities. For Kageyama Hideko (1865–1927), for instance, listening to Toshiko's speech in Okayama in 1882 was a turning point in her life.[12] In her brief autobiography, she describing her excitement at hearing Toshiko's speech: "A large audience gathered like a cloud, and there was no space left to stand. I was quite moved by her eloquent speech arguing for the need to establish justice and expand women's rights, so much so that immediately afterwards I organized, with a few other women of the city, a study group. We held meetings, inviting various people to give speeches."

Hideko's involvement in the Popular Rights Movement was very different from Toshiko's, and so was the direction she took after the movement died out. Hearing Toshiko's speech was indeed the beginning of her lifelong involvement in radical politics. Although it is not clear if she heard Toshiko's speech, another woman, Shimizu Toyoko, spent a few years of her youth actively participating in the movement. These women were inspired by the example of Kishida Toshiko, and, in return, influenced other women.

"If a flower was placed in a small box with a narrow opening ... it would naturally envy those flowers in the fields, free and fragrant, and ... it would eventually try to free itself from the box," Toshiko stated in another speech, entitled *Hakoirimusume* ("Boxed-in Daughters," a term referring to unmarried women under the zealous protection of their parents), delivered in Otsu in October 1883. Toshiko concluded her speech by saying that if young women are placed in small, suffocating boxes, they will try to find a much larger box called *sekai*, the world. This and other speeches were presented as *gakujutsu enzetsu*, or scholarly speeches, and on the surface they were about women's need to become more aware of themselves and society. But the real meaning of the speech concerned avoiding police interference. Using the metaphor of a "box" in reference to Confucian teachings of blind obedience to parents, the speech criticized the government laws and regulations

that limited political assemblies. The disguise was a bit too thin, however, resulting in Toshiko's imprisonment for a week and a fine of five yen. After she was released because of illness, Toshiko went to Tokyo with Nakajima Nobuyuki, one of the central figures in the movement, the man she would marry a few years later.

Although Toshiko is considered the precursor of the Meiji's political woman, responsible for stirring the first feminist consciousness, she was involved in activism through delivering speeches and writing articles for less than seven years. The ending of the political fervor around 1887 was the immediate cause of her withdrawal from public life, but her marriage and various new demands were also powerful deterrents. Toshiko's marriage to Nakajima Nobuyuki (her first and his second) was a "love marriage" (as opposed to an arranged marriage) and was said to be a happy one based on mutual respect and devotion. In Toshiko's words, it was founded on "love and compassion, which is a natural virtue stemming from the best of human emotions." It was a union so rare for those days that it was gossiped about by journalists. And yet it was not without pitfalls for her. Her husband's eminent government position, obtained as the result of his playing an important role in the Popular Rights Movement, forced Toshiko to spend much of her time and energy entertaining his friends and meeting the demands of conservative upper-class society. Compared with her early days of political activities, her life became very subdued.

Earlier, in 1885, Toshiko converted to Christianity, and for a few years she taught at the Ferris Seminary, a missionary school for girls in Yokohama. She was suffering from tuberculosis when she went to Italy in 1892 with her husband, who had been appointed ambassador. With her husband, who was also ill and would die three years later, she then led for several years a quiet life in seclusion until she died at age thirty-seven.

Men in the Popular Rights Movement did not consider women participants to be their true partners; they did not take them seriously, either. It was a very broad political movement, but in the mind of the public, as well as in those of the movement's leaders, the freedom and rights of women were not an issue. Although the men Toshiko associated with in the days of delivering speeches acknowledged the importance of women's participation in theory, in practice they demonstrated their view that women essentially existed to meet the needs of men.[13] The experiences of Toshiko, Hideko, and Shikin attest to how the early Meiji political activists exploited women. It was through these women's awareness of an obvious discrepancy between the male colleagues' espoused position on "equality for all people" and their habit of ignoring and denying women's needs that they became proponents of women's rights. Back in Tokyo, Toshiko turned her attention to the subject

of women's subjugation by men, and having adopted the pen name Shōen, she started writing essays, attacking, sometimes vehemently, men's practice of excluding women, as well as their insensitivity toward women's needs and aspirations.

Toshiko's first publication was an article in the first issue of *Jiyū no Tomoshibi* (*The Light of Freedom*, 1884), a periodical of the Liberal Party, which had been formed as a result of the Popular Rights Movement. In this and subsequent articles she defines the condition of Japanese women as that of being on "the dark roads of the old days," where "men are as cunning as foxes and badgers, as savage as fiends and as violent as thieves and robbers." Sometimes, she added, "their licentiousness is so boundless that one might call them mentally deranged."[14] She (and other women in the early Meiji period) began her campaign for women's emancipation by pointing out men's moral degeneracy and their total indifference to the dignity of women. In her articles, which were published in ten installments under the title *Dōhō shimai ni tsugu* ("To My Fellow Brothers and Sisters," 1884), Toshiko argued against the popular notion that women were inferior to men, discrediting it as a "myth." When she did this, however, unlike the men who advocated "Civilization and Enlightenment," she warned her readers against looking to the Western nations as models. In the Western nations as well, she wrote, men subjugated women. Women in England and the United States had no voting rights, she stated, and therefore "to consider the Occident as civilized" was a mistake.[15]

The rhetorical approach Toshiko took in these articles was to attack men fiercely on the one hand and plead with them on the other — a style employed by other women polemicists of the Meiji era as well. This would change in a few years, however, when Toshiko started writing articles and essays, mostly in *Jogaku Zasshi*, focusing on the more commonplace phenomena in women's everyday lives. Her arguments became much more subdued both in appealing to men and in defending women's rights. Still recommending that men begin to change their behavior in ways that would help women feel more self-respect, she now discussed the importance of the education of girls at home. "Though women were present (in social visits with friends), they were there purely for the sake of formality; the men talked only to each other while the women usually sat for hours like decorative ornaments without saying a word," she observed.[16] Against the rising sentiment among parents to consider higher education for girls as superfluous, she advised young women to read, debate, and judge on their own. In 1891, Toshiko published, also in *Jogaku Zasshi*, an article criticizing the practices in the court and suggesting a few ideas for reform, a daring act indeed at a time when the country as a whole was in full swing toward traditional conservatism.

According to some literary historians, the best creative writing Toshiko did is her poetry written in Chinese.[17] The diary she kept during her last years is also said to be written in excellent style, although her will made much of it unavailable to the public. From what was published (only the portion from her final two months), the diary shows that she was a superb observer of life; it also gives a glimpse of her remarkable personality and of the state of her mind as she faced imminent death. The reader can see in this writing a sensitive and broad-minded woman who had transcended the limitations imposed on her sex. Her serene acceptance of life, as shown in her Chinese poems — her small joys in finding beauty in nature and her painful reactions to human drama — further reveals the mature view of the philosopher. A sense of humor, another important dimension of Toshiko, is also demonstrated in these entries.

Toshiko attempted translations as well, and published Bulwer-Lytton's *Eugene Aram* under the title *Zenaku no chimata* ("The Crossroads of Good and Evil," *Jogaku Zasshi*, 1888). Dealing with the rather commonplace topic of a man's return to prosperity with the support of his chaste wife, this work has nothing to do with women's emancipation. Her last work was a story entitled *Itchin ichiyū* (*Submerging and Floating*), published in 1897 in *Literary Club*'s second special issue on the work of *keishū* writers. With poor construction and an incoherent plot, it again is about a man who loses his fortune but, with the help of his wife, recovers his good name.

Toshiko's fiction was not particularly inspired. Although she also wrote essays, a few pieces of fiction, and a great deal of poetry in Chinese, she is now known primarily as the first woman who was actively involved in the Popular Rights Movement. It was her actions and her life that represented a source of great encouragement for other women of her age, as well as for those who came after her. Along with her published polemical writings, her revelation of the existence of a personality far removed from the popular image of the ignorant and passive Japanese woman is an important guidepost. Shimizu Shikin, also involved in the Popular Rights Movement, followed a path similar to Toshiko's; she would take up and develop the theme of women's emancipation and the question of marriage treated in Toshiko's fiction. Modeling her main character after herself and young followers who were actually around her, the author of *Splendid Flowers* dealt with the issues of political life and marriage and asked whether it is possible for a woman, like Toshiko, to be happily married while engaging in activities beyond her domestic responsibilities. This question was not fully developed, as the novella was unfinished, but it hints at a dilemma that Toshiko experienced in her own life.

The Popular Rights Movement ended with the promulgation of the

Meiji Constitution and the opening of the Parliament. The end of the movement was the end of political ardor and activism for the time being; young people left the political arena, shifting their mode of expression on behalf of freedom, basic human rights, and equality to other concerns. Some of them turned to writing fiction, like Toshiko and Shikin, aiming at the political emancipation of readers and expressing their views on current social issues.

Writing novels on the theme of political emancipation during the period when favor for political enlightenment swept Japan was a popular activity of a group of intellectuals of early Meiji years; having been the authors of Tokugawa *gesaku* fiction, some of them maintained their original slanted, antiestablishment orientation. These writers tended to criticize, if not directly oppose, the government. The authors of these novels, referred to as *seiji shōsetsu*, or political fiction, largely disregarded literary concerns; plots were haphazard, characters were largely sentimental and idealistic, and story lines, as well as characters, were essentially vehicles of propaganda. Dealing primarily with the political life of the hero, these fictions, however, introduced Meiji readers to the issue of heterosexual love. It was here, as well as in works of translation, such as Bulwer-Lytton's *Ernest Maltravers*, that readers saw that the hero finds the object of his passion in a young woman, along with political adventure.[18]

Political novels presented women as men's true companions, and as the hero becomes involved, women's lives and emotions are seriously discussed. *Setchubai* (*Plum Blossoms in the Snow*, 1886), a widely read novel by Suehiro Tetcho, has a central female character who insists, against her guardian's objections, on marriage to a man she loves, an impoverished young politician. Not only well educated, extremely bright and politically aware, she has the strength to carry her convictions into action. Advocating the freedom of individuals against patriarchy, the heroine proclaims here a kind of love that is markedly different from that cultivated in the demimonde described in Tokugawa *gesaku* fiction. Although political novels were the product of a transitional period and had limited influence, they nonetheless helped to make the spirit of the new age more accessible. Aspiring young women who had read books by Western authors in translation were as much impressed as young men by the messages they found in novels such as *Plum Blossoms*.

However popular these refreshing portrayals of self-assertive young women were, the central idea of a political novel—that women are intelligent and sympathetic supporters of men's aspirations, and that they should be rewarded for such compassion—was merely a notion. It did not reflect reality, but rather ignored the facts and concentrated on idealism. The notion of mutual commitment and affection between a man and a woman as free

agents was so alien, for example, that the cognate *rabu*, for the English word *love*, had to be adapted. Likewise, the thrust toward self-improvement was in reality a concern for men only; women were excluded from opportunities to apply the message of success through self-help. While many success stories of Meiji men are filled with accounts of their early struggles to reach their goals, what we hear about women are the stories of their sacrifices so that those men, their brothers and husbands, could succeed. Kimura Eiko was one such women whose short life ended with thwarted aspiration.

Kimura Eiko, "Akebono"

Under the pseudonym of Akebono, Kimura Eiko (1872–1890) published a novella in 1889 that was serialized in *Yomiuri Shimbun*, a daily newspaper; she was seventeen years old then. Although literary historians do not generally include it in their discussion of political novels, the work, *Fujo no Kagami* (*Mirror of Womanhood*), clearly belongs to that genre. Like *Kajin no kigū* and *Secchūbai*, which are considered representative works of the political novel, it has a large scope, taking its central character, a woman, abroad. The difference between this and political novels written by men is that the heroine in *Mirror* is also the hero. The central character who pursues a mission here is a young woman — beautiful, bright, and with considerable integrity. The character who helps this hero-heroine realize her goal is also a woman. The theme of *Mirror* is a woman's search for independence through social participation; it reveals a woman's dream to be set free from a confining environment, to become a useful member of her society, and to promote the cause of better lives for other women.

Like many other women discussed in this book, Akebono died very young, a year after she published *Mirror of Womanhood*. And, as is the case of most *keishū* writers, very little is known of her life. It is therefore difficult to determine what influence the political fervor of the day might have had on her, but judging from what is known, she was not directly involved with the Popular Rights Movement, as Kishida Toshiko and Shimizu Shikin were. Her motivation to write fiction more likely came from reading Tanabe Kaho's *Songbirds in the Grove*, which was published a year earlier.

The eldest daughter of a successful businessman who had accumulated great wealth single-handedly in a short period of time, Eiko shared her father, Kimura Sōhei, with thirty or so siblings by different mothers. Sōhei, originally a tea merchant, made a fortune by running restaurants that served beef, a new favorite of the Meiji Japanese. Eiko attended the Tokyo High School for girls as a boarding student, and it is said that she preferred to dress in

Western clothes and was fond of dancing and music of the West. This was not particularly surprising, since such tastes and activities were encouraged in those years of the Rokumeikan era. Eiko's father, however, was more like a feudal lord than a modern businessman, and he exerted total control over his family and many other people who depended on him. An incident recounted by Eiko's nephew after her death, which she incorporated into her story, tells what a tyrant he was: while still in school, Eiko received a proposal from a law student, a promising young man who had fallen in love with her. This angered her father, and thinking that it was his daughter's immoral nature that had invited such a proposal, he made her cut her hair. Cutting hair had been a symbol of repentance as well as renunciation of worldly desire practiced in feudal times (Tanabe Kaho used this reminder in her "Double-Petaled Cherry Blossoms").

Eiko thus married the son of a wealthy merchant, a man her father chose for her; it was also her father's decision that she divorce this man when his licentiousness became widely known and embarrassing. After her divorce at age seventeen, Eiko worked at one of her father's chain restaurants managed by her mother. Sitting at the cash register, she then secretly and slowly wrote *Mirror of Womanhood*. Having contracted tubercular peritonitis, she died at the end of the following year. Except for the fact that the manuscript was recommended by a journalist and critic named Aeba Kōson, the circumstances under which the novella was published are unclear. A short article in *Yomiuri* eulogized her, stating that her early death prevented her from becoming the "George Sand or (George) Eliot of the Orient."[19] Although this comparison does not mean much, since the eulogizer was simply following the custom of the time in using superficial Western analogies, it does point to a great deal of curiosity about a young woman who wrote and published, an activity limited to men at that time.

Mirror of Womanhood is about Hideko, a young woman who led a life very different from that of the author. It is a story of her going abroad and about her successful venture in getting an education and professional training, with which she contributes to her society and to the welfare of other women. Hideko first goes to Newham College (which in reality was founded in 1875) in Cambridge, England, and there she demonstrates herself to be a hard-working and conscientious student with all the virtues a Japanese woman ought to have. With her magnanimity toward a jealous and dishonest classmate she even wins classmates' admiration. Hideko, in other words, embodies "a mirror of true womanhood."

A title such as *Mirror of Womanhood* certainly gives an impression that the story has something to do with Confucian doctrine, but virtues such as self-sacrifice and subservience are not advocated in this novel. The title and

the state of mind of the heroine can be understood better once we know the meaning of *ryūgaku*, or study abroad, in Meiji Japan. Upon leaving to the United States for their education, Tsuda Umeko and four other girls,[20] for example, were given an official letter from the Empress recommending that they be "a model for all women" and not "harm the national polity of Japan." Pay attention day and night, advised "The Rules for Those Going Abroad to Study" issued by the Ministry of Education, for those who were idle or behaved poorly, as well as those who demonstrated no signs of future success, would be called back. In other words, for the people of early Meiji years, going abroad was not just a matter of personal gain but of national interest as well.

Hideko's reason for going abroad is honorable and totally unselfish; her motivation is neither to advance her own position in society (as was the case with many early Meiji men who went abroad) nor to express her rejection of the political climate of the time (as is the case for the hero in political novels written by men). After her time in England, she goes to the United States, where she acquires training in the textile industry. Upon returning to Japan, she builds a factory where young women can work and learn new skills. What she achieves in the end, in other words, is something more concrete than what the heroes in political novels written by men generally accomplish. In fact, Hideko's focus on the training of textile workers made perfect sense, as silk was one of the few commodities Japan was able to export then. The idea of helping young women develop skills that would lead to financial independence may have seemed a fantasy in the 1880s, but in less than a century it became a reality. It is not clear where Akebono got the idea of setting up a child care facility attached to her factory, but the exploitation of workers in the rapidly expanding textile industry — exclusively young women — had already been brought to public attention by then.[21] In this conclusion and happy ending, the reader sees a glimpse of the author's idea that a woman, like a man, can be not only useful but socially responsible.

Compared to its staccato ending, the first part of *Mirror of Womanhood*, in which Hideko encounters difficulties in carrying out her plan of going abroad, has a solid tone with more details, giving an impression that it is based on the author's experience in real life. This is an aspect that is not seen in political novels written by men, and it connects Akebono to most of the other *keishū* writers discussed in this book.

Hideko was originally supported by her father, but her plan of going abroad had to be aborted because of some malicious slander circulated by her rejected suitor. Feeling responsible for having damaged her father's reputation, Hideko leaves his house (since an unfilial daughter has no right to remain under her father's protection), and during her self-exile she comes

close to death. She is rescued by a young woman, Haruko, who by chance she had saved from dying of hunger several years earlier; the two happen to be half sisters. When she learns of her sister's problem, Haruko obtains money by selling herself to a geisha house so that Hideko can go abroad.

Hideko is uniquely a product of the 1870s and early 1880s, when Japan was experiencing intense Westernization; it is the same era depicted in the opening scenes of *Songbirds*. Hideko is totally comfortable with foreigners; in fact, her best friend, Coddet, is a native English speaker. As mentioned earlier, Eiko herself spoke both English and French adequately; in a photograph showing her in her Western clothes, she looks quite natural. In other words, it was not unusual for Akebono to create a heroine who was totally comfortable with foreigners. Among a handful of young women who recognized in the Meiji government's early attempts at improving women's social status a harbinger of change for themselves, Eiko in fact was said to have mentioned to her friends her plan to go abroad.

Stories of innocent women whose lives are adversely affected by men with either malicious intention or simple selfishness abound in Meiji fiction, particularly those works written by women. The sense of powerlessness and helplessness felt by women in a patriarchal society is conveyed through such a device. It is Hideko's sense of powerlessness that makes her simply acknowledge, without a hint of protest, her father's withdrawal of his support; furthermore, although she is an innocent victim of a slander, she somehow feels guilty. This guilt of the victimized woman is another feature commonly observed among heroines in Meiji fiction.

Akebono published one more work, also in *Yomiuri Shimbun*, but this, a short story entitled *Wakamatsu* ("The Young Pine"), resembles Tokugawa fiction in its plot, sentiment, and style, and it lacks any new, refreshing elements. Because of its classical style as well as its title, *Mirror of Womanhood* seems more like a product of the Tokugawa era than modern fiction: a strong emphasis on such womanly virtues as loyalty to one's family and quiet resignation (as Hideko demonstrates in facing her father's displeasure) is in agreement with the official doctrine of Confucian teaching of that era. One should notice, on the other hand, that Haruko's act of self-sacrifice (a woman's raising money by selling her body was not uncommon in those days, although it was usually initiated by the father rather than the young woman herself) is not presented as an obligatory gesture made to fit the traditional Confucian morality, *giri*, or debt of gratitude. Rather, it is an act of genuine compassion, and therefore the author has Haruko enjoy the result of her self-sacrifice by being a part of Hideko's life after she returns from abroad. This altering of the common situation — women's sacrificing themselves for men according to the moral prescription of the time — has an ironic overtone.

In other ways, too, *Mirror of Womanhood* is distinctively a modern work. Hideko sees herself in terms of the larger society in which she lives, a life beyond the circle of her family and friends. She has aspirations to learn and grow, and, most importantly, she joins men in acknowledging that changes for a better life are possible. This quality, as well as her magnanimous personality, connects Hideko to the heroine of Kishida Shōen's work discussed above. Another common characteristic in the fiction written by Akebono and Shōen is that both are firmly based on real experiences. This feature, which separates them from political novels written by men, can be identified as a female tradition, since it can be also observed in the work of other women writers discussed in this and the following chapter.

The period of openness to the West did not last long, because soon, as a surge of nationalism with a traditionalist sentiment took over, Japan recoiled. As the nation turned its primary interest to fortifying itself with military and economic strength, intellectual leaders dropped the idea of women's emancipation. Although the government continued to send many men abroad, the plan of sending young women for the second time (the first was in 1871, when Tsuda Umeko went) was not carried through. By the time Akebono was writing her story, her idea of going abroad had become only a dream.

The creative writing by the women discussed in this chapter was embryonic, showing an obvious lack of skill in dealing with structures or characterization, particularly in delineating a more complex psychology. Women writers who began writing after the end of this highly political era (they are discussed in the following chapter) would write with more skill, albeit their main characters are without the forward-looking posture maintained, for instance, by Akebono's heroine. Rather than expressing a hope for emancipation, the writing of the next decade repeatedly and unanimously tells of the victimization of women by men in a patriarchal society. But before discussing those writers, we need to pay attention to two other pioneering literary women, Wakamatsu Shizuko and Shimizu Shikin. Although Shizuko is known primarily for her translations from English, and although the small body of her original work is not significant enough to discuss here, it is clear that she had a great deal to say about her own life and emotions. This is particularly evident in the writings she did in English, a language she excelled in. Shikin has written fiction with greater depth, as well as on a variety of topics; she has shown an exceptional talent in forming stories based on her own experiences, a characteristic which, though unnoticed by contemporary critics, ties her to other women writers discussed here.

Wakamatsu Kashi, "Shizuko"

Wakamatsu Shizuko is represented in the *keishū* special of *Literary Club* with her work *Wasuregatami* ("An Orphan"); it is a translation of "The Sailor Boy," a narrative poem written by English author Adelaide Proctor (1825–1864). Earlier, Shizuko published a few short stories and essays, mostly in *Jogaku Zasshi*, a magazine started by Iwamoto Yoshiharu in 1885 to help promote women's emancipation and education. It was through her interest in this magazine that Shizuko became acquainted with him (they later married).

Jogaku Zasshi was an important publication of the early and mid–Meiji period because of its contribution in the area of women's emancipation. Starting in 1885, it published commentaries on social and political issues related to women, philosophical treatises, essays, interviews, book reviews, and articles on religion and education. It was liberal and progressive, sometimes even radical, in its content. Calling for the attention of administrators of girls' schools in a May 1894 article, Iwamoto maintained, for example, that the proper education of women lay in training their minds and personalities and that domestic and practical skills were not enough.[22] He also argued against the old customs and morality that were hindering women's social advancement, and criticized men for their practice of keeping concubines and promoting the *kōshō* system of licensed prostitution. His original intention in starting his magazine was largely to enlighten Japanese male intellectuals, and at least in the beginning it was read by many men.

Regular contributors to *Jogaku Zasshi* included Tanabe Kaho, Kishida Toshiko, and Shimizu Shikin, who wrote articles aimed at the more educated young women of the middle class. Except for those by Shikin, they are generally low-key and on a variety of topics intended to enlighten women in the area of marriage and homemaking. The magazine also introduced the life and customs of Western society — heterosexual love and the romantic worship of women as seen in Western literature — in an attempt to show how Japanese society could better treat women in all areas. While Shizuko's translation introduced the works of Victorian England, Kitamura Tōkoku energetically wrote essays and treatises on *ren'ai*, or heterosexual love. Toward the end of its publication (it lasted until 1904), the magazine published creative writings as well. In fact, *Bungakkai* (*Literary World*), a literary magazine discussed in the following chapter, was an offshoot of *Jogaku Zasshi*.

Iwamoto was also involved in the education of young women. Meiji Jogakkō, a secondary school for girls, was founded in 1886 by a woman, but he developed it into a school with unique characteristics. The school was closely associated with Meiji literary women, some of whom taught while

others were students there.²³ At one time it had as many as three hundred students. Among the teachers were young poets and aspiring writers who were recruited by Iwamoto and who would soon start the Romantic Movement on the Japanese literary scene. Shimazaki Tōson and Kitamura Tōkoku were the best-known such figures, and, with them, students attempted the zealous pursuit of knowledge in the classroom while discussing new European literary developments and philosophies. In many cases the teachers were not much older than the students, and in an atmosphere freer than that in missionary schools, and with a stronger interest in literature and art than in religion, the students enjoyed their youth, sometimes engaging in platonic love relationships with their teachers.

> Through the spirited writings of these teachers, we've come to know Dante, Raphael and Michelangelo. Then, what we had held deep inside, beneath the pessimism that is found in the novels of the late Tokugawa period, and that colored the concept of women, was evoked in all its simplicity. We were made to understand the brilliance and the colorfulness of life. When we read *Bungakkai*, we felt we were able to rectify and improve our position.... At any rate, we discovered ... a largely idealized view of women. This was something I also saw in people at the Meiji Jogakkō.²⁴

In this environment, and through studying Western literature, art, and philosophy, students at Meiji Jogakkō were made to feel that they belonged to a generation distinctly different from that of their mothers.

By the end of the second decade of the Meiji period, eleven private *jogakkō*, girls' secondary schools, like Meiji Jogakkō, were being run by Christians. The students enrolled in these schools not necessarily because of their interest in Christianity, but rather to satisfy their love of learning and to receive a well-rounded education. Many of the teachers there likewise approached their students with the goal of cultivating their minds, rather than narrowly indoctrinating their students with Christianity or with practical morality. Each of these schools had unique characteristics and a history of its own, but by maintaining good communication with each other they were able to work toward common goals. Iwamoto, a Christian, was among these educators and saw that his work in publishing *Jogaku Zasshi* and promoting the status of women would go hand in hand with educating young women at school.

It is said that Iwamoto became a Christian in order to combat the deep pessimism he inherited in his earlier Confucian education, and in his early attempt to discover a new approach to the question of the purpose of life, he, like other Christians of his time, had found his role models in missionaries. In early Meiji years Christianity was welcomed by upper-class people who were more or less attracted to it as a way of satisfying their enthusiasm

for the exotic; because they offered meeting places for young men and women, churches were even a center of high fashion. The work of Christian missionaries, which had begun before the Restoration, almost always involved the teaching of the English language (sometimes also provisions for medical care, another attractive feature). This initial superficial appreciation of Christianity was short-lived, however, and by the 1880s several churches had been established by the Japanese themselves in various parts of the country, and these churches began attracting the middle-class young men and women like Iwamoto. They approached Christianity as a useful tool in combating various old attitudes, both in themselves and in their society.

If one looks at public school education, the situation was different. During the 1880s, when the national educational system became better organized, sex-segregated secondary schools were built and the government policy of public education now treated the girls with an apparent inequality. Under this system, *jogakkō* was to be the entire educational opportunity for women beyond four years of primary schooling unless one chose to go to a higher normal school for women (four years).[25] A shift in focus was seen as well, from that of sexual equality to a more pragmatic approach, and education for girls was now aimed at preparing them to become homemakers. Public education in general would soon begin embracing nationalism and the doctrine of subservience to the state.

In contrast to this shift, the more liberal view of women's education, held by "Civilization and Enlightenment" advocates during the 1870s, found continuous support among the educators in private schools. These institutions, like Meiji Jogakkō and schools run by missionaries such as the Ferris Seminary, maintained their original stance of humanistic and well-rounded education. In the minds of students of these private schools, the traditional Confucian notions that women were inferior and depraved, and that obedience was their essential virtue, continued to be challenged.

The Ferris Seminary was one of the oldest and best-known missionary schools for girls. Started by a woman known as Mary Kidder ("Miss Kidder"), an American missionary sent by the Reformed Evangelical Church, it began as merely a small group of students who came to her house in Yokohama. By the end of 1875, when it officially became a girls' school and was housed in a small but fine school building (financed with help from Kidder's church in the United States), there were fifty students and ten teachers, four of whom were foreigners. With its individualized instruction based on a flexible academic curriculum, combined with scholarships for needy students, the school quickly built a good reputation, increasing student enrollment eightfold in a little over ten years.[26] It was at this school that Wakamatsu Shizuko (1864–1896) learned English and was introduced to Western literature.

The daughter of a lower-ranking samurai from the Aizu region (Fukushima prefecture), Shizuko (given name, Kashi) had experienced her family's total disintegration at the time of the Boshin War of 1868, when the Aizu Castle was seized by the new government's military forces. As she had lost her mother to an epidemic two years later, and as her father's whereabouts were unknown, she was adopted by a merchant from Yokohama. She was a difficult child determined not to adjust to the new environment, and as her adoptive parents' financial circumstances declined, she was put under the care of Mary Kidder; she was one of the youngest students at her school. It was here that Kashi, later adopting the name Shizuko, "a humble child," learned that, for instance, in God's eyes man and woman are equal, that marriage is a sacred union of an individual man and woman, and that happiness in life does not lie in material welfare. In 1882, Shizuko completed her eleven years of education at the Ferris Seminary.

Shizuko became acquainted with Iwamoto through her strong interest in educating girls; she had a passion for women's emancipation similar to that of Iwamoto. While she was teaching at the Ferris Seminary, she organized extra-curricular activities and conducted writing and discussion groups for students. Her initial interest in translating English stories came in part from her desire to recommend appropriate reading for her students. In a report on the conditions of Japanese women (in response to a request by Vassar College, which was conducting worldwide research on women's status), she wrote that limiting women to the occupational areas traditionally assigned to them was still being widely practiced in Japan, and that the literary achievement of women had been far less than that during the golden era of the Heian period.[27] In a speech she made in English in 1889 at the Ferris Seminary and entitled "Yesterday and Today," she expressed her conviction that the days when "women were expected to devote themselves exclusively to their homes are over." Women, she declared, "must now contribute to the improvement of the society."

Shizuko married Iwamoto in 1889 when she was twenty-five. Considerably older than other *keishū* writers except for Kishida Toshiko, she had by then established her career as a teacher and had just started publishing her translations. For seven years after her marriage, until she died at age thirty-two, Shizuko wrote between the chores of her busy days as a mother of four children and assistant to her husband. During her last year or two, much of which she spent in bed (she was suffering from tuberculosis), she continued to write, against her physician's strict advice, for an English-language magazine that Iwamoto published from 1884 to 1886. Facing an increasing hostility toward Christians in Japan, Iwamoto began his evangelical work in Korea. The magazine *Nippon Dendō Shimpō* (*Japan Evangelical News*) published articles by Shizuko, who was responsible for the "Women's Section."

"We are married, they say, and you think you have won me," Shizuko wrote in a free verse entitled "The Bridal Veil" immediately after her marriage to Iwamoto.[28] In this poem, a young bride challenges her husband to see and accept her as she really is:

> Well, take this white veil and look at me;
> Here's matter to vex you and matter to grieve you,
> Here's doubt to distrust you and faith to believe you.
>
> Look close on my heart, see the worst of its shining.
> It is not yours to-day for the yesterday's winning,
> The past is not mine. I am too proud to borrow.
> You must row to new heights if I love you to-morrow.

That Shizuko wrote this in perfectly good English is not surprising, as she was almost as proficient in English as in Japanese; in fact, she found it easier to express more complex emotions in English. Having spent her first seven years in the dormitory as a boarding student where English was the first language, and having enjoyed reading Charles Dickens, George Eliot, and the works of the nineteenth-century poets, she learned to express herself in English.

The thoughts and emotions expressed in "The Bridal Veil" are fairly complex as well as revealing; it would not have been possible to express them in Japanese with the stilted literary style used by Shizuko's contemporaries. In translating English works into Japanese, Shizuko would soon realize, like other Meiji writers who engaged in translation, that preserving the flavor of the original text required creating a new literary style.

The literary style used by early and mid–Meiji writers was a combination of classical and vernacular, the former for description and the latter for dialogue. Because the classical style, with its emphasis on traditional poetic images and rhythm, was not appropriate for depicting the psychology of modern men and women, fiction written in this style tended to depict characters exterior much more than their interior. The writers who are aspired to achieve realism in style as well as in subject matter knew that they must abandon this conventional literary mode and create a new one. This task was enormous, as is illustrated by the testimony of Futabatei Shimei (1864–1909), who is said to have written his fiction first in Russian, the foreign language he knew best, and then translated that into colloquial Japanese.[29] When Shizuko discovered the joy of expressing herself through writing, she faced the same predicament. Translating English stories into Japanese was a challenging and, as attested to by her husband, strenuous activity for her.[30]

Shizuko took advantage of her linguistic strength nonetheless, and ventured into translating from English, mainly the works of the nineteenth century. Her most successful translation is that of *Little Lord Fauntleroy* (Barnett, 1886), which she published as *Shōkoshi* in *Jogaku Zasshi* between 1890 and early 1892. A painstaking job, the translation was executed quite smoothly and consistently in a style that transmits intricate and subtle feelings and behavior.

Meiji readers owe a great deal to Wakamatsu Shizuko, not just for her translations, but for creating of a new style that is, as shown in *Shōkoshi*, more natural and closer to daily speech. While credit for role in shaping a new colloquial style is generously given to Futabatei Shimei, literary historians have not given the same to Shizuko's accomplishment. The reason for this is, in part, that the pieces she translated are all of minor authors. It is not altogether wrong, at the same time, to speculate that another was that as a woman, she existed outside the literary establishment of the time. *Shōkoshi*, however, will be read and reread by the generations of readers to come, making her name known not only to contemporaries but to posterity as well.[31]

In Shizuko's case, the difficulties of translating stories from a foreign language were superimposed upon those she endured in her early life. She took the personal task of her own Westernization in stride, but as she did so she was simultaneously held back emotionally by her cultural heritage. Education at the Ferris Seminary helped form her values and her way of thinking, but since the seminary was her home during her formative years, she received very little of the basic training that one would normally get at home, a deficiency she would later become keenly aware of. Shizuko's life can be represented as one caught between two irreconcilable forces, each claiming legitimacy.

That she was born in the Aizu region seems also to be significant. The people of Aizu, who were among the last to give themselves up to central control under the Meiji's new regime, were particularly proud of their history and regional integrity. And her perception of herself as a person uprooted from native soil and emotionally torn between two divergent cultures seems to be related to specific pieces she selected to translate. Her longing for her lost family and for her roots made her identify with the characters of "The Sailor Boy," for instance. Shizuko transformed this into a short story about a boy from Aizu and published it in 1890 as *Wasuregatami*, "An Orphan." By shifting the narrative point of view from that of the boy to that of a mother who had given up her son, and by changing the title, she represented in this story the guilt of a woman who cannot openly claim what belongs to her. Changes Shizuko made help increase the pathos transmitted in the original text, the impact of which is shown in a statement made by a critic who said

that those who didn't cry while reading it were "cold-blooded."[32] The orphan boy, with his courage and yearning for love, indeed stirs deep emotion.

Choices Shizuko made in deciding what to translate seem to reflect her view of literature as well — namely, that fiction ought to serve a moral purpose. This notion, which might be called the Victorian view, had been underlined in the more serious type of Tokugawa fiction, and in Shizuko the two coalesced. She believed, for instance, that the writer's responsibility was to depict characters carefully so that the reader "can respect their good behavior while detesting that which is undesirable." Fiction should exert an immediate and lasting influence on its readers; it should educate, temper, and improve the moral life of the public, she thought. Without this consideration, she stated, the work would become mere entertainment, "unworthy of the attention of people who seek the true way of life."[33] *Michi*, the way, or guiding morals of life, the term she uses in explaining her position, is a concept taken directly from Confucian ideology, and it was combined in Shizuko's mind with a desire to introduce Tennyson and Proctor. This merging was possible because Shizuko's view of literature was a utilitarian one, a view that can be seen both in the Victorian and the Confucian notions of literature.

Through her education and reading, largely of the works of the nineteenth-century English authors, Shizuko was strongly influenced by the Victorian concept of motherhood and family as well. In her preface to *Shōkoshi* she states that children are innocent and unselfish and that they have a special mission, that of bringing out the goodness in adults. When she translated a chapter from *David Copperfield* (the section depicting the child-wife Dora), Shizuko was advocating the strength of being natural and loyal to one's own feelings. Through translating stories that had a child or an adult with a child's heart as the central figure, Shizuko showed the Japanese reader the special qualities children have, a contribution unmatched by other Meiji writers.

Shizuko's views of family, home, and the roles of women, demonstrated in her personal life and through the works she translated, were more than simply refreshing. She defined "home" (she used the English word to stress her point), for instance, not as a unit with its basic components of duties and obligations, as stressed in Confucian teaching, but as one created by the mutual efforts of husband and wife, a place where children are nurtured and educated. Presenting a view radically different from that commonly accepted at the time, she even has shown spirituality as a prominent quality of women. With this she was able to counter the Confucian view of women as simply inferior to men. Shizuko, who called her own children "the guests of our home," demonstrated, particularly to the students of Meiji Jogakkō, her concept of

family life with children at the center. She also made a point that children have the right to grow up as free agents, an idea quite foreign to most Meiji people.

Although Shizuko wrote a few short pieces of fiction,[34] they are not nearly as significant as her work of translation. As one who believed that "a pen in the hand of a thoughtful woman can become a powerful weapon," and as one with a unique perspective as well as skill, she helped Japanese readers understand and feel closer to a few key concepts of Western life and culture. In supporting her husband's work in managing the Meiji Jogakkō, she indirectly contributed to the social awareness and personal development of many Meiji women as well. By putting her enlightened views of marriage and motherhood into practice, Shizuko helped emphasize, particularly for the students of her husband's school but also for her readers, the concept of equality between men and women.

Shimizu Toyoko, "Shikin"

If we compare Shimizu Shikin (given name, Toyoko) to Wakamatsu Shizuko and Tanabe Kaho in terms of educational background, the difference is obvious. Unlike Shizuko, who had opportunities to learn about Western customs, thoughts, and values through her contact with American teachers and missionaries, and unlike Kaho, who received excellent, though informal, early instruction as well as education at Tokyo Kōtō Jogakkō, Shikin had only a haphazard education. At a time when the public school system was not yet well organized, she was more or less left alone to pursue her own studies. That she was born and raised in Okayama, a remote southwestern city, may have been a factor. Shikin was aided, however, by her strong personal aspiration, and like Kishida Toshiko, four years her senior, she learned about ideas such as the equality of all people through involvement with the Popular Rights Movement.

Toyoko was born in the first year of the reign of Emperor Meiji. Her father was a scholar of Chinese classics who was also interested in business, and her mother was an ordinary, traditional homemaker. Toyoko was married at age eighteen, though this lasted only briefly. Around 1888, soon after her divorce, she became involved in presenting a petition that proposed to reform Article 311 of the Penal Code, which treated the adultery of wives as a punishable crime. She also took part in the Popular Rights Movement in the Kyoto area and made the acquaintance of several key activists, including Ueki Emori, Ōi Kentaro, and Kageyama Hideko. Toyoko was among seventeen women who wrote for the preface of Ueki's book *Tōyō no Fujo* (*Women*

*of the Orient).*³⁵ She is said to have made public speeches around this time, and also planned the publication of a magazine to advocate her political and feminist position.

In May 1890, Toyoko, now twenty-three years old, went to Tokyo and was employed by Iwamoto Yoshiharu, who had started *Jogaku Zasshi* six years earlier. Its first full-time reporter, she became the editor in chief six months later. Her biography indicates that for several months in 1892 she suffered from a nervous breakdown, the cause of which was most likely Ōi Kentaro, who was also involved with her friend Kaeyama Hideko. At the end of this year she married Kozai Yoshinao, an assistant professor of Tokyo Agricultural College. She died at age sixty-nine after an uneventful but busy life.

At first Toyoko wrote interview articles for *Jogaku Zasshi*. When she did this, she chose as her subjects not only well-known figures but also nameless individuals such as switchboard operators (then a new group of working women) and the students in girls' high schools. She also wrote essays, now under the name of Shikin, expressing her own opinions on various social issues. *Jogaku Zasshi* was a perfect place for Toyoko to work, and in her essays, as well as in the fiction she would soon write, she sent out a message: women should achieve their autonomy, and for that they must be willing to work hard.

Like Iwamoto, Shikin was quite vocal in expressing her opposition to repressive government policies. In her article entitled *Naze ni joshi wa seidan shūkai ni sanchōsuru koto o yurusare-zaru ka* ("Why Are Women Not Allowed to Participate in Political Assemblies?" August 1890) she questioned an 1890 law reinforcing the 1880 regulations that further denied political rights to women.³⁶ This law, she argued, would leave the next generation in the hands of women who had no chance to exercise their responsibility toward their society. Such a policy, she went on, would make twenty million Japanese women into "disabled persons": would any human being, she asked, be able to enforce such a law against another human being?

In November 1890, Shikin wrote an article entitled *Tōkon jogakusei no kakugo ikan* ("How Well Prepared Are Our Female Students?") in which she asked her readers, specifically young women, whether they had clear ideas on issues beyond the immediate environment of their parents' homes and their schools. She warned against young women's tendency to consider marriage the ultimate goal of their lives. "Therefore, only those who are thoughtful and those who can persevere will be able to meet the various difficulties (in marriage)," she stated. "Only by working hard over many years will you succeed in favorably influencing your husband." Speaking as one who had been unhappy in her own marriage, she wanted to remind the reader what marriages are like: "if you are weak and impatient, or if you put yourself

under the influence of popular notions and customs," she wrote, "you will lose your aspiration and you will become a slave, a machine that moves automatically." Young women with higher education (though for them merely of the secondary school) had ideals as well as awareness of their likes and dislikes when they entered marriage, but sustaining their original ideas would not be easy. In choosing a husband, therefore, one needed to look at a man's personality rather than his job, social status, or wealth. Even though the common practice of those days was still for parents to make marriage decisions for their daughters, more young women were beginning to exercise new freedom in expressing their own opinions and making decisions about their futures. And because they were grossly inexperienced in making these decisions, they needed guidance. Shikin's advice, not irrelevant in Japan even now, was therefore particularly apropos at the time.

Calling her readers *shimai*, or sisters, Shikin wrote in this essay (as well as in others) that many changes needed to be made in order to realize the life to which they aspired, that reality was not what it appeared to be. Her tone in this and other essays written around this time conveys deep conviction, similar to the speeches (and writings) of Kishida Toshiko. The central message in those essays, however, resembled very much that of Iwamoto, that what was essential in a woman's life was being a good homemaker. By this time the doctrine of good wife/wise mother was firmly entrenched in society in general, and in public schools for girls in particular.

Shikin's writing conveys a definite sense of purpose, and there is always a point which she wants the reader to not only understand but also put into practice. She was a realist in this sense, and she wrote many more articles, sometimes in plainer language, offering information on a variety of subjects concerning daily living. Shikin also wrote children's stories, which were useful to mothers in an age when children's books were not readily available. The keen critical sense characterizing Shikin's writing is evident even in these stories, which were also intended to teach readers to think and judge for themselves. *Bunmei no Obake* ("The Ghosts of Civilization," 1891), for instance, tries to help the reader distinguish between what is real and what is an illusion.

In 1891, Shikin published a short story entitled *Koware Yubiwa* ("The Broken Ring") in *Jogaku Zasshi*. Her first attempt at fiction, it received favorable reviews. Mori Ogai, for example, praised her "natural" style, stating that he expects her to write "a finer work once she learns all the skill of story writing." Tanabe Kaho also praised the smooth style, saying that the story "does not seem to be crafted word by word." The colloquial style employed in this story is strongly reminiscent of Wakamatsu Shizuko's translation of Proctor's "The Sailor Boy," published a year earlier. Shikin's first attempt at fiction, a

form she now used to get her point across to her readers, had found a perfect medium, which was shown by Shizuko.

The story of "The Broken Ring" is about a disastrous marriage and its result. Having observed her parents, whose relationship is basically that of a master and his servant, the protagonist does not wish to be married. "My mother demonstrated the teaching of *Onnadaigaku* [a bible for Confucian teaching for women], and to her husband she'd speak in a humble manner and only from outside the room; it was as if he was an important guest." Not only is this wish denied, but the man her father chooses for her turns out to be a bigamist, and in a few months the protagonist learns about another woman who had been living in the husband's house till a few days before her marriage. The husband's absences become more frequent and lengthy, but the protagonist nonetheless follows the Confucian teaching of "submission three times over"—first to her father, then to her husband (and then, after her husband's death, to her son, the teaching goes). When her mother dies heartbroken by her daughter's misfortune, however, she decides to leave her husband. The protagonist realizes that her attempts to "reform" her husband have been unsuccessful:

> I agreed to enter this unwanted marriage so as to relieve my mother from unnecessary anguish, but in the end my unhappiness caused her more worry and eventual death.... I blamed myself for having invited this situation, and though I was miserable, I stayed on for two more years.... It was during this time that I came to see the situation in broader terms, and I became indignant for other women as well. Having read and become acquainted with the idea of women's rights advocated in the West, I came to believe that we Japanese women must follow their path.

In concluding the story of her disastrous marriage, the protagonist states that "unhappiness and misery are not necessarily a woman's destiny given by heaven."

"Breaking the ring" symbolizes freedom from a humiliating life, says the protagonist, and because she does not want to forget her many heartbreaking days of pain and sorrow, she continues to wear the stoneless ring, a "broken ring." It also enables her, she says, to meet, with courage, the criticism and condemnation she will receive for what she has done — namely, for committing the "insolent" act of demanding a divorce.

In "The Broken Ring" we see a literary expression of the disaster of polygamous practice. The cruelty and unfairness women experienced in polygamy led many women to seek divorce,[37] and abolishing this practice was one of the major concerns of women's rights advocates during the late 1880s.[38] Shikin, having been involved in the campaign to abolish polygamous practices, wrote

this story in order to help young women become aware of the reality of marriage as she herself had come to know it; her interest in the emancipation of women was aided by a creative talent in producing a moving story. Although it is a story of pain and conflict, "The Broken Ring" is ultimately about the triumph of an autonomous self and about the courageous act of assuming responsibility for one's own destiny. Unlike Tanabe Kaho's quiet heroines and the resigned women in Kitada Usurai's stories (discussed in the following chapter), Shikin's protagonist acts in order to change an unacceptable reality.

According to feminist critic Imai Yasuko, it is a mistake to interpret the thoughts entertained by the protagonist of "The Broken Ring" in terms of independence and autonomy as we think of them now. It is, in other words, not a story of Nora in *A Doll's House*.[39] Although she freed herself from the idea that "things would be fine if [she] suffered quietly," the protagonist continues to believe that she has "failed"—in other words, that she did not succeed in influencing her husband into correcting his behavior on his own. This, however, is not the limitation of Shikin; the reality in which she worked granted men a polygamous practice and made prostitution a legitimate and lucrative business. Women existed primarily to serve men's needs, and in such circumstances and against many obstacles, the author's unfailing trust in women and humanity in general comes through in the story, inviting positive reactions from young readers like Sōma Kokkō, who noted in her memoir how excited she had been when she read this story, and how eagerly she had awaited more of Shikin's stories.[40]

"You wonder why this ring doesn't have any stone; you're right it is unsightly, a ring without a stone.... But, this is a kind of reminder for me ...," begins the protagonist, confiding in a younger female friend. What is attempted here is neither a confession nor self-exploration. Although the colloquial language may help to account for the author's success in conveying both the complexity of real emotion and a sense of urgency, the choice of the first-person narrator with an impulse to tell the "true story" makes this work poignant as well as believable. Moreover, by basing it on her own experiences but deliberately leaving out specific details, Shikin manages to convey a sense of truth about a difficult marriage. It is an early example of an author basing a story on her own experiences, a characteristic seen so frequently in the work of women writers discussed in this volume so that one might call it the female tradition in Meiji literature. In Chapter 4 we will examine more examples of this type of fiction writing.

That there is a close connection between fiction and earlier polemic writings in Shikin's mind can be seen again, though not as overtly as in "The Broken Ring," in another short story, *Kokoro no oni* ("Demon in the Heart").

Published in *Literary Club*'s second *keishū* special, this story tells about an abusive husband who will not consent to a divorce. He is a man with an *oni*, or demon, in his heart, the story says, and his desire to dominate his wife, which seems to have no limit, deprives him of judgment and self-control. After he fails to get his wife back from her parents, he loses his mind and lands in a mental institution. It is not impossible for a husband to turn tyrannical, the story also says, if he sees a woman as existing solely to meet his needs; a man's selfishness and intemperance can not only destroy a marriage but make his existence grotesque. These messages, embedded in the story, are not easy to sort out without careful reading; they most likely escaped the readers of the time. A reviewer commented that it is a "common-place story of jealousy," considering it somewhat exaggerated though plausible.[41] Obviously, this reviewer did not feel that the story portrayed a bizarre marriage. A careful reading of the story reveals, however, that Shikin had a different intention; she may be saying that although such obvious abuse should not be permitted in a civilized society, a woman is also responsible for allowing such behavior through her passive submission, which can also be a "demon."

Earlier, in 1892, Toyoko wrote a story entitled *Ichi seinen no iyō no jukkai* ("Unusual Confession of a Young Man"). Quite different from "The Broken Ring" and "Demon in the Heart," it is about a man who has learned to respect a woman as the result of falling in love with her. "Why do I think of her so much; it was only a few days ago that I met her," says the first-person narrator-protagonist, confessing that he cannot suppress "a strange but strong" emotion: "I cannot think of anything else but her; I can't remember anything but going to a friend's hoping to see her again.... I have become a person unknown to myself.... And yet, in the face of her existence I've become blind, one who stutters, one who can't hear well." Proud of being "tough and undaunted under any circumstance," the protagonist is truly puzzled, but soon he realizes that the woman he loves has a "spiritual glow" that can "purify men and make them gentle."

Confession of love that stirs a man at the core of his heart was rare as a literary topic in the early years of the Meiji era. In 1892 the idea that a man could love and respect a woman was quite foreign to most Japanese. Moreover, although platonic love would become an important literary theme in the next decade, when romanticism was introduced to Japanese readers, it would be treated mostly by male authors. It is understandable, therefore, that "Unusual Confession" was thought by the critics and readers of the time to be merely an expression of the author's hopes and dreams, a fantasy. The story, in fact, continued to be taken as such until letters written to Toyoko by Kozai Yoshinao were discovered many decades later.

As in the case of "The Broken Ring," "Unusual Confession" is in part

based on the real experience of its author. Yoshinao, who would eventually marry Toyoko, confessed in his letters to her that his conception of women had been drastically altered after coming to know her well. Until then, he said, he had thought that women were "all presumptuous and vain, if not stupid." The young man in Shikin's story likewise states that "strangely a feeling of respect [for her] has slowly grown" and that his knowledge of her past and her disillusionment with men in general have made him resolve to marry her. After much deliberation, Toyoko agreed to marry Kozai Yoshinao.[42] He was a scientist and entirely different from those with whom she had associated earlier through her political activities, and his genuine enthusiasm helped her overcome her distrust of marriage after the failure of her first marriage and the depression she suffered shortly afterward.[43]

During the two years after the publication of "Unusual Confession" and her simultaneous marriage, however, Shikin produced no fiction and very little journalistic writing. Although she had published "A Broken Ring" four years earlier, she is not represented in *Literary Club*'s *keishū* special. That year she spent looking after her mother-in-law; her husband had left to go to Germany to study. Then, a year and half later, Shikin started writing again. The next three years proved to be her productive period: in 1897 she published six stories, and two years later, *Imin gakuen* ("The Immigrant School") was published in *Literary Club*.

"The Immigrant School" received favorable critical responses. Its protagonist, Kiyoko, is a woman happily married to an influential politician, but because of her beauty and unknown family background, she is subjected to various jealous suspicions, including a rumor that her father, who has deserted her and whose whereabouts are unknown, is a petty moneylender. Kiyoko discovers, through her own investigation, that her deceased mother was an *eta*, a pariah class (against whom discrimination had been legally forbidden since 1871), and that her father hid himself so that the truth about Kiyoko's identity would not be revealed. Although discrimination against the *eta* was pervasive and real then (to a degree now as well) in certain regions, Kiyoko, indignant over the cruelty of such discrimination, goes to take care of her father, who, when discovered, is sick. She is willing to give up all she has as a lady of the privileged class, and in the end her husband is forced to resign from his public office. Treating the ambitious subject of social injustice perpetrated against the *eta*, "The Immigration School" presents Shikin's conviction about the equality of all people and the value of human compassion more straightforwardly than ever. A kind of utopian story, it ends on a positive note, with Kiyoko's going with her husband to the frontier of Hokkaido in order to start a school for the children of the *eta*, hence the title.

As a story treating the predicament of the *eta*, "The Immigrant School"

reminds the reader of another story, *Hakai* (*Broken Commandment*) by Shimazaki Tōson. Better known, *Broken Commandment* (1906) is considered a monumental work, heralding the Naturalist School of writing in Japan. A longer piece with in-depth descriptions of the hero's inner struggles, it shows numerous similarities to Shikin's story: Ushimatsu, like Kiyoko, accepts his heritage in the end; both motherless children, they seek a new start in a new land. Differences are also obvious. The hero's internal battle described in *Broken Commandment* is that of Tōson himself; it symbolizes his personal battle against various constraining elements in society, against people who were unsympathetic to his devotion to literature. Shikin saw the *eta* status as the basic condition of all women; therefore, unlike Ushimatsu, Kiyoko experiences no personal dilemma in disclosing her identity. While the liberation Tōson's hero achieves is on a personal level, a new start for Kiyoko represents the hope of liberation for a new generation. Shikin probably had the idea for this work while she was exposed to the *eta* in Kyoto, and it stems from her sense of indignation toward social injustice. A work that precedes Tōson's novel by seven years, it impresses upon the reader the force of an indomitable spirit in the face of a reality that was grim and resistant to change.

Shikin herself seems to have had the same undaunted mind and spirited personality. The following amusing anecdote reveals that part of her very clearly. When Ōi greeted her at their first meeting by saying that in spite of her reputation he found in her a very ordinary woman, Shikin is said to have retorted, "The moon one sees from a beautiful garden and that seen from a lavatory are the same moon." Demonstrating her wit and undauntedness, this was quite an apt statement made to a man who, despite his professed belief in the freedom and rights of common people, failed to treat women with the respect they deserved.[44]

"A Broken Ring" had been a promising start for Shimizu Shikin as a fiction writer, and with "The Immigration School," for which the publisher paid well, she showed signs of maturity as a writer. After writing a few more short essays, however, Shikin stopped writing altogether. While reasons for her slowing down after her marriage to Yoshinao, as well as for her creative outburst during his absence, were not difficult to understand, her sudden total silence was mysterious. It caused some curiosity and suspicion, and a rumor spread that Yoshinao prohibited her from writing. Some maintained that she stopped writing under a mutual agreement with her husband. Since Toyoko had gained a certain notoriety as a woman who had been divorced and become involved with men in political activities, people were ready to judge her accordingly. They almost expected that her second marriage could not be sustained without concessions on her side.[45]

Deciding whether or not to write, however, was a bit more complex for

Shikin, as it often is for women writers. Besides, it is hard to imagine that Yoshinao would have been so tyrannical and Toyoko so submissive. They were an unorthodox couple who were often seen discussing and debating at length various social and political issues. On those occasions, it is said, Toyoko would not refrain from openly challenging Yoshinao's opinion. It is very probable, on the other hand, that Yoshinao, a natural scientist, had inflexible ideas about fiction and did not think highly of his wife's vocation of writing stories. In the end, what prevented Shikin from writing was something much more pervasive and difficult to identify than just a husband's objections. It was the same treacherous problem that faces women both in Japan and elsewhere even today — namely, the visible and invisible demands made on them because they are also mothers and homemakers. As the wife of a man who became a faculty member and then president of the University of Tokyo, Japan's most prestigious school at the time, and who in his private life could be as demanding as a child,[46] Toyoko managed a large household on a very modest income, maintaining the respectability appropriate to her husband's social status. The mother of six children (three died in their early years), she also took care of her aged, sickly father and blind older brother. Perhaps there was scarcely time or energy left for her to write.

In contrast to most literary women discussed in this volume, Shikin (along with Tanabe Kaho) lived a long life; it was a rich life with early political involvement, a journalistic career, an affair, and marriage and family life. After subsequent frustrating years, she stopped writing at the height of her productivity and reputation, when she was thirty-four years old. Tracing her life, it becomes apparent that it represents that of a woman writer, not of the Meiji era alone, but of any age.

Shikin once wrote an article entitled *Onna bungakusha nanzo derukoto no osoki ya* ("Why Are There So Few Women Writers?" *Jogaku Zasshi*, 1890). With this she covered all of the three important areas to be improved in order for Japanese women of her time to lead more satisfying lives: political emancipation, self-knowledge, and courage to express themselves. The reason for the scarcity of women writers, she claimed in this article, is not lack of education or cultural accomplishment, nor even a low intelligence often attributed to women. "Not a small number of women have similar training as men," she stated, but "it is that their talent is not used, but rather kept stored." She thought this was because women tended to confuse fearfulness and cowardice with modesty. The real enemy, she said, is timidity in women, which deters their venturing into the act of self-expression. Pioneer literary women discussed in this chapter are those who ventured to express themselves. Having overcome reticence fostered by the time-honored practice of extreme reticence toward matters beyond family affairs, they not only expressed themselves but also published what they wrote.

Having begun writing under the influence of the nation's modernization efforts in early Meiji years, these women took as one of their themes women's emancipation, and some of them actually participated in political activities. In everyday reality, however, they saw many problems, and they noted discrepancies between the officially avowed position and the behavior and opinions of their fathers and husbands. Shikin, one of the most vocal, stated once that "many [of the men involved in the Popular Rights Movement] are pseudo-scholars who know full well that only the principle of equal rights between the sexes accords with the truth, and yet for their own convenience they hold to the old practice of treating women as inferior to men."[47]

The women discussed in this chapter had introduced some refreshing portraitures of women to Meiji readers before the shift toward nationalism and conservatism took place. What is clear in studying the life and work of these women is that their experiences and education in their formative years affected their literary expressions. Opportunities to receive nontraditional, progressive education or to be involved in political activities would soon become almost nonexistent for women. In the example of the women in this chapter, particularly in comparison to those discussed in the next two chapters, we see how social climate played a role in determining the nature of women's writing.

2

The Ethos of Reactionary Conservativism and Women Writers
Kitada Usurai, Higuchi Ichiyō, and Tazawa Inafune

Many of the progressive approaches taken by the Meiji government during the 1870s, with the idea of enhancing women's status in society and improving their lives, were tentative, perhaps a token merely for formality's sake; the result, therefore, was extremely short-lived. Women who joined the men in the Popular Rights Movement, believing that the idea of freedom and equal distribution of rights, for example, would apply to all of the population, found out rather quickly that demands made by the movement were intended for men only. The inequality and subjugation experienced by women were not addressed at all. The House of Representatives, organized through an election, would have nothing to do with women because they were not given the right to vote. Although the Constitution was promulgated in 1889, as the result of the strong appeals by the movement, the majority of women most likely did not know what the celebration was for.

Public education policies similarly shifted away from the "enlightened" stance to one that greatly reduced opportunities for girls. Thus the ambitious plan of implementing public education on the basis of the idea of sexual equality gave way to a more practical approach that discouraged coeducation after the first four years. The cost of implementing the original plan was one reason for the shift, but the lack of support among parents, who complained about the impractical education their daughters were receiving (girls were needed at home for domestic help also), was a factor as well. Coeducation was

unpopular also because it was against Confucian teaching ("after age seven, girls and boys must be separated"). And, as the national educational system became better organized, inequality of educational opportunities for boys and girls became quite evident: after going through several changes, secondary education for girls was now firmly based in the *jogakkō*, or higher schools for girls (roughly equivalent to boy's middle school); it was a completely separate educational program with an academic level definitely lower than that of the middle schools for boys. In 1886 a decree issued by Minister of Education Mori Arinori (who was once an advocate of Enlightenment and "the improvement of women") stated that "the primary purpose of girls' education is to prepare them to become good wives and wise mothers." In his view and that of others, women should "cultivate good personalities" and learn to "manage household work and educate children."[1] Thus, along with classes on child rearing, homemaking skills, and the management of domestic servants, the curriculum at Tokyo Kōtō Jogakkō now included "Understanding Marital and In-law Relationships."

The shift in emphasis in education from being liberal and well rounded to being more pragmatic as well as nationalistic was not limited to girls, however. The goal of education in general, as now clearly laid out, was to produce citizens who were loyal to the regime and had the basic skills necessary to enhance the development of an industrial society. Education was to be subordinate to service to the state; it was to carry a message that would motivate youth to strive not for personal fulfillment but for increased earning power attained through hard work and self-discipline, which in turn would lead to a prosperous and strong state. The shift was in accordance with the direction in which Japan was heading — toward a prosperous and militarily strong state rather than toward an egalitarian nation providing education for its subjects democratically. The Imperial Rescript on Education, enacted in 1890, was used to indoctrinate students into the idea of unifying the nation, with the Emperor at the center and under moral principles based on the Confucian teaching of filial piety. This ethic of national self-improvement and unity now operated in the curriculum development and policy making of the public schools.

As we saw in the previous chapter, the Christian influence on Japanese education, particularly for women, had been significant, but this was also short-lived. Daily ritualistic use of the Imperial Rescript on Education forced educators to express loyalty to the state, effectively eliminating the Christian impact within educational institutions. An incident in which Uchimura Kanzo, an influential Christian leader and educator, refused to worship a picture of the Emperor during a school ceremony was widely publicized as "disloyalty" to the state.[2] The final blow against churches and missionary schools

came in 1899 when the Ministry of Education issued a decree prohibiting any form of religious education or ceremony in schools. This was particularly effective because a violation meant the loss of exemption from conscription. This and an earlier punitive measure denying graduates of missionary schools admission to public institutions of higher and professional learning made it impossible for private schools to continue to base their education on Christian faith. Education for girls was hurt badly because many of the secondary schools for girls were missionary schools.[3]

After attacking education that based its principles on Christian belief, the reactionary conservatives next tried to deny that women needed education of any kind beyond the compulsory first six years.[4] In 1889, for instance, Katō Hiroyuki, then the president of the University of Tokyo, made a speech on women's education at a national assembly, stating that higher education for women should not be the same as that for men. It was around this time that conscious attempts to discourage young women from seeking higher education were introduced in the form of newspaper articles claiming that education would make girls arrogant and unruly. *Yomiuri Shimbun*, a national daily newspaper with large circulations, for example, serialized articles such as *Jogakusei no shūbun* ("Scandals of Female Students") and reported various types of slanderous accusations. One such article implied a spread of venereal disease among female students, causing frightened parents to remove their daughters from school. Some efforts (for instance, by Iwamoto Yoshiharu) were made to correct these journalistic abuses, but the proponents were powerless against the mounting public sentiment that wanted to deny liberal education, particularly to girls.

After the government rejected more liberal proposals that were originally considered, the Meiji Civil Codes were put in place in 1890, the same year the Imperial Rescript on Education was issued. The codes set out policies leading to the entrenchment of the patriarchal ideology of *ie*, or family.[5] They treated women in such a grossly unfair manner that their social and economic status was not significantly different from what it had been during the Tokugawa period. The head of the household, almost invariably male and usually the eldest son, for instance, had special rights and power: he would make most of the decisions for all the family members — whom they should marry, where they should live, whether they could adopt children, and so forth. Wives had almost no legal authority, and since marriage was perceived as a transaction between two families, the groom's family sometimes did not register a marriage until the bride proved to be capable of adjusting to her husband's family. Once married, a woman practically belonged to her husband, and like the heroine in "The Thirteenth Night" (discussed later in this chapter), she had no one to turn to but her father in event of the husband's

abuse. Although she could own property, her husband had the right to manage it. As shown below in "Dark Spectacles," there was nothing the wife could do even if her husband appropriated money that rightfully belonged to her. A daughter's claim to head the household came after those of male members, including any illegitimate son who was recognized by his father. Meiji wives, unlike Tokugawa women, could legally obtain divorces, but in practice such cases were rare as the husband always retained custody of the children. Although the husband could not divorce the wife as easily as before without a good reason, adultery was a punishable offense and constituted grounds for divorce only if committed by a wife; a husband could rationalize the practice of keeping more than one woman, ostensibly as a measure of securing offspring for the sake of family continuity. Since the child of a mistress could become the heir, wives were in a precarious position indeed. The reconfirmed notion that women's contribution to society was only through their husbands and sons perpetuated the old attitude of contempt for women.

The need to disregard democratic principles for the more immediate goals of building a strong nation and restoring its pride came from a new awareness of Japan's national identity. A sense of frustration in reaction to too much borrowing from the culture of the West was also responsible. During the period between two imperialistic wars, against China (1894–1895) and Russia (1904–1905), nationalism developed even further, causing the entrenchment of the ideology centered around the patriarchal system of *ie* in every aspect of life. The rise of nationalistic sentiment and the resurgence of conservatism among the public were also manifested in a revived interest in traditional painting and music, classical theater, and such minor arts as flower arranging and the tea ceremony.

During the mid–Meiji years (late 1880s and 1890s) the practice of keeping mistresses also came back into favor, and although keeping them in the same house with legal wives was now rare, having mistresses was a status symbol by which men could demonstrate new wealth accumulated in developing commercial capitalism. Despite earlier opposition by the advocates of "Civilization and Enlightenment" and by Christian groups such as *Kyōfukai* (Women's Reform Society), the practice of keeping mistresses had never been eliminated. Since many high government officials as well as old aristocrats indulged in this practice, repeated appeals to abolish the practice had achieved little effect.

In *Sanninzuma* (*Three Wives*, 1892), Ozaki Kōyō (1867–1904), among the most popular writers then, described this situation rather straightforwardly. The three women (all referred to as *tsuma*, or wives, even though only one is a legal wife) exhibit different attractive features that men might look for in a woman, while sharing common characteristics of ignorance, small-mindedness, and

jealousy. Presenting a wealthy married man who keeps two mistresses and enjoys a variety of women he can control, the novel reveals a harem mentality. And, as shown in Tanabe Kaho's story "Double-Petaled Cherry Blossoms" (see Chapter 1), it was the parents, primarily the father, who would make an arrangement for a daughter to be a mistress, sometimes on the pretext of work as a domestic servant.

While more powerful men kept mistresses, the majority of common Meiji men favored buying prostitutes. Running a house of prostitution was a profitable enterprise that developed significantly during the mid–Meiji period. Prostitution quarters, of which Yoshiwara in Tokyo is the best-known, continued to be in specifically designated districts, and these districts existed in almost all large and medium-sized cities throughout Japan. Statistics show that the number of licensed prostitutes, referred to as *kōshō*, as well as those of privately operating street prostitutes, *shishō*, doubled between 1885 and 1898.[6] Since the Meiji Civil Codes gave, in effect, a legal framework in which women were viewed as men's property, the increase is not surprising. Encouraged by new developments in commercial capitalism, the business of prostitution houses expanded as well. The prostitutes were mostly from the lower-class families of impoverished farming regions, and selling a daughter sometimes helped the family survive. It is said, however, that between 10 and 20 percent of the parents who sold their daughters did so not out of a desperate financial need but out of selfishness and greed.

In understanding the *kōshō* system of legal prostitution (which did not come to an end until after World War II) in terms of the history of Meiji Japan, one needs to bear in mind two facts. With the opening of the country to the world as a civilized nation, the government did issue a decree, as early as 1872, which succinctly prohibited "selling and buying human beings." This decree, however, was in response to a scandal, called the "Marie Louise Incident," in which Japan was internationally accused of practicing slavery.[7] Because it was merely a face-saving device, the decree did not change the substance of the practice: the owner of a prostitution house, to whom prostitutes were still bound through an intricate system of financial exploitation, rationalized the practice, saying it was women's "free will" and that they were only leasing a room to them.

How excruciatingly difficult the work of bringing real changes and finally getting rid of *kōshō* has been is seen in various testimonies of the people and groups involved. The Japan Salvation Army, for example, made this their major target to fight against, and women's groups as well as some prominent individuals got involved in similar activities. *Haishō undō*, or a "movement to abolish the practice of legally sanctioned prostitution," is said to be the largest social movement in modern Japan in which men and women

worked together. The movement also holds a record for the length of time in which it persevered. Getting away from the sexual and economic exploitation of women has been that difficult.

There is a close link between firm entrenchment of the *ie* family system and the flourishing of well-organized prostitution businesses and the custom of keeping concubines. The subjugation of women by men (and of people in general by the state) and the sexual as well as commercial exploitation of women were both the direct result of the *ie* reorganization.

Kōshō prostitutes were most crudely victimized, yet in their exploitation they represented the predicament of all women under the Meiji Civil Codes, with its clear denial of women's basic legal rights. The idea that women could be easily and openly bought with money was a substantial impediment to men's seeing women as their equals. Over many years, Confucian ideology had instilled a certain mistrust and contempt toward women in men's minds, and now Meiji men perpetuated another inheritance that hobbled social progress by their socially sanctioned practice of selling and buying women.

The view of women expressed in the Meiji Civil Codes had deep psychological effects on relationships between men and women, as shown in the basic plot of many stories written during the mid–Meiji era. These stories often involve one man with two or more women, and the basic theme is women's submission to and victimization by men. As if they were entrapped in the morality of *ie* doctrine, women are powerless, helpless against men's attempts at exploitation. In many stories written by *keishū* writers men appear to be capricious, as if they represent some unknown will. Given this reality where men could easily and legitimately exploit women through their prerogatives guaranteed in the Meiji Civil Codes, the dominant tone in the emotional lives of the heroines in the work of Kitada Usurai and Higuchi Ichiyō, discussed below, is therefore that of resignation. Their lives are imbued with laments over insoluble problems, which sometimes even destroy them and their loved ones.

Kitada Takako, "Usurai"

Unlike her contemporary Higuchi Ichiyō, Kitada Usurai is scarcely known to posterity beyond a small circle of scholars studying the Meiji literary women, despite the fact that she published nearly two dozen short stories during the early half of the Meiji's fourth decade. She is among a dozen literary women whose work was published in *Literary Club*'s special issue on *keishū* writers. Treating matters such as marriage, divorce, and other family-related issues, Usurai's fiction begins and ends with the submission of the

female characters to men and to their destiny. As the first female student of Ozaki Kōyō, Usurai was greatly indebted to him for her mastery of literary style and narrative skill; the themes she treated in her stories, as well as her characterizations, reflect the art of fiction writing developed by her mentor.

The second child of a man who was among the first to practice law and who had earlier participated in the Popular Rights Movement, Kitada Usurai (1871–1900), called Takako as a girl, grew up in a stable middle-class family in Tokyo. She was a studious girl and did well at the primary school, but by the time she was to receive her secondary schooling, the educational environment had shifted. Thus, like other women of her time, but unlike her literary predecessors who started publishing a decade earlier, she received an education with a strong emphasis on domestic skills — a "bride training," as it is called. Even that was interrupted by her mother's death, which occurred when she was fourteen, and for a while she and her sister had to care for their siblings.

An obedient, sickly child, Takako showed an early interest in reading and writing. She did have some examples to follow in her attempt to write fiction to publish, such as Tanabe Kaho and Kimura Akebono. As in the case of Kaho, she showed a story she wrote to a well-established writer — Ozaki Kōyō in her case — to whom she was introduced through acquaintance of her father's who owned a publishing house, Shunyōdō. She was seventeen years old then. Always eager to help aspiring writers and support them in developing their literary careers, Kōyō was known as an excellent teacher. Takako was a good student and quickly became skillful in fiction writing, and soon she adopted a *nom de plume*, Usurai, given by her mentor. Later, Kōyō even found a husband for her, a painter who was supportive of his wife's writing endeavors. Takako, however, did not live long after her marriage. Soon after the birth of her first child, her health declined and she died of tubercular infection at age twenty-four. Shunyōdō published a collection of her stories for the occasion of the first anniversary of her death.

Usurai wrote stories very much like those of Kōyō and other Kenyūsha writers. It is the plot, often quite contrived, that is of central concern. *Sannin Yamome* ("Three Singles," 1894), the original version of which she most likely showed to Kōyō, is a good example. Three main characters are the hero, Kōichi, a passive man with exceptional good looks but without interest in women; Tsuyako, the daughter of Kōichi's employer, Kōichi's pursuer; and a modest and gentle woman, Okiyo, whom Kōichi's mother has found for him. The plot develops with some coincidences and not-so-plausible twists: Tsuyako's father, who has a better offer for his daughter, disapproves of her choice of Kōichi, who is uninterested in Tsuyako anyway and takes Okiyo as his wife. Tsuyako threatens her parents with suicide, forcing them to ask

Kōichi's mother to make Kōichi divorce Okiyo. Kōichi's mother was previously helped by Tsuyako's family, and is thus morally obligated to comply with their request. Okiyo understands the situation and withdraws without a word of complaint. Tsuyako, however, is not happy in the ensuing marriage because Kōichi enters a life of debauchery. This time neither Tsuyako's parents nor Kōichi's mother intervenes, and the result is another divorce, leaving three people without partners, hence the title.

Even though the plot would indicate otherwise, the theme of "Three Singles" is neither love nor marriage per se. "Greatly saddened by his unfilial behaviors around the business of marriage, Kōichi promised his deceased mother that he would not take a wife for the rest of his life," the narrator says, and the story ends: "Regrettable is the occasion in which three people, fair and still young, found themselves without a spouse." It is the sense of filial piety and the network of *giri* (duty and obligation) that dominate this fictional world. Usurai would write more stories with similar themes through which her worldview, dark and full of pessimism, is revealed.

As shown in their names, the characters are merely types: Kōichi means "fragrant son," Okiyo, "pure," and Tsuyako, "voluptuous daughter." Women are separated into two groups: on the one hand, rich or brilliant, but selfish; on the other, poor and modest, but gentle. The plot revolves around two women in an inherently competitive situation. Exploiting the formula of a triangular relationship, one of the most basic in storytelling, Meiji writers favored one that involved one man and two women, never the other way around. Usurai's second work of fiction, *Nureginu* ("Accusation," 1894), follows the same pattern, this time a rivalry between friends. Introducing a more independent and capable woman — a teacher at a girls' middle school — as one of the two women, it ends with both women arriving at a final solution through renunciation: they become nuns. The characters in both of these stories give the impression that they are simply following a predetermined course. The skill with which Usurai manages to sustain the reader's interest while unfolding a complicated plot in "Three Singles," however, is remarkable for a young woman of seventeen. A reviewer commented that although she did not have Ichiyō's ability, her accomplishment earned her the name "young lady of many talents."[8]

Kuromegane ("Dark Spectacles"), included in *Literary Club*'s first *keishū* special issue, is a better-constructed story that takes off from the triangular rivalry theme. It presents a situation in which a man and his family scheme to successfully destroy three good women. Here, echoing the Confucian curse on those who are born female, women's sad predicament is conveyed more clearly than in Usurai's two earlier stories. In the story, the heroine, Ohide, reluctantly marries the dissipated son of her stepmother's former

patron and employer — a man (wearing dark glasses in order to hide his artificial eye) who pretends to be madly in love with her while he entertains a cruel and mercenary scheme. Ohide and her mother lose all of their money and property when this man manages to transfer it, legally, to his own family.

Unlike Tanabe Kaho, who set up a similar situation for her negative heroine Hamako (in *Songbirds in the Grove*), whose poor judgment causes her to lose her inheritance, Usurai does not attribute Ohide's loss and defeat to the lack of good judgment or personal integrity. For Usurai, the issue is not that of an individual choice. The man in dark glasses and his family behind him represent a general condition that victimizes women. It is an inescapable situation. Ohide's mother pushes this marriage, though reluctantly, because she does not want to turn down the request of her former employer, to whom she is tied through her sense of obligation. Likewise, the mother's best friend, whose son is Ohide's childhood sweetheart, feels obliged to send her son away so that the marriage will not be hindered. It is a sense of duty that makes these mothers defenseless, and Ohide is likewise crippled by her sense of filial obligation. For these women there is no way to escape the entrapment of duties and obligations, and they simply surrender.

Usurai wrote several more stories depicting situations in which abominable violence is inflicted upon her own sex, but her later work shows a shift in emphasis from plot development to psychological delineation. *Uba* ("A Wet Nurse," *Literary Club*, 1896), for example, focuses on the emotions of an older woman torn between a sense of duty toward her former master's daughter and love for her own son. It introduces the theme of a young woman of a good family without anyone to protect her, a situation depicted in quite a few stories by Higuchi Ichiyō. Here the girl, Hisako, awaits the return of her fiancé from abroad where he has been studying; having lost her parents, she has only her faithful wet nurse to protect her. The wet nurse, with her strong sense of duty, has successfully shielded her from the menacing hand of her son. When she sees, however, a "beautiful Western young lady of age twenty-two or twenty-three" standing on the railroad platform besides Hisako's fiancé, now "with neat mustache carefully groomed and looking quite distinguished," she loses her composure completely: "Since then, people see a madwoman wandering the streets of Ningyocho. 'Oh, God of mercy, I won't hear it. Why? Why did you forsake my dear mistress? ... discarded because of *keto* [a foreigner, literally meaning "hairy one"] woman.'" It is suggested that as her madness progresses, the wet nurse will kill herself. This ending is markedly different from that of "Dark Nights" by Higuchi Ichiyō with the similar story of a man's betrayal of his fiancée. While Ichiyō's story tells the mind of the heroine who is resolved to get revenge, Usurai's story leaves the

reader only with an overwhelming sense of helplessness. The fiction Usurai wrote and published during the six years of her creative life lacks breadth as well as depth, and this fact, among others, distinguishes her from her contemporary Higuchi Ichiyō, who also wrote for less than a decade.

Usurai participated in the second *keishū* special issue, published in January 1897, with *Shiragazome* ("Hair Dye"). It is also a story of a triangular relationship involving one man and two women, though with a slightly different twist. Not knowing that a middle-aged man, Jihei, already has a wife and child, a young and good-looking woman, Oito, marries him. Because of cheerful and hard-working Oito, Jihei's drugstore business prospers and the couple is happy until Jihei's estranged wife comes to Tokyo from a remote province, looking for him. Kindhearted Oito sympathizes with this woman and asks Jihei for a divorce. Jihei misunderstands this request, and suspecting that Oito is attracted to a young customer who admires her, he refuses. As a last resort Oito then tells a lie, confirming Jihei's suspicions. As a depiction of a jealous husband, the story strongly resembles Shimizu Shikin's "Demon in the Heart." Unlike Shikin's conclusion, in which the husband found himself in a mental institution, Usurai has Oito killed by the deranged Jihei. Usurai has the narrator of this story say: "It's her own doing that caused her death, say the people in the neighborhood." The story seems to say that Oito's death is her fate; her selflessness and generosity do not affect her life favorably. Although in this piece Usurai showed greater skill and more complex characterization, it is the same sad story. It ends: "Who would console Oito's soul? Deep in the cemetery of Yanaka lie her insurmountable grief and bitterness for certain."

Not having written a single story with a heroine who achieves final happiness as the result of either her own efforts or the sympathy of other people, or even because of mere luck, Kitada Usurai demonstrated her understanding of gender relationships. The perception of women's final judgment shown in her work is invariably cruel, as if women are born cursed. Her heroines reflect the ethos of the time when, at the end of the Meiji's third decade, women's role was viewed as limited to procreation and serving men's needs; women were instructed, both at home and at school, to obey the orders given by men without questioning. The stories are not perpetuating the outdated morality of the feudal era, but accurately depicting the popular sentiment of the time. This point can become clearer if we look at the heroine of a best-selling novel of the time, *Hototogisu* (*The Cuckoo*).

Treating a theme Usurai developed in her fiction, the unescapable predicament of women, *The Cuckoo* (a bird known by the Japanese to sing its heart out till it bleeds) was enormously popular when it was serialized in *Kokumin Shimbun* in 1898. The first half of the novel introduces the conjugal happiness

of a newlywed couple, Namiko and Takeo, in blissful hours together. Unlike Usurai, the author, Tokutomi Roka, a young idealist when he wrote this novel, made his central characters freely display their mutual love. The latter half of the book, however, treats the tragedy of Namiko, who is caught up in the claims of *ie*, the family. "She is replaceable, but the name of Kawashima is not," Takeo's widowed mother, the novel's villain, tells her son when she discovers that her daughter-in-law has contracted tuberculosis. She demands that Takeo divorce Namiko. In his mother's as well as in the commonly held opinion, wives were expendable (to show this, the author introduces another woman into the story, one who is eager to replace Namiko, thereby creating another triangle situation). The mother arranges for a divorce while Takeo, a career military man, is away. Although unhappy, Takeo lets the divorce take place. Namiko's illness worsens, and she dies with a sad outcry that she "would not be born again as a woman."

The Cuckoo was popular because it poignantly told the sad story of a woman whose predicament was familiar and quite predictable. Women's submission to parents and husbands was instilled through their education and other forms of indoctrination during the mid–Meiji era, when the novel was published. This was the time when Usurai was writing also. As discussed above, her stories tell the reader repeatedly that no matter how virtuous a woman is, she is not to be rewarded and is destined to lose in the end. Usurai does not explain why this has to be the case. In the world of Usurai's fiction very few positive features stand out, and domestic problems are solved through the female characters' self-abnegation.

Although Usurai tried to expand her fictional theme and go beyond that of her mentor, and although her later works incorporated a wider view of society and individual, she was not as successful as Ichiyō. "A quiet woman with few words and alone in her room all day long with brushes and ink as her only companion, she is remarkably free from nitty gritty of this world," wrote a journalist. Hers was a very different life from that of Higuchi Ichiyō, a *keishū* writer whose personal life we know much more about.

Reviewing "Dark Spectacles," Mori Ōgai, a critic and writer who also had medical training, stated that "dealing with an intrigue, the story centers more on ideas than emotion, and this is unfortunate."[9] Ōgai objected to the lack of lyrical quality, and that may be understood. It seems, however, that there is more to his unsympathetic reaction. The reader of Usurai's stories, including "Dark Spectacles," gets the message clearly embedded there — that some overpowering forces destroy the defenseless women who live according to the moral dictates of their society — and it is this message that Ōgai was repelled by. The forces that destroy women, furthermore, are sinister (as it is symbolically represented by the man's artificial eye — wide open without

movement or perception — in "Dark Spectacles"), more than mere wickedness or human weakness. Usurai's fiction does not poignantly tell the sad story of a woman as *The Cuckoo* did.

An examination of negative critical responses to Tazawa Inafune's *Shirobara* ("The White Rose"), another work that appeared in the *keishū* special issue of *Literary Club*, might shed more light on this point. The critical reactions of Mori Ōgai and other critics are related to the basic message embedded in Usurai's and Inafune's stories; critics, all men in those days, did not like to hear what is said in these stories, a point no literary historian, also mostly male until recently, has raised. However, we have a woman — Usurai's contemporary — who was aware of this fact. While writing stories of a woman's sad fate and enjoying critical acclaim, Ichiyō recorded her private thoughts in her diary, and there she revealed her mistrust of her male readers and of their critical appraisals of her work.

Higuchi Natsu, "Ichiyō"

Along with Kitada Usurai's "Dark Spectacles" and Tazawa Inafune's "The White Rose," *Jūsanya* ("The Thirteenth Night") by Higuchi Ichiyō appeared in *Literary Club*'s first *keishū* special issue. It received thoroughly positive reviews, a sharp contrast to the halfhearted praise given to Usurai's story and negative appraisals of Inafune's work. The story is about a woman married to a man above her class and mistreated by him; she goes to her parents, looking for a way out of her unhappy marriage, and on her way back she meets by chance her old love, now reduced to pulling a rickshaw. Needing words of consolation, the woman finds herself filled with nostalgia and sadness. Unlike the two negatively reviewed pieces, "The Thirteenth Night" has no plot to speak of, and it received praise for its rendering of subtle sentiment as well as for its flowing language and highly polished style. When Ichiyō's *Takekurabe* ("Growing Up") was published in the same magazine (it was actually a re-publication made because of the positive review of "The Thirteenth Night"; the story first appeared in *Bungakkai*, a small coterie magazine), it was given an even more enthusiastic reception. About an adolescent girl who is destined to spend her life in a prostitution house, this story was also rendered with soft feminine touch and pathos. Reviewers considered it one of the finest pieces of fiction of the day.

With enthusiastic critical responses to "The Thirteenth Night" and "Growing Up," Ichiyō established herself firmly as a committed writer. Between her first publication of a story in early 1892 and her death at the age of twenty-five, Ichiyō produced altogether twenty-one short- and

medium-length stories, as well as many *waka*, poems in the traditional style. By the end of her life, the literary establishment had recognized her as a fine writer; a few male writers, including Kōda Rohan, even tried to include her within their circle. This was an accomplishment no other Meiji literary woman, with the possible exception of Yosano Akiko (discussed in the following chapter), achieved. The central question to ask, then, is how was it possible that Ichiyō produced work which resulted in such remarkable success?

Although it is true that Ichiyō's critically acclaimed stories are written in a style approaching a level of perfection that no other woman writer among her contemporaries achieved, she treated the same theme as other *keishū* writers — women's victimization. With the exception of *Warekara* ("Skeleton of a Shrimp") and *Usumurasaki* ("Pale Purple"), which are often ignored by literary historians because they were unfinished, her work concentrates on the lot of women who are filled with pain rather than joy, who are resigned to accepting such a lot as their fate. As Ichiyō would be accused of later, at the turn of the century, when the first wave of the feminist movement reached Japan,[10] most of her work is filled with pessimism and devoid of any significant ideas about women's lives and their place in society.

While Ichiyō's fictional world is imbued with a view that the world is rigidly organized according to traditional morality and Confucian determinism, the victimization of her women is less severe than that in Usurai's stories. However, her heroines do not openly criticize their male counterparts or express radical ideas, as Inafune's do. The basic orientation of Ichiyō's stories is familiar and nonthreatening; her realistic depiction of characters was more palatable, perhaps even comforting, to her male readers. One can say that the key to Ichiyō's critical success is, at least in part, her moderately conservative heroines.

Critical assessment of Ichiyō's fiction in general is not inaccurate. Her representative work indeed has a quality that represents the essence of the time. "The last woman of the old Meiji," as one of her literary acquaintances labeled her,[11] Ichiyō immortalized the women of the Meiji period during its middle decade, a time when a renewed conservative perspective replaced the frenetic efforts to Westernize. At the same time, it has qualities that transcend her time, an accomplishment other *keishū* writers could not match. How did Ichiyō manage to do this? This question has yet to be fully answered, despite the abundant research on her life and work.

Regarding how Ichiyō became the most successful among the *keishū* writers, literary historians in the past, mostly male, have readily agreed upon two points: first, unlike other women authors, she wrote to earn a living and therefore was quite serious about her endeavor; second, she followed the

example of Tanabe Kaho primarily because of the monetary reward that came with publication. The implication underlying both points is that Ichiyō's success as a writer can be attributed to her sense of commitment born out of financial necessity. It says that because women in general do not have financial responsibility as men do, they cannot be serious in choosing writing as a career and that in this sense Ichiyō was an exception. It is true that Ichiyō needed to support her mother and younger sister when she became the head of the Higuchi household at the age of seventeen; the news that Kaho's *Songbirds in the Grove* had earned thirty-three yen was a revelation to her. Kaho's successful venture no doubt inspired Ichiyō to consider writing as a means to earn income, since the amount Kaho's novella fetched would be enough for the three Higuchi women to live on modestly for three months. In fact, at one point of her life she did weigh writing against other means of supporting her household — teaching *waka* poetry, running a five-and-dime store, even becoming the kept woman of a pseudo-religious leader and speculator.

Obviously, however, the relationship between the life of the author and her literary production is not as simple as the claim that a need to earn an income enabled Ichiyō to become an exceptional writer. It is quite possible to speculate that it was Ichiyō's competitive spirit, generally kept to herself, that encouraged her to write for publication as Kaho had done. Ichiyō knew Kaho as a fellow student at a private conservatory called Haginoya, and the two shared the reputation of being the most brilliant students there. It is also possible that Ichiyō would have gone into writing even without Kaho's example. Like most of the women discussed in this book, she had had a keen interest in writing since she was a young girl; as a precocious child who preferred reading to playing with other children, she wrote a *waka* poem about the power of words.

Perhaps one need only look at the body of Ichiyō's work to learn how she came to enjoy literary fame. A closer look at her life, which is possible because of her extensive journal, also enables us to conclude that her fame was founded upon not only her career ambition but also her strong desire to become a good writer. Ichiyō left rather extensive journals, which she kept intermittently from the time she was sixteen until several months prior to her death, in which she recorded both what she thought and what she did. Initially she used journal writing as a means to practice calligraphy and writing, but it gradually became a means of helping her to see things objectively; her journals include entries on views of literary art as well as comments on reviews. Published shortly after her death, these journals indeed delineate her transformation from an obedient daughter and aspiring student to a tough, mature adult and writer with a cynical view of the world. It is here that one sees an outline of a woman who is much more complicated than the one known to her acquaintances — shy and tongue-tied, modest and reserved. Reading these

journals leads us to conclude that there is indeed a relationship between her life and her art. Ichiyō's journals are self-conscious, reflective writing that follows the golden tradition of the literary ladies of Japan's Middle Ages.

Despite her love of learning, Ichiyō (called Natsu at home) was given only six years of formal education, since her mother, like most other parents at that time, considered further education superfluous. Her father, Higuchi Noriyoshi, recognized his daughter's strong interest in learning, however, and encouraged her aspiration for learning by buying books for her and eventually enrolling her in Haginoya, a private conservatory. Noriyoshi, a farmer by birth, was a man of strong ambition. He had given himself a basic education and worked his way upward until he was able to purchase the rank of lower samurai shortly before the Meiji Restoration.[12] At the arrival of the new era, he managed to establish a reasonably comfortable home for his family by securing a low-ranking civil service position. In 1888, however, he died, after having lost all his savings in a risky business venture.

Because the eldest son of the Higuchis had died earlier of consumption, and the other son, unreliable and indolent, had been disowned, Natsu became the head of the household, which consisted of three women. People who had previously been congenial and friendly to the Higuchis now revealed different aspects of themselves; the human network that Noriyoshi had developed was held together by a business tie rather than natural ties based on kinship. A young acquaintance of Noriyoshi, to whom Natsu had been informally engaged, changed his mind; while his reluctance in carrying through this marriage is understandable, Natsu felt this withdrawal to be a betrayal and experienced a bitter disappointment. The death of her father and what she saw and experienced gave Natsu an impression that life was unpredictable and altogether precarious.

Because she was encouraged to hope for the privilege of succeeding her teacher in directing the conservatory, Natsu continued to attend Haginoya, holding to a thin thread that tied her past to her present life. Although she was able to earn a small amount of money by assisting her teacher, Natsu was not comfortable there, and her self-conscious behavior, along with her reserved yet proud manner, won her the nickname *mono tsutsumi no kimi*, "the lady who covers things." Associating with young women who were socially superior but intellectually and morally inferior seems to have caused Natsu not a small amount of internal struggle, traces of which would surface in the characters she was to create in several years. Her early fiction depicts the envious yearnings of a young daughter of an impoverished family for high society and the romantic dreams of marriage. As she rid herself of these romantic fantasies, Ichiyō, the writer, grew; she was now capable of writing sympathetically about the lives of different kinds of women. Examination of her own

self-image and reflection on class consciousness, which Ichiyō recorded in her journal, all contributed to making her into a fine writer.

Natsu's main reading during her formative years was fiction of the late Tokugawa period, which was filled with chivalrous heroes and imbued with Confucian ethics and morality. Reading these books made her resolve, she later wrote in her journal, not to lead an ordinary life but to do something worthwhile. It may well be that Natsu also inherited the moral ideology and ethics of Confucianism from her father, and because of the peculiar circumstances under which it was transmitted to her, its influence might have been unduly strong. The moral idealism of the Confucian school stayed with her throughout her life, affecting her thinking and occasionally surfacing in her fiction. When critics stated that her fiction sometimes gave an impression that it was not written by a woman, they were referring to this strong ethical approach. This and a nostalgic attitude toward the past, as embodied in the traditional style of *waka* practiced at Haginoya, were what Natsu claimed as her own when she launched her writing career. Her lack of higher education played a crucial role as well, as it meant that she had little exposure to the new thinking, such as on women's emancipation, that was being introduced from the West. In contrast to women like Wakamatsu Shizuko, who had direct contact with Western literature, or Tanabe Kaho, who had some exposure to the new ideas espoused by the Civilization and Enlightenment advocates, Natsu had little opportunity to experience the new tide, or even to hear or read about it, early on in her life.

In discussing Meiji writers, particularly women writers, the issue of mentors is important. Writers' choice of mentor affected them not only in terms of learning the craft and literary influence in general, but also in the way their career was launched and developed. We have already observed the case of Kitada Usurai; as shown below, it is especially true with Tazawa Inafune; even the preliminary assistance Kaho received from Tsubouchi Shōyō in getting her first manuscript into the hands of a publisher was not insignificant. Natsu, who saw Kaho as her model, naturally looked for support from a literary figure like Shōyō. Not as lucky as her friend, she eventually found Nakarai Tōsui, a newspaper reporter and popular adventure story writer. He, however, was not a writer of the caliber of Shōyō and Kōyō; furthermore, he held fiction and its readers in rather low esteem. Readers, he told Natsu, "do not appreciate serialized novels unless the author strings together the usual tales of schemers and bandits or else accounts of the doings of wicked women and prostitutes."[13] Discouraging though his initial words were, Natsu was given hope by his sympathetic interest in her situation and his willingness to help.

Actually, Natsu had been introduced to Tōsui to do some domestic work for him. Having lost his first wife sometime earlier, he was living alone, and

the Higuchi women at this time were trying to maintain the minimum decency of their middle-class lifestyle by doing whatever they could, including sewing, mending, and laundry. Between April 1891 and June 1892, Natsu made many visits to see Tōsui, ostensibly to get advice on her writing as well as to deliver the sewing. Although he did not give much actual guidance in fiction writing, he made many corrections in her manuscripts, particularly by changing her elegant, classic prose into a more colloquial style. He did, however, help Natsu publish her first story in a small coterie magazine called *Musashino* (*The Musashi Plain*), which Tōsui is said to have started for her sake. This first piece brought no income, but after she had published three stories in this magazine she was able to sell a piece to a better-known literary magazine, *Miyako no hana* (*Flower of the Capital*). This was at the end of 1892.

According to her journals, Natsu was quite bold in the way she approached Tōsui, and quickly she became attracted to him. Her falling in love with Tōsui was perhaps inevitable. She was desperately in need of someone sympathetic, and found in him a dependable man who was experienced in worldly matters. On the other hand, he seemed to have found Natsu naive and unexciting as a woman. Before anything came out of this relationship, however, interferences took place: a student at Haginoya reported a rumor that her friend's younger sister had had a child by Tōsui while boarding at his house, and Nakajima Utako, a poet who ran the Haginoya Conservatory, was disturbed. Although this rumor turned out to be false, another rumor — this time that Tōsui had referred to Natsu as his mistress — caused people at Haginoya, including Kaho, to urge Natsu not to see Tōsui again. Natsu entered in her journal in May 1892 that since "in everyone's judgment that was what she should do," she would force herself to forget Tōsui.

Natsu's decision not to see Tōsui represents a yielding to the pressure of petty bourgeois society, at the fringe of which the Higuchis were still trying to remain. The prevailing mood of loneliness and the sense of bitter resignation that readers find in most of her stories is not unrelated to this experience. The decision also reflects the complex internal battle between irrepressible emotion and internalized resolve, and Natsu's ambivalence and struggle in negotiating the two are closely delineated in her journal. The experience of love found and lost, its many-layered complex processes, must have accounted for Natsu's personal growth as much as did the Higuchis' economic problems and her responsibility as the head of the household. It helped her grow into a person in touch with various human emotions and prepared her to write stories with sensitivity. In this more indirect way, Tōsui aided Natsu in becoming a writer.

Feeling responsible for Natsu's (who had earlier adopted the nom de plume Ichiyō, or "Single Leaf") giving up Tōsui under the pressure of the Haginoya group, and thus having lost her only channel to the literary market,

Kaho offered her help by arranging for the publication of a story, *Umoregi* ("The Buried Tree"), for the magazine *Miyakonohana* (*Flowers of the Metropolis*). Written in traditional literary style with a highly contrived plot, this story is about an artisan, Irie Raizō, who has lofty ideas and moral integrity. A certain power comes through the uncompromising and rebellious spirit of this hero. Although the detailed delineation of this character makes one wonder if Ichiyō based her observations on her artisan brother, Raizō also reminds the reader of the hero in *Goju no to* ("The Five-Storied Pagoda"), a story by Ichiyō's contemporary Kōda Rohan. Underneath a surface deceptively similar to Rohan's story, however, "The Buried Tree" has a deeper connection with the work of other women writers of the Meiji era. Unlike Rohan's hero, who is glorified in his final victory, Raizō is betrayed in the end, rendering his sister's act of self-sacrifice futile. The story implies that men's treachery and greed lead to the destruction of innocent people — a theme repeatedly treated by Meiji *keishū* writers. "The Buried Tree" also reflects Ichiyō's critical view toward the type of fiction Tōsui was writing. She recorded in her journal shortly after she wrote this story that Tōsui's style was "crude" and that his plot was designed merely for "a novel effect."[14] Barely a year after her resolution to forget Tōsui, Ichiyō seemed to be consciously trying to surpass the art of her mentor.

"The Buried Tree" received favorable reviews, and it also brought Ichiyō an opportunity to associate with a group of aspiring young writers who would soon publish a coterie literary magazine called *Bungakkai* (*The Literary World*). Associated with Iwamoto Yoshiharu, either through teaching at his Meiji Jogakkō or contributing to *Jogaku Zasshi*, these young men, some still university students, had new ideas about literature. They advocated the liberation of men and women from the constrictive morality that tied them down in patriarchal practices both at home and in society, and they insisted, among other things, that free heterosexual love was a key to such liberation. They read "The Buried Tree" and liked it. It was fortunate for Ichiyō to be introduced to this group at a time when they were planning a new kind of magazine with a view of art and literature markedly different from those of the older generation.

Ichiyō contributed to *The Literary World* with *Yuki no hi* ("A Snowy Day"). A short, impressionistic sketch without a solid plot development or character delineation, it begins: "A day like this inspires poetry and song. How I envy those who see the snow spread out before them and fashion their metaphors." The story is about the young female first-person narrator-protagonist's reflections on her involvement with her male teacher. "But for me, the snow invites fresh pain, summoning as it falls and falls a past beyond forgetting. Eight thousand regrets I have — what little good they do me. What

waste I've thrown away a lifetime, a family heritage."[15] Bittersweet disappointment in the man and a life that has turned sour form the basic tone of this piece. Even though it is rendered in a fleeting manner, merely suggested, this very short piece reveals a new romantic notion of heterosexual relationship that Ichiyō's young acquaintances were exploring both in their personal lives and in their writing.[16] This short story also gives a glimpse of Ichiyō's later heroines, who, with their habit of introspection, probe into their complex minds.

The young men of *The Literary World* became close to Ichiyō, finding in her a yearning, similar to their own, for freer and more fulfilled lives. They also saw in her serious artistic aspirations. Ichiyō likewise found in them a position akin to her own: disgust for the material world. These idealistic young men frequently visited her at her house, and sometimes stayed late into the night talking about literature. The Higuchi family — three women with Ichiyō as the head — offered a much freer atmosphere than most households of those days, and since Ichiyō herself was a good hostess, a phenomenon resembling a literary salon developed. This was extremely rare in the days when heterosexual associations outside the family occurred primarily in the red-light district. When the discussion became heated, "her eyes shone, glowing in the dark corner of the room,"[17] wrote Kawakami Bizan, describing Ichiyō at one of these soirees. Although most of the time Ichiyō simply listened to these men's discussions, her exposure to various new ideas presented by them on these occasions was a precious experience.

Through her close contact with a group of male writers, and through studying on her own, Ichiyō gradually gained more knowledge about literature and fiction writing. It was from one of these men who came to her house that she borrowed Dostoevsky's *Crime and Punishment*, a partial translation of which had just been published.[18] She was thus introduced to a spirit of protest and opposition to counter her previous utilitarian view of literature. Her close association with these aspiring young writers who would soon launch the Romantic Movement was indeed an advantage not shared by other literary women of her time, a point deserving more attention than it has generally received. It was also in their small coterie magazine that Ichiyō published *Takekurabe* ("Growing Up"), a piece that would not only firmly establish her reputation as a writer but also immortalize her name in the history of Meiji literature.

Writing stories, however, was an agonizingly slow process for Ichiyō, and making a living by it turned out to be much more difficult than she had imagined. In June 1893 the Higuchis decided to move from their middle-class neighborhood to a downtown section near Yoshiwara, a famous red-light district, where they opened a five-and-dime store. Ichiyō wrote in her journal

around this time that "literature was not meant to be a means of livelihood" and that she was resolved to "mingle with the dusty aspects of life."[19] Thus she spent each morning going to the wholesale store to replenish stock, while still trying to write through the afternoon and night. Although the Higuchi women worked hard for a very small profit, their new venture, launched with inadequate capital and beset by new competition, lasted only ten months. During these months, however, Ichiyō gained invaluable experiences and opportunities to observe people she had never known before, and these she would use in her stories when she had again resolved to devote herself to writing. Children who came to her store, for instance, gave her the idea for "Growing Up," and the lower-class geishas who came to her for help in writing letters to their customers became the source for *Nigorie* ("Troubled Water").

Late in 1894, after the failure of their business venture, the Higuchi women returned to their old neighborhood, and although Ichiyō went back to assisting her teacher at Haginoya, her salary was very small and they experienced intense poverty. Ichiyō's journal describes how the three women worried about day-to-day survival, how they managed by borrowing small amounts of money from one acquaintance to repay another, and how they constantly pawned their meager possessions. Through the experience of poverty, doors to a multitude of experiences opened, however, teaching Ichiyō about the dynamics of human relationships; it toughened her as well. Whenever she could, she now went to the library and read the works of past masters, including Ihara Saikaku. In this year she also made a visit to Tōsui and realized that, although her feelings toward him were still warm, they had become more objective. It had been two years since she first resolved to write seriously, and Ichiyō seems to have learned to observe her own emotions more closely and with a writer's eye.

In the early months of 1894, Ichiyō started a new journal, which she entitled *Chiri no naka* ("Among the Maddening Crowds"; most of her journals have titles as if they are literary works), with her new resolution: "In attempting a venture with all of one's heart, discarding worldly desires and being unafraid in all matters of life and death, a woman can achieve as much as a man can."[20] Stories, she also observed, must be artistically satisfying; the writer's ultimate pursuit as an artist was to present "the true beauty" that existed "somewhere between heaven and earth." The *waka* poems she had written at Haginoya, she came to realize, were superficial, as they followed mere formality; they were empty and "corrupt." At this stage of renewed resolve about writing, Ichiyō produced several important pieces of fiction, starting with *Yamiyo* ("Dark Nights") and *Otsumogori* ("The Last Day of the Year"), both published in *The Literary World*. She was now experimenting

with parody: having departed from the work of her mentor and contemporary writers like Kōda Rohan, she turned to masterpieces from the long past, namely, *The Tale of Genji* and stories by Ihara Saikaku, a then newly rediscovered eighteenth-century fiction writer who excelled in depicting the lives of commoners in a realistic manner.

Oran, the heroine of "Dark Nights," is a beautiful young woman from a once-prominent family. Her father has gone bankrupt and killed himself, and now she lives alone in a dilapidated house: "People often wondered just how large the compound was, surrounded by its garden wall. How long had the front gate been boarded up? Storms had had their way with the place, and what remained was disquieting.... Who was it who lived there mourning the past?... Scant effort was expended to maintain the place. Rooms not in use were closed off, and the shutters were fastened tight for days on end. It was like the empty villa where Prince Genji's love, Yugao, had died of fright." Like many other heroines created by Meiji *keishū* writers, and like Lady Suetsumuhana of *The Tale of Genji*, the heroine, Oran, suffers from an adverse situation in life as people around her forget the benefits they have received in the past. However, the parallel between "Dark Nights" and the canonical work by Lady Murasaki is limited to this basic situation and the mood permeating the vast, discarded compound in which they live. While Lady Suetsumuhana is rescued by Prince Genji, Oran is betrayed by her fiancé, a member of Parliament and the Meiji version of the shining Prince. In this rewriting of the beautiful heroine's destiny one sees the reflection of the author's experience of her former fiancé's breach of promise: he, Shibuya Saburō, would later become a governor. Oran, who appears to be gentle and reticent on the surface, is actually filled with a dark desire for retribution. Her anger and need for revenge are acted out by an orphan boy whom Oran has taken under her care. The boy's attempt to assassinate the betrayer, however, is in the end unsuccessful. The story ends with the omniscient narrator's detached comment that no one knows what happened to Oran and the boy.

It is noteworthy that a scene in which Oran stares at the mirrorlike surface of the pond in her abandoned garden is similar to a scene in Ichiyō's journal. While Oran contemplates suicide in this scene, Ichiyō, similarly disillusioned and distraught, is thinking about the relationship between reality and illusion. The moon reflected in the pond seemed more real than the actual moon, she wrote, concluding the entry by identifying her state of mind at that moment as "monoguruoshi," a madness.[21] No further contemplation was recorded, but one might conjecture that what Ichiyō grasped at this moment had something to do with a separation of her true self from an imagined one. One might further speculate that the insight she gained then helped her in shedding the romantic image of herself as a lady with poetic

talent living in adversity; she might have learned not only to view the external world objectively, but to observe herself similarly. After "Dark Nights," Ichiyō would no longer write stories about beautiful and fated young women with a propensity for looking back into the past. She now turned to Ihara Saikaku, the eighteenth-century writer and realist who depicted the daily lives of ordinary men and women, particularly of the mercantile class.

The theme of "The Last Day of the Year" is, as Saikaku's theme often is, money and the people who are controlled by it. A champion of the newly risen townspeople, Saikaku was the first to recognize the issue of money as a fictional topic around which to write stories with down-to-earth realism. And Ichiyō wrote a story on the same subject, only seeing it through the eyes of a girl servant, Omine. Omine's uncle (to whom she is bound by a sense of filial obligation, having been raised by him and his family) urges her to ask her employer, a well-to-do usurer, Yamamura, to advance some money. When Mrs. Yamamura refuses her request, Omine steals two yen from a drawer. However, because the eldest son of her employer also takes the whole packet of money from the drawer, leaving a note to that effect, Omine is saved from the accusation of theft. Whether the son left the note in order to rescue Omine or simply out of spite at his mother is left unclear; he uses the money, the narrator tells, to treat poor folks in the neighborhood with good food. This sort of ironic ending is characteristic of Saikaku's stories, but Ichiyō adds a new dimension to the prototype. When she took the money, Omine knew that the act was against her moral code, but having done so, she feels somewhat elated; she feels that she is entitled to the money she has taken. On first reading, "The Last Day" seems to merely explore Confucian ideas of honesty, loyalty, and filial duty, but a careful examination of Omine's thoughts reveals that she did have some further understanding about herself and her relationship to society ("That was the way when one was poor"). Her act signifies the action of setting herself free from the many layers of subjugation under which she feels herself suffocating ("If they didn't listened to her, she would bite her tongue and bleed to death").

The degree to which Ichiyō experimented with different subject matter, each time showing a deeper understanding of her material as well as technical mastery, is rare among Meiji writers, both male and female. After conscious borrowing from Saikaku, Ichiyō was ready to write fiction based on the observation of her immediate surroundings. For a little over a year between this time and the time of her death, she wrote energetically, pursuing her own themes. "Growing Up" and *Nigorie* ("Troubled Water"), Ichiyō's two best-known stories, were written during this period.

"Growing Up" is a story about many things: it is about the loss of innocence and the harsh destiny some people must accept when childhood is

over; it is also about a first love destined to be thwarted. Midori, whom the reader meets in the opening of the story, is popular among a neighborhood gang of children for her high-spirited, generous nature. However, for her and her male counterpart, Nobu, the future is already decided: while he, a shy, serious boy, will follow his father into the priesthood, Midori is to become a courtesan like her older sister. The strength of this story, in which plot is not the most prominent feature, lies in its evocative sketches of the various interactions of children during their precarious transition to adulthood.

Against the seasonal changes of background, and as reality slowly unfolds its force, the reader sees the transformations that take place in the main characters. "Then she saw who it was. The blood rushed to Midori's head. Her heart pounded as if she had encountered a dreaded fate. She turned to see, was anyone watching? Trembling, she inched her way toward the gate. At that instant Nobu, too, looked around. He was speechless, he felt cold sweat begin to bead. He wanted to kick off the other sandal and run away." Ichiyō describes in this scene the agonizing moment of a self-conscious adolescent heroine, Midori, who no longer is a girl getting involved in the silly fights of neighborhood gangs. In the following section, Midori's uneasiness with herself is reinforced: "The scarlet scrap of Yūzen silk lay in the rain, its pattern of red maple leaves near enough to touch. Odd, how her one gesture moved him, and yet he could not bring himself to reach out and take the cloth. He stared at it vacantly, and as he looked at it he felt his heart break." No story with such subtle evocation of the internal drama of adolescence had been written in Meiji Japan before.

Likewise, when Midori, with her elaborate coiffure, appears one day in front of Shōta, a moneylender's son who adores her, she is presented with great accuracy as one who is no longer the innocent girl she was only a few weeks earlier. "This awkwardness all of a sudden! How was she to explain it." Just when she has become aware of her feelings for Nobu, the reader is told, time has caught up with her. Midori's difficulty in conveying her confusion to Shōta is given in her utterance: "For god's sake, go home, Shōta. I feel like dying with you here. All these questions give me a headache." Because of this foreshadowing, the reader knows at this point that the day for Midori to move into the gay quarter on the other side of the gates is near.

Until recently, when Sata Ineko questioned the reading of this scene, scholars (mostly male) have taken the change in Midori to mean the start of menstruation, a sign of becoming a woman. Sata proposes that it be read as Midori's having experienced *hatsu-mise*, a term used in Yoshiwara and other places of prostitution to refer to "the first tasting" of a prostitute-to-be by an important patron.[22] Sata's more realistic reading changes the meaning of the work: instead of a poignant story of a girl growing up, it now reveals a

darker side of reality, hinting at the sexual exploitation and greed observed around Midori. Her resignation and sadness are only suggested, however, enhancing the rare, subtle beauty of the story.

The drama of "Growing Up" is set in the century-old pleasure quarter of Yoshiwara, where men went to obtain women, a world where, separated ever so clearly from the rest of society, names, status, and a sense of honor had no meaning, where only money eloquently asserted its power.[23] Ever the realist, Ichiyō fixed her eyes on the fact that money controls many things. Midori's popularity among her playmates, we are reminded, is supported by her ability to treat her friends to candy, thanks to the hard work of her older sister, Agemaki. These children are, in a symbolic way, all orphans. Miles apart from the ambience of *Little Lord Fauntleroy* (which was also enjoying an enthusiastic reception about this time), however, these children's future is grim; pain and disappointment rather than the promise of fulfillment are likely ahead of them.

It is the basic elegiac tone stemming from the theme of lost innocence that caused critics to give the story rave reviews. At the same time, the story moves its readers because of its vivid and realistic depiction of the characters, whom Ichiyō modeled after the residents in the immediate vicinity of the red-light district of Yoshiwara, where she lived briefly. When Shōta's fear is verbalized by another boy, a comic figure ("Well, next year I'm going to start working, and then I can go and have her for the night, can't I?"), it is with stark realism and honesty.

"At the risk of being mocked as an Ichiyō-idolator," critic Mori Ōgai (who did not approve of other pieces by women writers in *Literary Club*'s *keishū* special issue, particularly Inafune's) declared that Ichiyō was a "true poet." Another admirer, Kōda Rohan, stated that "the beauty of the style and the profundity of the themes left [him] at a loss for words."[24] These comments focus on the mood created in the story: subtly yet unmistakably sad, this mood stems from the understanding that a carefree, vivacious girl is about to be made into a woman who will exchange her body for money.

"Troubled Water," published in *The Literary Club*, also received largely positive responses, if not as enthusiastic as those for "Growing Up." Again about a woman of the red-light district, the story concentrates on delineating the mind of its main character, Oriki. A popular prostitute of a less reputable section within the district, Oriki has among her customers Genshichi, who has lost not only all of his money, but his head as well, over her. Oriki cannot envision a future with Genshichi, partly because she sees herself as "a misfit" and partly because she feels that the life of a wife would not be much of an improvement over what she has now. Her appraisal of marriage seems accurate in view of Genshichi's wife, who, though hardworking and faithful,

has fallen victim to a man who has ruined himself and his family through his obsession. Having no families of their own to return to, both women share the same predicament: if they become dependent upon men, they must give up their sense of self (as the wife has done, and as Oriki is unwilling to do); without men, however, they can hardly exist. "Why do I have to live in this petty, mundane, disgusting place which gives me only grief and loneliness?" In a long outburst, Oriki pours out her feelings: "If only it were possible, she would keep on going, to China, to India. How she hated her life!... How long would she be stuck in this hopeless situation, where everything was absurd and worthless and cruel?... She felt almost delirious and leaned against a tree at the side of the road." Finding herself at an impasse in her life, she eventually lets herself be killed by Genshichi in an apparent double suicide.

Oriki experiences a peculiar feeling of detachment from reality in the midst of the bustling noises and people of busy streets: "Oriki left the darkness of the alley and walked along a street lined with shops.... As she trudged along, the faces of passersby seemed tiny to her. Even those of people who walked directly in front of her seemed somehow very distant. She felt as if she were hovering ten feet above the ground. She could hear the din of voices, but it sounded more like the echo of someone falling to the bottom of a well." How can she arrive at a place where there are "no voices nor any sound, a place so quiet that she can completely lose herself," Oriki has asked earlier. What is delineated here is a state of mind that appears to border on schizophrenic dissociation. In depicting the complex mind of a woman who feels she is in a double bind, "Troubled Water" is remarkably modern.

Ichiyō is said to have written "Troubled Water" in response to Kawakami Bizan's suggestion that she write an autobiography. Bizan, already an established author when they met, saw in Ichiyō's life a drama similar to those he was writing about in his fiction. Ichiyō's life was indeed potentially very close to that of Oriki and some of Bizan's characters. The perception that life brings more pain than joy is emphasized particularly in Ichiyō's later fiction. It is this basic tone of prevailing weariness, a feeling akin to romantic melancholy, that caused her work to be welcomed at a time when the Romantic Movement was beginning to be embraced on the literary scene. Ichiyō's interest in the experiences of merging the real and the unreal — the psyche of a person who has gone to the edge of life, as it were — is shown in another story, *Oborozukiyo* ("Night of Hazy Moon"). The heroine in this story is mentally ill, needing to be treated by a medical doctor.

As mentioned earlier, the male critics of her time praised Ichiyō most for her poignant descriptions of a sad life rendered in a poetic presentation, of which "The Thirteenth Night" is a good example. Although it introduces the message gently, the story nonetheless contains the author's criticism of a

society that protects the needs of men at the expense of women's happiness. The presentation of this criticism, however, is so subtle that the criticism may easily escape the reader. Oseki, the heroine, has married a man above her station. He mistreats her, but when she returns to her family hoping to get sympathy there, her father tries to persuade her to go back and endure her misery. "Women are always complaining," he says, pointing out to Oseki that a man with her husband's status and responsibility is expected to be difficult at home. "I'd be surprised if there are many wives who enjoy completely happy relations with their husbands," he adds. He does not forget to remind Oseki of her responsibility to her small child. Underneath his eager speech, ostensibly made for the sake of his daughter's welfare, one senses a selfish, pragmatic, middle-class father who wishes to protect the privileges he and his son have been enjoying thanks to Oseki's wealthy and influential husband. His logic, plainly stated, is that a virtuous woman should be willing to sacrifice her personal happiness in the name of filial duty and motherhood. "Oseki was resigned to her fate. 'That's the end of it, this talk. I'm going home. I'm still Harada's wife.... Don't worry. As long as you are all happy, I won't have any regrets.... From now on, I'll consider myself Isamu's property. I'll do whatever he says. That way I can bear Isamu's cruelty for a hundred years to come.'" On her way back to her husband's house, Oseki encounters a rickshaw pulled by her childhood sweetheart, Ryūnosuke, whom she had wished to marry, a man whose life was ruined because of Oseki's marriage to another man. Oseki realizes that she is still attracted to this man, but there is no way she can reveal this to him; she had just told her father that she would live for her son ("I will consider myself dead — a spirit who watches over Tarō"). Not knowing how to cross the bridge that now separates them so clearly, Ryūnosuke is equally unable to express his emotions, and they part without confessing the unhappiness in their hearts. Since real conflicts are submerged well below the surface, "The Thirteenth Night" in the end conveys only a longing and the sense of unconsummated dreams. The elegant language helps create a unity of tone and content.

Ichiyō thought that the beauty of polished sentences had to be matched by the force of strong emotion, and if she could achieve this, she said to herself in her journal, she could write something that "represents one generation and yet is remembered for hundreds of years." She aspired to tell the truth about men and women, the essence of life; this attitude places her in the tradition created by masters like *haiku* poet Matsuo Basho, for whom art was a way to reach truth, an act of self-understanding and a means of salvation. It is easy to see why she had to toil over her work day and night and still, sometimes, was unable to produce even a few lines.

The reader of Ichiyō's journals does not find a single pronouncement

of excitement or a word of satisfaction with her literary triumphs. What is found there instead is a stoic attitude that shuns fame, as well as a self-directed caution not to "fall into self-delusion."[25] This attitude of warning against the "ephemeral nature of fame" stems, in part, from the Confucian school–inspired samurai ethic underlying Ichiyō's thoughts. Some of her lofty ideas about writing fiction are not unrelated to this orientation. It is, on the other hand, not so hard to see why Ichiyō reacted to her overnight success, and to the generous words of praise the critics gave her, with suspicion.

In contrast to her low-key approach to her literary success, Ichiyō's appraisal of the critics who raved about her work is shockingly outspoken. Their critiques were vague, failing to take concrete account of either defects or merits, she stated in her journal; as far as she was concerned, their thinking was superficial. In these remarks she reveals her sharp-tongued, aggressive side, which she for the most part carefully concealed.

Ichiyō was accurate, to a degree, in discrediting the critics as superficial in their praises, in that they identified primarily the beautiful language and lyrical overtones of her stories. She was also not mistaken in suspecting that "nine out of ten" showed an interest in her work primarily "because she was a woman." She was right in that critics assessed her as a woman writer, a *keishū sakka*, evaluating her work by the standards set for women. Ichiyō was also aware that critics praised because her themes were appropriate for a woman and because she wrote in elegant language with feminine subtlety. "Pondering many things as I sit at my desk, I am made to realize that indeed I am a woman; what can I hope to accomplish then, even if I think very hard," she wrote in her journal.[26] Ichiyō cautioned herself also about the gossip and jealous competition to which her success had opened the door.[27] Afraid of appearing proud and aloof, for instance, she never refused to see visitors no matter how busy or tired she was. Keeping a journal in which she could freely express her thoughts and feelings, including those that are both sharp-tongued and cynical, was thus an important activity for her. This is why, when it was published after her death, readers found it fascinating.

There was one critic among her contemporaries who saw beyond Ichiyō's facade and identified her as a person more complex than the world recognized her to be. Saitō Ryokuu, a talented man of letters who seems to have had a great personal interest in Ichiyō, approached her with the intention of "revealing the truth behind her veneer."[28] He announced that he would write an essay on the relationship between her personality and her work. In this man Ichiyō seems to have found qualities comparable to her own, but her interest in Ryokuu as a person was never developed, nor was the projected essay written. Ichiyō's ambition and the more aggressive side of her personality were apparent, however, not only to Ryokuu but also to the careful

reader of her fiction, particularly of her later work. The majority of her contemporaries, men in particular, did not see those qualities. To them she was a writer who beautifully told the sad stories of women.

If she had lived longer and developed more confidence in herself, Ichiyō might have written fiction that incorporated various aspects of herself which she did not reveal easily except in her journal. What should women like Oriki and Oseki do to pursue a life true to themselves instead of merely surrendering? Ichiyō must have asked this question, too. After writing "The Thirteenth Night" and having completed "Growing Up," she wrote another story, *Wakare-michi* ("Separate Ways," 1896), specifically on this question, representing in it a woman with strong desire to live an unvarnished life (although in the end she let her succumb to becoming a wealthy man's mistress). In the same month, Ichiyō also wrote another story in which she experimented with an entirely new theme and style. Written in the vernacular language instead of the more elegant literary style and treating the power of innocence in a child, the story, *Kono ko* ("This Child"), shows the influence of Wakamatsu Shizuko in both topic and style. This experiment was unsuccessful, but the next two stories she wrote, going back to her original style of mixing the literary (for narration) and the colloquial (for conversation), revealed another new dimension in her thematic concern.

"So you want to divorce me and get this house, too. Try and you'll see. I've got my own plan," says Machiko to her husband in *Warekara* ("Skeleton of a Shrimp," 1896). The heroine of this story is not a subjugated woman, and she does not let herself be intimidated. She tries to protect her reputation and is willing to fight against a rumor that she has had an illicit relationship with a young male boarder. She even seems to think that her interest in this boarder can be justified by her husband's neglect of her. This self-assertion of a married woman and her awareness of her own emotional needs is taken one step further in *Usumurasaki* ("Pale Purple," January 1896), in which the heroine actually goes through with an extramarital affair.

Ichiyō wrote several stories dealing with unhappy marriages, in most of which wife's pains and suffering are caused by the husband. The husband in "Pale Purple," however, is different: a well-do-do man and owner of a shop that sells "Western dry goods," he is generous, considerate, and loves his wife. The wife, Oritsu, naturally feels guilty deceiving him when she leaves home to meet with a man she secretly loves ("Perhaps I shouldn't go, I mustn't, maybe"). The first half of the story, the part completed, deals with her guilt and rationalization (the man she loves is someone she had known prior to her marriage), and in her lengthy monologue she examines her behavior: "What's pushing me into such a dangerous act, like that of walking on the blade of a sword? What's lacking?" She doesn't know the answer, although

she feels she cannot help but follow her urges. Betraying such a good husband, she sees herself as "wicked ... and beastly," on one hand, but she calls him "a husband only in the name ... in truth [he is] is a prison guard." With such self-examination, Oritsu, like Oriki in "Troubled Water," is presented as a character with the consciousness of a person who is thoroughly modern. The image of the blade of a sword reminds us that the wife's adultery was a punishable offense in those days.

Having established a reputation as one of the finest writers of her day, Ichiyō now seemed to be more confident in writing stories that would explore other alternatives for her heroines than that of living their lives in passive resignation. The two last stories (and particularly "Pale Purple" because it is incomplete) are often dismissed by Ichiyō scholars as insignificant,[29] but it is important to include them in order to get the full view of Ichiyō's short career and locate her on the continuum of the literary women of the Meiji period. Literary historians tend to single Ichiyō out among mid-Meiji women writers of fiction, making her represent all others and thus creating the impression that no other women existed. They also narrowly focus their discussion on a few representative works, such as "Growing Up" and "Troubled Water."

Ichiyō was indeed a writer who developed exceptional skill while writing under unusual circumstances, and in her writing she made attempts that were considerably greater than those of other women writers of her time; she was more serious in intent, perhaps. But she was not born in a vacuum; more than literary historians have acknowledged, she was aware of other women who had published before her and who were writing along with her.

After the republication of "Growing Up" in *Literary Club*, a commercial magazine whose circulation was much larger than that of *The Literary World*, Ichiyō's name became known beyond the limited circle of writers in Tokyo, making her such a famous woman that the nameplate at the gate of her house was repeatedly stolen as a souvenir. Some aspiring writers sent their stories to Ichiyō for her comments, and publishers solicited her work. The number of women wanting her to tutor them in *waka* poetry also increased. While Kōda Rohan suggested that the two of them write a story together, one publisher, with the basic interest of exploiting her fame, asked her to write how-to books on epistolary writing. Although the joint venture with Rohan did not happen, she wrote the epistolary reader. Her financial situation, however, was not improved, as she could not write fast enough to make a profit. While the Higuchi women continued to borrow money, Ichiyō's health started to deteriorate rapidly. It had been only four years since the publication of her first story, and in September 1896, when she finally went to see a doctor, her body was hopelessly infected with tuberculosis. Two months later, she died.

Ichiyō's work was attractive to men, wrote Hiratsuka Raichō (discussed in Chapter 5) a few decades later. Although it "sincerely and intimately depicts the private emotions of women, Ichiyō's work renders women's sad fate," she stated; a woman she created "fits into the concept men have of women" and assures "an egotistical need, inciting masculine pity by awakening in men the pleasant sensation of awareness of their own strength."[30] As a woman who would introduce the feminist movement nearly a decade after Ichiyō's death, Raichō criticized Ichiyō severely. Yosano Akiko (discussed in the following chapter) was also critical of Ichiyō and her acceptance of traditional values. Her criticism is understandable, considering what she did with her life: it in fact is a rejection of the lives lived by the heroines created by Ichiyō and Usurai that we see in the life and work of Akiko.

Sata Ineko, a woman writer who lived a life of economic hardship in her youth and started her career by writing fiction in the vein of the leftist school during the 1930s, thought otherwise. Acknowledging the clarity and subtlety with which Ichiyō rendered "the constrictions of the society of her time," she described Ichiyō's stories as having qualities "surpassing the aspirations of the human spirit."[31]

Like a shooting star, Ichiyō shone brightly for a moment, then disappeared. Some cherished her work because of its lyrical and nostalgic quality; for them she was "the last woman of the old Meiji." However, a close examination of her fiction — particularly the later works — reveals that Ichiyō was more than a writer who depicted the sad fate of Meiji women beautifully and with resignation. A protest against the men's domination of women is in her fiction; although it is not very easy to see, there is a thread that connects her to Yosano Akiko, who would launch a literary career just as dramatic as Ichiyō's in 1901, five years after Ichiyō's death. Before examining the position and contribution of Akiko in the history of Meiji literary women, however, we need to look at the life and work of another woman, Tazawa Inafune, whose stories, with their strongly rebellious and eccentric heroines, caused negative appraisals from the critics of the time. In Inafune, too, we see an unmistakable seed of revolt that would sprout in Akiko and other women who would start writing at the end of the Meiji period.

Tazawa Kinko, "Inafune"

"It's hard to believe that she is the author," wrote Mori Ōgai in his review of *Shirobara*, ("A White Rose"), a story published in the special *Literary Club* issue on *keishū* writers of in December 1895.[32] He was referring to Tazawa Inafune, whose photograph, along with those of several other women

authors, appeared in the issue—a promotional tactic, no doubt. In the picture, Inafune's face is heavily painted, and she is wearing a formal kimono and adorned with an elaborate coiffure.

It is not surprising that "A White Rose" received an unsympathetic response from Ōgai, an established writer and well-respected critic, who was also a stern moralist. He was not alone in reacting to this story negatively, however. Takayama Chyogyū, a young critic who knew the author personally and valued her potential as a writer, was clearly displeased: "It is not an honorable piece of work from the hand of a lady writer," he wrote, concluding that it must have been caused by "some evil effect" working on her "virtuous personality."[33]

The characterization of Mitsuko, the heroine of "A White Rose," is in sharp contrast with that of the women in stories written by Kitada Usurai, and Mitsuko does not perceive men, as Usurai's heroines do, as monolithic and indestructible authorities. The daughter of a well-to-do family, she is eccentric, though not egocentric like the pampered upper-class young women depicted by Tanabe Kaho. When she is pursued by Atsumaro, the son of a high-ranking nobleman, and when her father tries to exert his authority to pressure her into marrying this man, she leaves home. Blinded by his desire to have Mitsuko, Atsumaro becomes villainous, and, aided by his maid who had been sent into Mitsuko's household, and by using chloroform, he rapes her; finding out that she has been sexually assaulted, Mitsuko kills herself. Victimized by a man's egocentricity and violence, she takes action in an attempt to regain control of her own fate. Unlike passive, benign heroines who accept their sad predicament as destiny, she is unwilling to be subjugated to the tyranny of men; her rejection of men—her suitor and her father—is definite and complete. Concluding her story quite abruptly, without any explanation of Mitsuko's suicide, Inafune leaves the reader stunned, but the message is clear: men are basically shrewd but cowardly, licentious but irresponsible, and they use women as sexual commodities.

Mitsuko thinks that men, without exception, are filled with lust; they are, in her words "as dirty as the fishmonger's barrel filled with fish intestines or the Ohaguro ditch of Yoshiwara,"[34] and there is no difference when they are in love. "Carnal pleasure may not be as vile as I think; it can be called sacred even. But, for whatever the reason I feel it despicable; I cannot help wonder if there's any other way to assure the succession of our species." Thus, she sees marriage primarily as a means for men to satisfy their needs, and therefore, she maintains, "love and marriage ... are not so sacred as people make them out to be." Mitsuko's indignation is directed not only toward her amorous suitor and her father (in fact, Atsumaro seems to be genuinely attracted to her, and her father's wish to advance his social status through

his daughter's marriage is nothing unusual for a Meiji father); her complaint is pervasive and her challenge is directed at all men: "Even though it is an affront to my parents to say such a thing, I would really rather not have been born."

It is no surprise that "A White Rose" invited negative comments: in addition to Mori Ōgai and Takayama Chogyū, who felt that the piece was not something a woman would write ("fierce, so rare for a woman to write a story like this"), another minor critic, Amachi Kenichi, writing in Inafune's native town of Tsuruoka, complained that it was "vile and obscene."[35] Amachi then added that he would like to write a story to counter it on the theme that all women are cruel. The shock the reviewers felt is no doubt intensified by the straightforward language in which Mitsuko's sentiment is delineated; it is also pointed and harsh, even hostile. The character of Mitsuko must have been more than puzzling; she was not only incomprehensible but seemed dangerous. Reviewers' various comments reveal a reaction that might be called a threat.

It was Mitsuko's open attack on hypocrisy in the institution of marriage that male critics and reviewers were responding to. Considering the contemporary perspective that a young woman's future was to be found only in marriage, her opinion is radical indeed. The similar position regarding marriage is described in her earlier story *Igaku shugyō* ("Medical Training") when the protagonist, Hanae, is characterized in these words: "She is not a bit like boys with rough behaviors, but whenever family acquaintances suggest marriage, she'd make such a face and declare that there's nothing as loathsome as men.... She would certainly not consent to degrade herself by having such a repulsive being as a husband." Published in *Literary Club* in July 1895, this story is similarly unconventional in plot and characterization and again conveys a clear and bold message of rejection of marriage. Hanae is given an ultimatum by her jealous stepmother: either she gets married or she attends a medical school.[36] The choice is between accepting the patriarchal pressure and going into pragmatic training; neither is agreeable to Hanae. An exceptionally beautiful woman, Hanae, like Mitsuko, expands her unorthodox ideas about men further: they "argue against licensed prostitution and defend moral life in the morning," she says, but they will "for sure visit the red-light district in the evening." Knowing the common practice among Meiji men, it is hard to argue against her appraisal that most men are "fake." Finding a Meiji man who had never been a customer of prostitution houses was next to impossible, even among socialists, political activists, and exponents of women's rights. What Hanae says is on the mark. However, she defines herself as *otokogirai*, one who genuinely dislikes men, and claims that she is not like other women who "too easily fall for gentle, pleasing words of men."

Since she has no intention of marrying, Hanae opts for medical training. She is sent to a woman doctor's house as a boarding student and enrolls in medical school. But of course she does not show any interest in the training; skipping her classes, she goes to the library and colors pictures in the anatomy textbook. In the conclusion of this story, Inafune makes her heroine a successful stage performer of *gidaiyū*, a solo performance involving storytelling and singing accompanied by *shamisen*, a three-stringed instrument.[37] "Medical Training" is a story of a young woman with strong opinions who in the end gains independence from her family and becomes an artist. Exactly how she managed to do this, however, is not told.

In another story, *Komachi yu* ("Komachi Bathhouse," published in 1896 in *Literary Club*). The protagonist, this time a man, refuses to marry the woman his father has chosen for monetary reasons. The son has aspirations of becoming a painter. Having studied women's naked bodies at a bathhouse while working there, he manages to produce a painting that wins a grand prize and is sold to "a Westerner" for 20,000 yen, an astronomical figure. His father, the reader is told, accepts the son now that he has earned such a large sum of money. Inafune, who attacked in "A White Rose" the vulgarity of aristocrats along with the marriage practices in patriarchal society, treated in "Komachi Bathhouse" (also in "Medical Training") the theme of art triumphing over conventional material life; she denounces the self-righteousness and narrow-mindedness of Meiji people with their philistine approach to life. The critics reacted once again with alarm mixed with disgust: "This is shocking even as a work by a male writer; after chloroform, it's a peeping Tom, and what horrific ideas will be next,"[38] wrote Mori Ōgai, labeling Inafune a writer with bizarre tastes. The story's basic message—the defense of art and new means of expression—seemed to have escaped him and other critics. This story in fact reveals that Inafune was aware of the disputes in the artistic community over nudity as the subject of painting.[39]

Inafune, or Kin (as her parents named her), was born in Tsuruoka, an old town in northern Japan, the eldest child and heir to a man who was highly regarded in his community as a practicing physician and an educator in medicine. Kin's mother was an exceptionally capable woman who managed more than a few lucrative businesses, including a bathhouse. As a child, Kin is said to have preferred being alone over playing with other girls except her younger sister; she was often seen reading, writing, or pondering something about which she told nobody. Feeling alienated in the provincial town of Tsuruoka and far from being practical and outwardly social like her parents, Kin focused her attention inward early in her life, developing an interest in writing as well as painting. Despite some superficially modern features, the people of the town were quite conservative.

As a child, Kin was an avid reader. Among fictional works she read, *Kochō* ("Butterfly," published in 1889) impressed her a great deal in the way its central female character is depicted and by the beauty of its language. Based on a story of medieval warfare between the Taira and Minamoto clans in *Heike Monogatarri* (*Tale of Heike*), it focuses on the ill-fated love and devotion of a young woman. It was the work that gave its author, Yamada Bimyō, a reputation as a genius. Soon, Kin wanted more than just reading; having adopted a pen name, Inafune, she began writing. She first sent her manuscripts to local magazines, then to a Tokyo magazine called *Iratsume* (*Young Women*). Founded in 1887 with Bimyō as one of the editors, it was the Meiji's first literary magazine targeting women readers. Kin left Tsuruoka for Tokyo eventually, a pattern that would become familiar for aspiring women (and men) to follow. She knew that in Tokyo several women were writing and publishing their work. Although having the freedom to pursue her passion for writing was an important factor in her leaving her hometown, her father's attempt to arrange her marriage was the more immediate reason. She was eighteen at the time.

Kin went to Tokyo under the pretext of studying to become a painter, but as soon as she got there she went to see Bimyō, with whom she had been corresponding. With sparkling talent, displayed both in his innovative style and in his revolutionary concept of art, Bimyō was ahead of his friend Ozaki Kōyō in achieving fame in the literary establishment. When Kin met him he was at the peak of his successful, though short-lived, career, and she was immediately attracted to him. No doubt she was impressed by the aura of modern life he projected — the clothes he wore and the room he decorated with Western paintings and bronze statues — but she also shared with him a contempt for practical-minded people.

Although Kin enrolled at the Kyōritsu Women's Occupational School and would stay there for about a year, she spent most of her time writing fiction and seeing Bimyō, whom she eventually married. This marriage not only forced her to renounce her right to be Tazawa's heir, but helped her confirm her feelings toward marriage. Bimyō was then living with his mother (an unhappy woman who had lost her husband to a rival) and paternal grandmother, a willful and domineering woman who controlled the household. In the age when one of the most important tasks of a young wife was to serve her in-laws, there was no way that Inafune, who was incapable of performing the simplest domestic chores, could satisfy these two women. A man whose habit of womanizing was public knowledge, Bimyō was involved with a few other women at this time as well. In a literary journal, Ozaki Kōyō called his friend's conduct immoral, to which Bimyō replied by stating that it was "for his art," that he needed to know many women in order to write

fiction.⁴⁰ Bimyō in fact would not have married Kin had not his financial decline made marriage to her, the daughter of a wealthy family, seem the wise thing to do.

How the private lives of writers attracted journalistic attention in those days can also be seen in various articles that appeared in the papers on the affair between Bimyō and Kin. Describing their relationship as a "love marriage of two artists," these writers primarily criticized Kin for having been "persuaded by an animal called love"; in her rebelliousness she had "ignored the common opinion of the world."⁴¹ The difficulties in their marriage were obvious to everyone.

Bimyō's reputation, which had shown signs of decline earlier, reached bottom when gossip-hungry journalists reported that Inafune was "yet another of his victims." Unable to cope with day-to-day life and having little time to write, she found herself both physically and emotionally defeated, and by the time her mother came to retrieve her she was ready to go home; her marriage to Bimyō had lasted only three months. *Yomiuri*, a national daily paper with a large circulation, now published *Inafune monogatari* ("The Inafune Story"). A beautiful young woman from a good family, her "love marriage" and quick divorce, and the notorious stories she wrote — all were easy to exploit. The psychological pain resulting from the marriage breakup and the humiliating position in which she found herself as a divorced woman returning to her parents' house was reinforced by these gossip columns.

Back in Tsuruoka, Inafune responded to the journalists' hypocrisy. Despite increasing physical deterioration with symptoms of tuberculosis, she put a great deal of energy into her writing, which she continued until the last day of her life. In free verse entitled *Shinobine* ("A Faint Tune," 1896), which she wrote in the classical language, she revealed her sense of defeat and great distress. In another piece, *Tsuki ni Utau Zange no Hitofushi* ("Repentance Uttered to the Moon," 1896), also in free verse, she blamed herself, acknowledging her role in bringing about the debacle of her life. Filled with regret, she was still sympathetic toward Bimyō, however, and stated that her real enemies were the journalists who exploited her situation from beginning to end. In defending herself and Bimyō, she showed that there was some fighting spirit still left in her.

Now far away from Bimyō's influence, furthermore, she was slowly finding her own mode of expression. And in her last struggles she seems to have discovered a theme that was quite different from that in her earlier stories, a theme around which she could write truly in her own voice. What emerged in her last two pieces of fiction was a woman who is not the victim of her family and society, but one who triumphs. These stories, *Godai-dō* ("Temple of Godai," 1896) and *Yuiga-Dokuson* ("Self-Conceit," 1897, appeared in

the second *keishū* special issue), both published posthumously, are about a woman who offers her life in her love of a man. The heroine of "Temple of Godai" understands and accepts a man as he is, and she dies with this man, a writer (modeled after Bimyō, no doubt) in rapid professional and financial decline. The story conveys Inafune's final statement that pure love triumphs over physical death, as does true devotion over petty conventionality. Although this work is her conclusion of a soul-searching examination of her involvement with Bimyō, the reader sees here that its author is not uncritical of the man for whom her heroine dies. Her last work, "Self-Conceit," which was completed a few months before her death, portrays a woman who asserts herself and acts with courage, in the end bringing about her own happiness. The story also suggests the victory of the individual over the patriarchal system. In these two stories, Inafune honors love as the most essential human emotion, as well as one that overcomes all social constraints.

Bimyō's influence upon Inafune's earlier fiction was strong. Unconventional stage props like chloroform (used to rape Mitsuko) and gruesome description (Mitsuko's dead body being scavenged by birds) are commonly found in his fiction. Inafune also shared with her mentor the view that art transcends all worldly concern. It was clear from the beginning of her career that she was not going to write fiction about the victimization of helpless women. The boldness in basic themes and messages embedded in Inafune's stories escaped many readers of the time, while her rebelliousness and outspokenness antagonized critics of her time — all males. It was her unconventionality and daring spirit, however, that made a critic state, after her death, that if she had lived until she was thirty or forty years of age, she might have produced some remarkable work.[42] Her life, like those of many of the literary women of the Meiji period, was brief; it is difficult indeed not to contemplate the possibility of her having lived longer.

Inafune died in late September 1896. One newspaper reported that she had killed herself, another that her death was caused by "mental derangement." She had abused her weakened body by continuing to write late into the night, using barbiturates. Stubborn and totally uncompromising, Inafune had gone her own way single-mindedly. Because she lacked "common sense" and a cautious approach to life, her commitment to writing proved to be self-destructive.

By the end of Meiji's third decade, slightly more than a dozen women were writing and publishing. One prominent characteristic of these literary women was that they lived short lives: after promising starts and signs of maturing as writers, premature death overtook them. Their early deaths, particularly those of Inafune and Ichiyō, do not seem totally unrelated to their taxing attempts to write seriously amidst a general lack of encouragement.

They were writing in the conservative climate that descended upon Japan in reaction to its opening to the powerful influences of the West, a time when marriage was women's only future and girls' education was geared solely to prepare them for this goal. The motto of *ryōsai kembo*, or "good wife/wise mother," which was originally meant to convey a view of women as men's valuable companions, had come by then to point to a very limited view of women, one in which they were discouraged from attempting activities beyond the narrow sphere of the home. Growth in the publishing industry, however, encouraged more people to write to earn income, and there were a few women who did this. Before examining this young generation of women, who were still sometimes referred to as *keishū* but were more and more successful in making a career out of writing, we need to look at Yosano Akiko. She is the first among Meiji literary women who enjoyed a long life as a creative woman and who was able support not only herself but her family as well.

3

The Romantic Movement in Poetry
Yosano Akiko

Even though it was in fiction that she showed exceptional skill and gained critical recognition, Higuchi Ichiyō also wrote a considerable number of *waka* poems throughout her life. Her introduction to literature was in fact this centuries-old literary form, the origins of which go back as far as the seventh century. *Waka*, which always held an important position in the cultural life of the Japanese and survived even during the reign of the samurai, received a renewed attention in the early Meiji period. This was only natural, since *waka* was an integral part of the court aristocracy throughout history, and since the Meiji Restoration was to reestablish the Emperor's reign (albeit in a modern form) and his court. By then, however, *waka* had come to represent the "feminine" tradition, and education in it was considered important, particularly for women. Women, including Ichiyō, wrote *waka* in the classical language on themes prescribed by the aristocratic tradition. This situation was to change at the dawn of the twentieth century, when the Romantic Movement took hold in Japan, or, more specifically, in 1901, when Yosano Akiko published a collection of *waka* entitled *Midaregami* (*Tangled Hair*).

At the end of the 1890s, with the victory in the war against China in hand and with a new sense of satisfaction and enthusiasm, Japan was experiencing mounting nationalism. Acutely aware of the exposure of Japan and other Asian countries to the world powers, some intellectual leaders proclaimed that Japan's mission was to prevent the enslavement of Asia by the West. Okakura Tenshin, an art historian who wrote the famous *Cha no hon* (*The Book of Tea*), for example, expressed his position in a well-known statement: "Asia is one."[1] Tokutomi Sohō, a journalist-philosopher, thought that a "resurrection," not a "transformation," was what Japan needed, and he proclaimed his ideas in

his slogan: "New Japan by the Meiji Youth." Both positions conveyed a sentiment of wanting to seek spiritual independence from the West. Succeeding the men who had carried out the Restoration, the new generation of the Meiji promoted their version of revolution.

The Russo-Japanese War of 1904 was inevitable in the mind of the Japanese, who were resolved not to succumb to the world power.[2] But the cost of fighting two wars in a little over ten years (the Sino-Japanese War had just ended with a victory but without actual gains to speak of) was not small, and now there were new problems that had to be addressed. Knowing the precarious situation their country had entered vis-à-vis the world powers, the intellectuals felt that recognizing the authority of the nation-state was important; individualism, a philosophy just introduced from the West, was also attractive to them. Caught between the two forces, they would rather have dissociated themselves from public issues, but at the same time their awareness of various social problems urged them to keep their eyes open; self-consciousness was an inevitable consequence of this vexing intellectual climate. Charged with emotions, they embraced romanticism as well as utopian socialism. It was no doubt a stormy time.

The romanticism held by this new generation of intellectuals and artists was also rebellious, if only in mood. In response to their growing alienation from the modernized bureaucratic state, they also tended to focus narrowly on their personal liberation, placing an emphasis on internal freedom and aesthetic experiences. Poet and Christian Kitamura Tōkoku, for instance, published complex philosophical verses promoting the idea that *ren'ai,* or heterosexual love, was "the key to life."[3] Having been involved with the Popular Rights Movement in his earlier days, he now tried to affirm his sense of individuality by setting himself free from his family and from the moral rigor of Confucianism. Changes were observed among other Christians as well: dissatisfied with the church leaders who had compromised under the pressures of the sweeping nationalistic sentiments, some of them renounced their faith and tried to direct their enthusiasm elsewhere.

Emphasizing the originality of Japanese culture meant pausing and looking back. Since the cultural and spiritual revolution of this period of the fourth Meiji decade thus incorporated the flavor of the past, it was poetry, not fiction, that dominated the literary scene. In other words, the Romantic Movement in Japan, as elsewhere, was activated by poets. Traditional *waka,* with its short form (five lines and thirty-one syllables), however, was clearly inadequate to express the complexities of modern life. Furthermore, its notions of beauty and related sentiments, rigidly contained in such subjects as the flower, the bird, the wind, and the moon, were irrelevant in the new age. Though poetry was first introduced to the Japanese through the

translations of German (primarily by Mori Ōgai) and English works (by Ueda Bin), the new generation of poets and writers, like those gathered around *Bungakkai* (*The Literary World*), wrote *shintai-shi*, or "poetry in a new style." In 1897, for example, Shimazaki Tōson, published a highly successful collection of lyrical poems entitled *Wakana-shū* (*Seedlings*). It was the popularity of this new genre that gave an immediate impetus to the reform of the traditional *waka* poetry, and several poets, including women, would soon show that *waka*, now more commonly referred to as *tanka*, could be effective in expressing modern perceptions and ideas. It is important to note, however, that although *shintai-shi* was first introduced through translations of the work of English and European Romantic poets, the young writers and poets turned for their inspiration also to the Japanese masters of the past, such as Fujiwara Shunzei and Matsuo Bashō.

Among those writing *tanka* at this time was a group of poets gathered under the leadership of Yosano Tekkan. One of the earlier reformers of *waka*, Tekkan had published — besides collections of poetry — articles and pamphlets in which he voiced his objections to the elegant style of the traditional school and advocating masculine subjects such as patriotic devotion and pride. During 1895, while living in Korea and teaching Japanese literature, for example, he wrote:

> kara ni shite
> ikade ka shinan
> ware shinaba
> onoko no uta zo
> mata sutarenan

(Here in Korea, how can I possibly die? If I should die, the poetry of real men would again be abandoned.)[4]

Tekkan also wrote on such subjects as polishing his sword or listening to a tiger's roar. In spite of his resolution to be a poet with a unique vision, his earlier poems were often written in unoriginal diction and using orthodox imagery. In April 1900 he founded *Shinshi-sha*, the New Poetry Society, and started a magazine called *Myōjō* (*The Morning Star*); in the beginning it had only sixteen pages of tabloid size.

Shortly after starting *The Morning Star*, Tekkan's topics changed from those expressing ideological concerns to those of personal experiences with a touch of romanticism: rather than boasting of his heroic sentiments as a man with deep concerns for his country, he began conceiving of himself as a sensitive man who appreciated love and other subtleties of life. Within six months, *Myōjō* also changed its outlook, and now it included a painting of

a young nude woman kissing a lily against the background of starlit sky; its length was also increased to sixty-eight pages. Other poets of the school, who tended to be more open and direct than the members of *The Literary World* in their expression of intense feelings, including sexual love, placed the utmost importance on their individuality and a sense of liberation; they were against all traditions, restrictions, and conventions. Because of the urgency they felt, poets of the Myōjō School tended to ignore forms, and occasionally they even took liberties with grammatical rules. They sometimes did not hesitate to coin new words, the result of which was unorthodox poems with strange diction. Immaturity in poetic skill was often obvious as well. For those who welcomed the new tide, however, the intensity revealed between the lines was refreshing, even moving.

The changes in Tekkan's poetic approach were directly related to his meeting with two women poets, Hoh Akiko and Yamakawa Tomiko, and it was Akiko, soon to be Tekkan's wife, who became the central figure of the Myōjō group. While linking herself to the literary women of Japan's Middle Age through the medium of *waka*, she demonstrated that combining the classical form with new sentiments could produce superb results. As *Myōjō* became the center for *tanka* poets, Akiko came to be known as "the queen of the Myōjō School."

Akiko was among the boldest of the Myōjō School poets. When her collection of *tanka*, entitled *Midaregami* (*Tangled Hair*), was published in the summer of 1901, she became a famous literary figure almost overnight. This slim volume had a cover drawn by a famous young painter in the then-popular style of art deco; it had boldly drawn outline of a heart, the face of a young woman inside, and an arrow with three tiny flowers on the tip. In this volume, the originality of Akiko's poetic conception and the revelation of deeply sensual experiences made in dazzling verbal displays were exciting, sometimes shocking, to her contemporaries. Readers found a woman's experiences of liberation in both mind and body; it was a type of freedom that Meiji readers had never been exposed to before. The powerful messages embedded in her poems were thoroughly modern and conveyed an utterly new concept of life and love.

Along with Higuchi Ichiyō, Yosano Akiko (1878–1942) appears in most texts of modern Japanese literature that discuss Meiji literary women. Although she was only six years younger than Ichiyō, she lived a much longer life, and in her later years she became an important spokesperson for women — a feminist social critic, if you will. The world Akiko expressed in her *tanka*, therefore, is entirely different from that which Ichiyō depicted in her stories. The distance between Ichiyō and Akiko is the span between the "old Meiji" and the new era — new at least in the ethos shared by the intellectuals. Akiko

was a woman of action as well, and unlike Ichiyō and most literary women discussed in earlier chapters, she lived a very full life. She died at age sixty-four, having enjoyed a reputation as a successful literary woman for nearly three decades. Furthermore, she was among the first literary women in Meiji Japan who were able to support themselves and their families by writing. The contrast between Akiko's life and activities and those of the *keishū* writers, who were writing less than a decade earlier, is striking indeed; it makes one wonder what brought Akiko such a huge success while most of her literary predecessors received only limited recognition.

Akiko's father was Hoh Sōshichi, who owned an old, established store in Sakai, a port city of western Japan once known as a free-spirited, vigorous commercial center. Long before Sōshichi succeeded in the family business of making and selling cakes, however, Sakai had become a mid-sized city with a narrow-minded conservative population. His acceptance of the new age was superficial, demonstrated, for example, in the remodeling of his shop front with modern decor. His old-fashioned autocratic despotism, on the other hand, was exercised upon the women of his household in various ways: already with two daughters from a previous marriage, he was said to have been so disappointed by the birth of Akiko that she was sent to a foster family until a boy was born three years later. A precocious child, Akiko studied the Chinese classics between ages eight and ten, and when she entered the middle school she started reading Japanese classical literature. She was not allowed any type of education beyond the secondary school (even though her two brothers were sent to Tokyo to study), however, and instead she received training in sewing and other homemaking skills, as well as in running the store, which she did with her mother. Having experienced inequitable treatment from the very beginning of her life, Akiko learned a great deal at home about the meaning of being female.[5]

Akiko sought consolation and temporary distraction from reality in the world of books — of which there were many at home, thanks to her father's snobbish interest. She read fiction, poetry, history, and philosophical treatises indiscriminately, and, as she stated later, reading books was an effective defensive measure for her. Her father, meanwhile, was contemplating the idea of making her marry his head clerk. In his daughter, who spent most of her time at the store, supervising servants during the day and doing bookkeeping at night, he saw a capable manager of the family business he himself was not interested in. Sitting in a dark corner of the store, Akiko considered the depressing outlook for her future. Then, one of her good friends died, shortly after marrying a man whose frequent visits to brothels were known to everyone. Akiko concluded that marrying against one's will, as her friend had done, was masochistic and suicidal. She was also persuaded by Tolstoy, whose work

she read in translation around this time, that marriage was evil and sexual desire sinful. In a few years she would flee from this stifling environment, and her successful escape was the starting point of her life as a Romantic poet.

While still at home, Akiko kept herself informed of the new literary movements and trends. In magazines sent by her brother in Tokyo she found translations of the European Romantics as well as the work of writers of the new generation. Shimazaki Tōson's *shintai-shi* poetry in particular offered her an opportunity to feel the spirit of the new age. In 1899 she became a member of a local literary group and contributed *tanka* to its coterie magazine, *Yoshiashigusa* (*The Reed*). The *tanka* she wrote were mostly in the traditional style; they are quiet and benign, showing the influence of Tōson. It was her encounter with Tekkan's work, which took place shortly afterward, that altered her view of *tanka* poetry altogether.

Akiko was deeply impressed with Tekkan's *tanka;* using ordinary speech rather than the traditional poetic diction, they seemed to express emotions naturally and spontaneously. She joined the New Poetry Society immediately, and became an active contributor to *The Morning Star*. A few months later, at a local poets' gathering, she had a chance to meet Tekkan in person, and she quickly fell in love with him. Akiko was not reticent at this point, and after two more meetings with him she left home and went to Tekkan's home in Tokyo, where he had been living with his legal wife and a child until a few days earlier. It was as if the energy with which she had been creating her *tanka* gave her an unexpected strength; throughout her life she would sustain this high level of energy, which, one can safely say, was unparalleled among the Meiji women writers.

It was her desire to express herself as Tekkan did in his *tanka* that led Akiko to the discovery of a style through which she was to express her emotions with an unparalleled sense of freedom. And it was her relationship with Tekkan that determined the course of her life. As she stated in her later writings, meeting with him and leaving home to pursue her love changed her life entirely. How daring her pursuit was can be made clearer if one examines the life of Yamakawa Tomiko, another student. Having been introduced to Tekkan along with Akiko, Tomiko was equally committed to the Myōjō style of poetry; she was in love with Tekkan as well. Tomiko did not pursue her passion, however, and instead agreed to a marriage arranged by her father. Tomiko's husband and in-laws disapproved of her literary activities, and although her marriage lasted only two years due to the death of her husband, her own health also began to fail and in 1908 she died of tuberculosis. Tomiko's life was very much like that of a heroine of Meiji fiction, one whose powerlessness deprives her of happiness and a fulfilled life. On the other hand, Akiko, with her single-mindedness, led a very different life. Although she

was not particularly sturdy physically, she did not suffer from tuberculosis, an ailment that is said to be related to emotional repression,[6] and she enjoyed longevity that was rare among women writers of her generation.

As Akiko herself observed, falling in love with Tekkan had transformed her into a poet. It was indeed the experience of loving a man, and the joy that comes with it, that Akiko expressed openly in most of her early poems. The following examples demonstrate how the joy and exhilaration of a newly discovered sense of self springs from total devotion to the experience of love.

> yo no chō ni
> sasameki tsukishi
> hoshi no ima wo
> gekai no hito no
> bin no hotsure yo

(A star once whispered the full extent of her love in the curtains of night. Now, a creature of the world below, sleepless, my locks are twisted.)[7]

At the time, the popular response to this *tanka* was that it was difficult to understand. A critic claims that this type of response reflects the reader's discomfort with such a straightforward expression of sensuality[8]; it certainly shows the influence of the Western poetry of the Romantics.

> Sono ko hatachi
> kushi ni nagaruru
> kurokami no
> ogori no haru no
> utsukusiki ka na

(The girl is twenty; Oh, the beauty of black hair, flowing through her comb. In the pride of her springtime!)[9]

Here, the poet's assertion of pride in her youth and beauty is at the same time her rejection of the old-world requirement that women be passive and modest.

The tenth-century poet Kino Tsurayuki, like the English Romantic poet William Wordsworth, claimed that poetry was to capture and express a "spontaneous overflow of powerful feelings." Romance and poetry were inseparable in the minds and the daily practices of the authors and their heroines during the subsequent centuries.[10] By the Meiji period, particularly after two centuries of the Shōgun's military regime with strong Confucian indoctrination, the Japanese by and large became reluctant to openly confess love or any other strong personal feelings, deeming such expressions improper. Expressions of strong emotion were more acceptable for women,

however, particularly in the traditional form of *waka;* this was in part due to the historical association that was conjured up.

For Akiko, to see herself as a passionate lover with a poetic talent was to identify herself with the literary ladies of the Middle Age who helped shape the golden age of poetry; it gave her a framework in which to stimulate and nurture her creativity. It is possible that for Akiko, discovering her poetic voice as a lover, along with the medium of *tanka,* meant finding ways to reach the part of herself that had been submerged. Akiko's proud, sometime rebellious self-proclamation in love and other strong feelings, therefore, appeared less offensive. In part, this is why the reception of Akiko's *Tangled Hair* was thoroughly positive, while Tekkan, with his *tanka* written in a similar vein, was severely criticized, being called "a demon poet." This accusation is no doubt related to the circumstances under which he married Akiko (his former common-law wife, whose father initially financed the publication of *The Morning Star,* was said to be in his house until a few days before Akiko arrived).

Rejecting a connection with the female poets of the immediate past, Akiko sought a tie between herself and the literary women of the eleventh and twelfth centuries, when more than a few literary court ladies, such as Murasaki Shikibu, Sei Shōnagon, and Izumi Shikibu, had produced a great deal of *waka* poetry. Her intense reading and thorough familiarity with the writings of those literary figures helped her identify with them and the poetic world they created. Although this was most likely not a totally conscious attempt in the beginning, Akiko benefited from this strategy. Her friends and acquaintances witnessed how much she cherished traditional elegance and beauty and how she managed to find such qualities in her daily life. Akiko herself stated, upon returning from a trip abroad, how deeply her sensitivity was rooted in Japan's traditional aesthetics. Although the Yosanos were poor most of the time, Akiko never lost her appreciation and her sharp sense of beauty; hardships in daily life never discouraged her from identifying herself with that refined courtly tradition. Hers is a good example of how a literary tradition, however remote in time, and however limited it is in its scope, can play a crucial role in helping writers envisage themselves.

The style and tone of Akiko's poems changed as time went by, but her love for Tekkan does not seem to have abated. She tried hard to sustain her self-image as a creative woman blessed not only with a unique sensitivity and highly polished aesthetic perception, but also with a passion for love. What is remarkable about Akiko is not so much that she intuitively knew that her love toward Tekkan was her source of poetic inspiration, but rather the tenacity with which she maintained her initial passion.

The Myōjō School of poetry was popular until 1908, when *The Morning*

Star was discontinued after having published one hundred issues. Although the increased cost of printing was the more immediate reason for termination, the shrinking of the membership supporting the magazine, which was in part caused by personality conflicts between the members and Tekkan, also contributed. Although he started a poetry magazine of the same title in 1921, Tekkan's career as a poet and leader of the *tanka* reform ended in all practicality. A very different kind of *tanka*, and a shorter form of *haiku*, had been introduced by then, primarily by Masaoka Shiki, and the Myōjō style was out of fashion. Takkan's last publication was a collection of *tanka* entitled *Aigikoe* (*Love Poems*, 1910). Akiko had published five volumes of poetry by this time, including *Koigoromo* (*Garment of Love*, 1905), which collected works of three of Tekkan's female students — Akiko, Tomiko, and Masuda (later Kayano) Masako. It is in this collection that Akiko's enormously famous poem "Do Not Die, My Beloved Brother" appeared. A verse with lines consisting of seven and five syllables, it reads like a chain of *tanka* poems, and it is a gentle but powerful protest against Russo-Japanese War:

> Oh, my beloved brother, I cry for thee,
> Do not die, my beloved brother.
> Being the youngest, the love of thy parents was ever great,
> And, they did not teach you to kill,
> They did not bestow a sword in your hand.
> They did not raise you, a lad of twenty and four,
> To lose you, to have you killed
> After having killed others.

This antiwar poem caused some trouble for Akiko, who was accused of being unpatriotic. Although the public demand for her as a teacher of poetry, which was now clearly greater than that for Tekkan, grew, she was no longer a poet who proclaimed the joy of love with such unsurpassed passion. She was asked to serve as a judge, selecting and correcting *tanka* contributed by amateur poets to magazines and newspapers, and she gave lectures on classical literature. She extended her creative activities also into writing *shintai-shi*, which were not very successful. Later she wrote essays and social commentaries, and they were welcomed by newspaper and magazine editors. One might say that Akiko was able to develop a career as an essayist and social commentator because she did not die young, but then again, literary women of medieval Japan almost always wrote both prose and poetry. The center of literary activities would soon shift once again to fiction.

Meanwhile, the differences between Akiko and Tekkan became increasingly obvious, and soon Tekkan began to write poems in which he mocked

himself as a lazy, tired man lost in a world where a "fat woman" (most likely Akiko) prescribed the direction of his life. Sensing a crisis in her husband, Akiko financed his extended trip to Europe, during which time she hoped he would reestablish himself.[11] As soon as she had sent him off to France, however, Akiko began to miss him keenly. She followed him to Paris, only to discover, after her unpleasant journey on the Trans-Siberian rail, the pain of missing her children left in Japan. She returned to them alone after five months' absence.

Upon her return from France, Akiko wrote a novel that was serialized in the leading national newspaper, *Tokyo Asahi*. Entitled *Akarumi e* (*Toward the Light*), it describes the life of a couple, a thinly disguised Akiko and Tekkan; other characters were also modeled after easily identifiable individuals. Although it was called *shōsetsu*, a novel, it was a loosely joined description of some aspects of the life and thoughts of the protagonist, Kyōko (the fictionalized Akiko). Kyōko, a writer, is in great demand, and her husband, Tōru, is jealous, even spiteful, of his wife's success. Torn between Tōru's resentment and the demands of her work, Kyōko is extremely uncomfortable but does not know what to do. She is stoic, and only in her dreams does she complain to her sister that Tōru is a lazy, selfish man as well as a bully. After she sends Tōru to France, Kyōko writes a letter to a friend: "It is true that I let myself indulge in the honey-like world I'd created at the time when I fell in love.... I let myself believe that the world of love was eternal." In the letter she also states that she "no longer feels alive." Suggesting Akiko's internal crisis, the novel ends with Kyōko's resolution to somehow get herself out of "the dark hole" and feel free again.

Through this confessional writing, published in a widely circulated daily newspaper, Akiko seemed to have made clear, to herself as well as to Tekkan, that she had no alternative but to cultivate her life without his, or anyone's, help. The fictional form allowed her the type of self-expression that could not be accomplished in *tanka* form; it also enabled her to be objective about herself in dealing with issues confronting her. Writers of the Naturalist School (discussed in the following chapter) were making similar attempts around the same time. Commercially unsuccessful and with little literary merit, *Toward the Light* received scant critical attention. Akiko did not write fiction after this.

In 1911 Akiko wrote a *shintai-shi* poem, this time at the request of Hiratsuka Raichō and for the first issue of a women's magazine, *Seitō* (*Blue Stockings*). The poem, entitled *Sozorogoto* ("The Rumbling Talk") and beginning, "The day of mountain moving has come," is as powerful as her *tanka* in *Tangled Hair*, carrying a clear message for women that it was possible to make changes in their lives. "All the sleeping women are now awake and moving,"

it proclaimed: women, like "the mountains, once active, danced with fire." In this poem, which concludes with the narrator's emphatic promise to herself that she will only write in the voice of "the first person," Akiko congratulated Japan's first literary magazine published by a small group of women for all women interested in changing their lives. It moved some young women to join the group to voice their protests against the old morality that had oppressed them and other women.

Akiko, who had earlier expressed her strong sense of self in her *tanka*, now realized that more complex ideas could be represented in a longer and freer form of *shintai-shi*. The novel would have been even more appropriate for achieving this goal. With the emergence of the Naturalist School of writers, the central activity of the literary world was once again shifting from poetry to fiction, but as mentioned above, Akiko did not succeed in becoming a novelist. She instead energetically wrote essays, reviews, and other miscellaneous pieces, and this was mainly to earn an income to support her ever enlarging family. She did all of her writing and other work to raise money while rearing four children. Still considering Tekkan to be her mentor (although in reality he was not), she also did many chores to relieve him of any unworthy activities. So much of her time was spent in attending to the daily needs of her family that a few days spent in the hospital after delivering a child, she wrote, were the only free time she could truly enjoy.

Writing numerous articles in newspapers and magazines on a wide range of topics — particularly those related to women — Akiko became a social commentator. Her first collection of essays, entitled *Ichigū kara* (*From a Certain Corner*), was published in 1911; in 1918 she became involved in a debate with two younger women — Hiratsuka Raichō, who was considered the leader of the "New Women," and Yamakawa Kikue, a Marxist scholar[12] — on the issues of women's emancipation and motherhood. The debate began with Akiko's article *Wakai tomo e* ("To My Young Friends," from *Fujin Koron* (*Women's Forum*, October 1916), in which she stated that women should gain their freedom and rights through financial independence, and that women, like men, ought to engage in self-fulfilling work. All women had both the right and the obligation to develop their innate abilities, she insisted, and motherhood did not give women an excuse to avoid or ignore their responsibilities toward themselves and as productive members of society. In her rebuttal, Raichō stated that it was society's responsibility to give women financial assurance so that they could bear and rear children without worry. Yamakawa Kikue, on the other hand, argued that neither Akiko nor Raichō understood the issue correctly and that a classless society was the only answer for women torn between independence and motherhood. The subject of women had become one of the central interests of journalism in the early 1910s, when, as discussed

in Chapter 5, some significant changes began to take place in the lives of women.

In this debate, Akiko insisted that equal pay for all types of work would resolve women's dilemma of negotiating both motherhood and work. Her position, which appeared naive to other feminists and socialist ideologues, was no doubt supported by her self-confidence coming from the fact that she herself was a mother and a breadwinner. She was among a few in her day who made the connection between women's perception of themselves and their productivity or economic independence. Akiko also had a perspective few other Meiji women had: having seen, on a London street, a group of women factory workers, she had felt the tide of a new era; in one of her travel essays she also wrote sympathetically about the suffragettes and stated that it was only natural for women to demand the rights enjoyed by men of the same class.[13]

Women's individuality and self-sufficiency were very important matters for Akiko. In the many essays she wrote between 1908 and a few years before her death in 1942, she tirelessly dealt with these issues. "Living in an imagined world had ceased to satisfy me," she wrote, reflecting her early days at her father's house, "and soon I found myself fiercely longing to be free.... Out of desperation I gained enough courage to seek and pursue my love, and then, I was able to set myself free from the prison of [my] home where my individuality had been locked in."[14] Because women of pre–Tokugawa Japan took their share of property with them when they married, they were free from a "slave-like" existence; women's subservience to men arose from their lack of financial resources, she concluded. It was from this perspective that Akiko maintained that it was necessary for a woman to work unless she had property of her own. This conclusion is all too obvious to us today, but it was not so clear to women in Meiji Japan. In other articles Akiko discussed girls' education, pointing out that the curriculum of public schools for girls did not foster the ability to think rationally; it was the same point raised earlier by women involved in the Popular Rights Movement. In her sharp remarks that various negative attributes commonly seen in Japanese women — the tendencies to imitate rather than create, to cling to formality, and to be sentimental and superstitious[15] — can all be attributed to the education given to girls, she echoes the voices of Shimizu Toyoko and Kishida Toshiko.

Many of her essays express discontentment with patriarchal domination and the hypocrisy and selfishness that accompanied it. The reason for men's insistence on the importance of homemaking to women, she stated in one of her essays, was that they felt that women were unfit for any of the more worthwhile activities in society and because they wanted to keep women at an inferior level. This is clear, she pointed out, because none of those who

preached the value of the home participated in the work of homemaking."[16] She also stated, in another essay, that during the excruciating pain of childbirth, she felt "the betrayal of men": no matter how profound men's work was, she concluded, it was incomparable to women's job of bearing and delivering children.[17] And yet, she went on, women were trained to fawn upon men, to please them. In an attempt to explain the scarcity of creative women, she observed that women's work tended to lack "the essence of truth," and concluded that this was because women tended to comply with men's perception of what was appropriate for them.

Against the prevailing male dominance and patriarchal principles that were operating in the Japanese society of her time, Akiko argued for the freedom of individual women. She did not systematically discuss these issues; her writings are more like informal talks. Her arguments, however, are similar to those of Simone de Beauvoir and other feminist thinkers in defining women as "the second sex," molded to fit society's perception and prescription. Most of the issues discussed by Akiko continue to be advanced without an accompanying solution to the problem. There is no wonder that "a mountain moving day," a line from her "The Rumbling Talk," was adopted as a dictum for the international feminist movement today.

Despite the many additional and better *tanka* she wrote afterward, Yosano Akiko is now best remembered for her first slim volume, *Tangled Hair*. Her successful launching clearly lay in the image of herself as a passionate poet and lover. It was this image, boldly presented to the Meiji readers, that finally replaced the old notion of submissiveness, passivity, and resignation. The introduction of romanticism, which had taken place in Japan shortly before Akiko emerged, was a major factor in helping her establish this new view of women. Although many of her ideas were quite radical from the perspective of the Meiji era, they began to be acceptable during the late 1910s and early 1920s, when a more liberal intellectual and social trend was sweeping over Japan, making such issues as women's rights a part of important public debates.

Akiko did not think of herself as a champion of women from the beginning. Only through her daily living did she slowly develop her ideas and opinions. Her willingness to do whatever she could to earn money came out of necessity in the beginning, but it was also based on her realization that working and being productive were essential to freedom of spirit. At the same time, she learned that the mundane matter of money was crucial for an emotional life. More than thirty years of life with Tekkan also brought Akiko to the realization that with financial needs came many, sometimes bitter, disappointments. The dreaming romanticist in Akiko had turned critic.

In 1921, Akiko and her husband were invited to join a group of people who were founding a private school, to manage it and teach there. The school espoused a view of education based on an unorthodox, liberal philosophy, and Akiko, fully supporting this school, gave it a great deal of her time for a very small financial return. Earlier, in 1915, she helped her husband run for a seat in the House of Representatives. In the eyes of the public, Akiko was an intellectual woman who had not lost her femininity, who was content to be a devoted wife and mother. (Why else, they reasoned, did she have so many children?) Memoirs written by her children, including one by her daughter-in-law, reveal a woman who was sometimes absentminded but all in all a strong, devoted mother. By all indications she seemed to have genuinely enjoyed her children, but in her more candid writings she indicated that it was her sense of responsibility that made her care for them.[18] Once a brilliant and rebellious young woman, Akiko in her later life appeared to be comfortably settled down, a woman accepting her role as the foundation of her family. In the minds of people of her day, she remained the wife of Yosano Tekkan and a woman who epitomized the good wife/wise mother.

Just as Akiko demonstrated in her real life, women writers discussed in the following chapter would try to set themselves free by expressing themselves in writing. Like Akiko, they would leave their parents' homes to make a living for themselves and to lead independent lives, to realize themselves as autonomous individuals. Presenting herself as a model, and with an exceptional insight and tenacity, Akiko had shown them how this could be done. Some of these women would go further: they argued and competed with men, and when love in the marriage they pursued failed, they even divorced their husbands.

By the time Akiko had established her reputation as a Myōjō School poet, the central literary activities had once again shifted to fiction and a type of writing referred to as *Shizenshugi*, advocated by the Naturalist School. At the core of this school's approach was a view of the self as autonomous, a notion that has been fostered by writers and poets of the Romantic School. These works, including those by women, would focus on individual liberation from various forms of constraint.

4

Women Writers of the Naturalist School
Mizuno Senko, Shiraki Shizu, Ojima Kikuko, and Tamura Toshiko

Fiction in the Meiji Thirties and Ōtsuka Kusuoko: A Transition

Literary historians often neglect to point out that there were women who can be called the writers of the Naturalist School. The focus in this chapter is to see how these women writers began writing under the influence of this school's professed approach to fiction writing, but first we need to look at the overall literary scene in the transitional period of the fourth decade of the Meiji, the very beginning of the twentieth century.

Fiction produced during the third decade of the Meiji era has received little systematic attention; this is partly because the works written in this era were overshadowed by a new kind of writing produced in the following decade by writers of the *Shizenshugi*, the Naturalist School. During this period the art of writing novels and short stories was still in an embryonic stage, and after Ozaki Kōyō died in 1902, writers of different backgrounds were experimenting with various approaches. Among them were Izumi Kyōka, Kōyō's disciple; Hirotsu Ryūryo, who had written political novels during the 1880s; Natsume Sōseki, a scholar of English literature who would become an influential novelist; and Kinoshita Shōkō, one of the earliest socialists.

Treating gruesome tragedies of people who lived at the lowest level of society, Hirotsu Ryūryo wrote stories in the vein of social realism, a type of fiction that is often referred to as *shinkoku shōsetsu*, or stories of wretched reality. *Kurotokage* ("Black Lizard"), for instance, is about an unattractive woman with dark pits in her face, who resorts to killing her lascivious and abusive

father-in-law. He and other writers of *shinkoku shōsetsu* wrote stories about distressing or unpleasant — sometime shockingly gruesome — aspects of life around which they developed dramatic plots, and these stories delivered a message of sympathy for society's victims, often women. Not many readers would enjoy reading these stories now.

Izumi Kyōka, the most successful among Ozaki Kōyō's disciples, found themes that had a wider appeal. One of his more popular novels, *Yushima mōde* (*Pilgrimage to Yushima*, 1899), for example, involves a love triangle, a situation that echoes stories written by women writers in the previous decade but with a different ending: a geisha, who had an abortion in order to protect her lover, is tried at the court and found guilty, and the hero decides to die with her (even though his mentor had someone else in mind as his wife and even though he considers abortion immoral). Pointing to a departure from earlier fiction, particularly those written by women with unremitting victimization of the heroine, Kyōka's story reveals the author's romantic view of love. A geisha (who, one might say, is the symbolic representation of all women as "bound," as someone who can be bought by men to serve their needs) is now the partner of a man's serious pursuit of love. This novel was enormously popular, and has since been made into a stage play many times. Kyōka himself is said to have fallen in love with a geisha and married her against the strong objection of Kōyō, who was also a father figure for him.

As in the case of the couple in *Pilgrimage to Yushima*, *ren'ai*, or romantic involvement outside the family's arrangements or interventions, provided men and women with an opportunity to express, among other things, a sense of autonomy from the autocratic head of the family, usually the father. *Ren'ai* was debated on paper by intellectuals, but those who practiced it in real life were few in those days. A Christian as well as a socialist, and one of a few Meiji men with a keen interest in women's emancipation, Kinoshita Shōkō wrote a novel, *Hi no hashira* (*Pillars of Fire*, 1904), in which he treated difficulties around *ren'ai*. While the main theme of the novel is a protest against war, it is also about love and marriage. The heroine, an intelligent young woman, confronts numerous psychological dilemmas. This large-scale fiction examines the issues of love and marriage in depth, and primarily from a woman's point of view, for the first time in the history of modern Japan.

The hero of *Pillars of Fire*, Shinoda, is a political activist and the leader of a group opposing the government and corrupt industrialists. Umeko is in love with him, but her father owns a business that has strong ties with high-ranking government officials. Hence a marriage between the two is problematic, and furthermore, a powerful politician wishes to arrange a marriage between Umeko and a career military man he is patronizing. Umeko refuses to accept such an arrangement. Her refusal to marry the man chosen by her

father, like her love for Shinoda, represents an exercise of autonomy on her side, and this is inexcusable even in the mind of Umeko herself. The novel shows through Umeko's predicaments and inner reflections how difficult it is for a woman like her to choose her own marriage partner.

Ren'ai in Meiji society indeed implied a rebellion against the head of the household, and it presented an additional difficulty for women involved because the freedom the associated with it inevitably conjured an internal association with geisha, a woman who is excluded from patriarchal marriage practices while existing as the object of men's free (and primarily, carnal) love. Geisha heroines abound in the late Tokugawa and early Meiji fiction and stage plays, in which they often falls in love against social rules, and sometimes in spite of themselves. *Shinjū*, double suicide, is often the result. In her determination to marry Shinoda and her rejection of her father's judgment, Umeko finds herself in a double bind.

Although she is a descendant of the assertive heroine of the political novels of the 1880s, Umeko has a more complex inner life, having to resolve a dilemma between the desire for self-determination and internalized guilt attached to her act of insubordination. It is possible to say this novel explores, at least in part, psychological pressure in the form of self-censoring experienced by a young woman. From the perspective of the theme studied in this book, *Pillars of Fire* is a particularly significant work. Published during the Russo-Japanese War, it sold several thousand copies to the utter surprise of the publisher.

If we look for women who were writing fiction at this time, we find only a few. After the deaths of Ichiyō, Shizuko, and Inafune — all occurring in 1896 — Tanabe Kaho was writing, but during the latter half of the fourth decade (and the rest of her life) she produced little fiction; Shikin kept her silence after 1899. A woman who started writing only a few years after Ichiyō but became quite serious about writing fiction around 1905 is Ōtsuka Kusuoko.

The name of Ōtsuka Kusuoko (1875–1910) first appeared among those of a dozen *keishū* writers whose works were published in *Literary Club*'s *keishū* special at the end of 1895. Her piece, *Kureyuku aki* ("Deepening Autumn"), is a story about two young women who are in love with the same man. Writing on the popular love triangle theme involving one man and two women, Kusuoko at this point was under the influence of the Kenyūsha group of writers who had exploited this fictional pattern. Her story focuses, however, on the beauty of a friendship between the two women and the pathos in the resignation of the one who loses. In 1897, for the second *keishū* special, Kusuoko wrote another love triangle story, *Shinobine* ("A Faint Tune"), this time about a blind masseuse who gives up her love for a married artisan.

Then, in 1908, after having written quite a few more short stories in a similar vein, Kusuoko wrote *Soradaki* (*Fragrance in the Sky*). It is a much longer piece, and its theme, style, and characterization of the heroine are significantly different from stories she had written earlier. The influence of Natsume Sōseki is apparent in this novel, which was serialized in *Tokyo Asahi*, a newspaper whose literary section was then headed by Sōseki.

Fragrance in the Sky, Kusuoko's first and only novel, is about a scheming young woman who actively pursues what she wants rather than becoming resigned and submitting to her fate. The heroine, Hinae, is an attractive, well-educated, and independent-minded young woman who marries a wealthy man twice her age. A type of femme fatale, she knows she has married for money and social status. She finds in her stepson, Kiichi, the image of her first love, a man who died some years earlier, and soon she tries to seduce him and is promptly rejected. Hinae then takes revenge on this young man by revealing to his innocent fiancée, Senko, the secret behind the death of Kiichi's mother — that her suicide was caused by Senko's father, a licentious and unscrupulous politician. Then, while her husband is ill, Hinae herself becomes involved with this corrupt politician. Hinae's husband dies, having arranged a divorce with a very small monetary settlement for his unfaithful wife. It is said that Sōseki encouraged Kusuoko to write this novel, and it is indeed strongly reminiscent of Natsume Sōseki's *Gubijinsō* (*A Red Poppy*), both stylistically and in characterization of the heroine.

In his 1907 novel *A Red Poppy*, Sōseki describes its heroine, Fujio, as a self-assured, if not egocentric, young woman who has her own opinions about various things, including the men with whom she associates. Sōseki revealed his interest in this type of woman is another novel, *Sanshirō* (*Sanshiro*, 1908), as well. The central female character, Minako, is again a woman who is not easily influenced by traditional views and social conventions, and the young hero finds a certain enigma in Minako's charm; her elusiveness is presented as a feminine characteristic. There is no question that Sōseki created these female characters based on his image of the "New Women"— Hiratsuka Akiko, in particular (see Chapter 5).

There are unmistakable resemblances between Fujio and Hinae. It is important to notice, however, that Sōseki final judgment on Fujio is negative. Fujio is clearly an unsympathetic character, and Minako is also described as a woman who does not seem to know what she wants. Ambivalent about his more assertive and mysteriously charming heroines like Fujio and Minako, Sōseki's sympathy clearly lies with the men who are mystified by them.

One cannot help but notice the differences, as well as the similarities, between *Fragrance in the Sky* and Sōseki's *A Red Poppy*, both of which were written about the same time. While Sōseki's primary motivation in creating

Fujio was to examine the destructive impact of selfish and proud individuals (and he chose a woman to do this), Kusuoko's aim was to tell the story of an assertive heroine who is punished in the end. Her disapproval of Hinae's assertiveness is much more severe than Sōseki's for Fujio. Hinae is different from Sōseki's women in other ways, too. In some ways, she is an extension of Mitsuko in "A White Rose," the unconventional heroine created by Tazawa Inafune. While the primary goal of Inafune's heroine is independence from her father and her suitor, however, Hinae is already free from patriarchal domination when the story begins. Hinae is assertive and undaunted, full of ambition and schemes. Far from being the typical Meiji heroine, she is a woman one would describe as self-possessed rather than self-sacrificing.

In further contemplating the differences between the two novels, one by a man and the other by a woman, one might ask why Kusuoko had Hinae reveal a family secret and commit adultery, acts that would destroy her in the end. The reason hinted at in the novel is her revenge on Kiichi for his flat rejection of her, but this is not convincing; nor are good explanations given for her other destructive behaviors. In contrast, Fujio's rejection of male domination is much more subtle, and so is her predicament; Sōseki neither punishes nor criticizes his "New Woman" character as severely as Kusuoko does Hinae. Hinae's behavior, which contradicts her personality, borders on being irrational; it makes the reader suspicious.

Why did Kusuoko need to punish her heroine so severely? Although the answer might be, at lease in part, the author's inability to delineate her character more subtly and convincingly, such an explanation does not seem sufficient. This surprising development halfway through the story seems to point out more than a technical problem. Perhaps, having created this independent-minded young woman who knows what she wants and acts accordingly, the author then needed to condemn her, and thus contrived some misconduct for her to perform. The unexpected plot development toward the end may have resulted from the author's inner censoring. In writing stories intended for publication in *Tokyo Asahi*, a widely circulated daily newspaper, Kusuoko made sure that she would not receive disapproval from her circle of friends. She knew that too candid a depiction of a woman's rebellion would evoke negative repercussions. She was no doubt aware of what had happened to Inafune, whose shockingly unconventional heroines invited strong negative reactions toward not only the work itself but its author as well.

A full-length novel with a complex plot, *Fragrance in the Sky* is a significant work in the history of Meiji women writers. It is an epoch-making work, if only for the representation of an intelligent young woman with a strong desire to shape her own life. However, despite all of her positive

assets — an independent spirit, passion, a good education, and ambition — Hinae impresses the reader as a woman who deviates from common virtues, someone overcome by desire and pride. Her self-confidence might have been used in better ways that would assure a more fulfilling life; failing this, she is in the end a despicable woman.

Kusuoko (called Kusuo by her family) received the best education a woman could expect in those days. In addition to an early and sound training in the traditional *tanka* poetry, she spent some time learning to paint. After her marriage at age nineteen, she took private lessons in piano and English; she also spent some time in Iwamoto's Meiji Jogakkō. The eldest child and heiress of a prominent judge, she married a promising young scholar of aesthetics who had been adopted into her family (the arrangement Inafune rejected in order to marry Yamada Bimyō). This meant that Kusuoko did not have to adjust to her in-laws' demands, giving her an advantage over most women of her time. This must have given her a considerable sense of freedom and self-confidence, a feeling that she was in charge of her own life. Kusuoko's cheerful sociability and openness toward the people around her, as witnessed by some of her acquaintances, were perhaps not unrelated to such an arrangement.

From what we know, Kusuoko cherished an active social life as the attractive wife of an elite scholar. According to Sasaki Nobutsuna, her *tanka* teacher, she was a perfect wife and mother, as well as kind and considerate employer to her domestic helpers. Having wide interests besides literature, she engaged in activities such as organizing a group of women with similar upper-middle-class backgrounds; she is also said to have had many admirersr.[1] She also valued her relationship with her scholar husband and his friends, including Natsume Sōseki. With opportunities to enjoy her freedom while married happily, a life denied to many contemporary literary women, she needed to consider the potential for disapproval from her family, friends, and general readership.

Kusuoko first published her *tanka* when she was seventeen years old, and like Higuchi Ichiyō did, she would write them all her life. She is said to have been good at writing prose as well. Her aspiration in writing fiction for publication developed slowly after her marriage, and in the process she used various established writers as her models — first Ichiyō, then writers of Kenyūsha, particularly Ozaki Kōyō, and finally Natsume Sōseki. It is said that, unlike Ichiyō, she wrote rather quickly and without expending a great deal of energy.

Her husband was understanding of Kusuoko's ambition in writing, but in the eyes of many men — including her husband's friends and colleagues — her inclination to lead a life as she saw fit sometime appeared immodest. As she became better known, they criticized her for being overly eager to attend

to her own needs, thus neglecting her husband's. To these people, Kusuoko's effort to cultivate an interest in writing appeared to be a weakness, though this opinion was based on the common perception of the time that a woman's interest in herself is selfish. Some even implied that she was attracted by fame, thus vain (women have this tendency to start with, they rationalized). Even though she had became quite serious about writing and gained some critical recognition by then, she remained inhibited. Sensitive about how society might judge her as a wife and mother, she might have internalized the subtle pressures exerted upon her. Considering how important a social life was to her, this is understandable.

Kusuoko's self-imposed restrictions on what a woman should write were powerful inhibitions from which she might have tried to free herself toward the end of her life. By that time, however, there were only a few more years left, for she, the mother of four children, died at age thirty-five. Her life as a writer, therefore, lasted only slightly longer than those of other pioneering literary women. It is possible to postulate that if she had lived longer, she would have gained more confidence; she might have become more selective in what she wrote and developed her skill in fiction writing as well. Since this did not happen, Kusuoko's status in the history of Meiji women writers remains that of one who wrote stories with subtle feminine sensitivity and lyrical overtones. She, however, published two books of short stories in her lifetime, a rare accomplishment for a woman at the time when the end of the Meiji period was approaching.

Kusuoko did not base her stories on her own experiences, but instead turned to the works of established writers, such as Sōseki and Kōyō, for a model and to help her structure her stories. This strategy had been used by a few earlier women writers, including Tanabe Kaho and Kitada Usurai. The literary establishment of the time more or less ignored *Fragrance in the Sky*, partly because by the time it was published, the notion that fiction ought to be firmly based on the author's real-life experiences had become popular. Under the sweeping influence of the Naturalist School, fiction once again had became the dominant form of literary activity. Now, however, the act of writing fiction came to be seen as a means of self-exploration, and the work became a direct expression of its author's inner life, filled with doubt, frustration, and anguish. According to writers of this school, *Fragrance in the Sky* was not firmly grounded in real life, thus a "mere fabrication."

Literary activities in general had expanded, however, and as the publishing industry became more diverse, several commercially viable literary magazines appeared, some aiming at a female audience. *Joshi Bundan* (*Women's Literary Circle*), started in 1905, was among the more successful ones, boasting at one point nearly twenty thousand subscribers and seventy regular contributors.

A few years earlier, *Jogakusekai* (*Women and Learning*), a magazine of general rather than literary interest, was published by Hakubunkan; four times a year it put out extra issues focusing on subscribers' contributions. *Women's Literary Circle* also had columns in which *tanka*, *shintai-shi*, essays, and short stories written by subscribers were published. While well-known authors such as Natsume Sōseki, Shimazaki Tōson, and Yosano Akiko wrote essays, aspiring young women approached this monthly publication as a place to try their talent. Under the editorship of poet Kawai Suimei, it later issued a "special on women's literature." For Mizuno Senko, discussed below, this magazine provided the start of a literary career.

This development in the publishing world shows that there was a sufficient new interest in writing among women, an increasing number of whom in fact ventured into publishing in other places. These women found the Naturalist School approach to fiction appealing. That writing could provide a means of self-realization had been shown a few years earlier by an enormously successful literary figure, Yosano Akiko, in whom the younger generation of women saw that the liberation of the self was linked to creative activity, and vice versa. Magazines with similar names but all aiming at readers slightly younger in age, such as *Shōjogaho* (*Young Women's Journal*), *Shōjokai* (*Young Women's Sphere*) and *Shōjosekai* (*Young Women's World*), were also published, encouraging aspiring young women with an interest in writing to express themselves. Although conservative in their basic stance, these magazines always had pages for literary work. Some women, like Yoshiya Nobuko, wrote juvenile fiction in these magazines with great success.

The Naturalist School

Authors of the Kenyūsha School, under the leadership of Ozaki Kōyō, held a view that fiction was for entertainment above anything else, and that therefore the plot and an elaborate style were of primary importance. Influenced by the Romantic Movement and looking for ways to directly express themselves and resist the old morality and its constraints, the emerging younger writers found the Kenyūsha approach to writing unattractive. They looked to the West for a new literary theory, and in the work of the French Naturalist School they found a professed "scientific" approach with which they could scrutinize how various aspects of social reality and moral conventions affect individuals. They found an affinity in the school's focusing on the main characters' disillusionment, their sense of penitence, and, ultimately, their rejection of the philistine world surrounding them.

Behind the emergence of the writers of the Naturalist School in Japan

was an intensified suppression by the government of all political activities, which became more flagrant after the Russo-Japanese War. The gap between those who had profited from the industrial progress and those who did not widened,[2] and workers, suffering from low wages and atrocious working conditions, began organizing unions and expressing their dissatisfaction. Labor disputes became more common, and the government reacted to them sharply by increasing the police regulations and suppression, further encouraging social and political unrest. The Great Treason Trial, as a result of which twelve socialists, including one woman, Kanno Suga, were put to death for an alleged attempt to assassinate the Emperor, was the outcome of such development.

How the intellectuals felt about the Great Treason Trial and the mood of increasing political repression is shown by, among others, Nagai Kafū. A writer who started his career several years earlier under the influence of French Naturalist writers, he recorded his reaction of guilt over the powerlessness he felt at the news of the trial. The trial indeed symbolized for Japanese intellectuals the arrival of "the winter season." Soon, Kafū would adopt the stance of an outsider merely observing, one similar to that of Tokugawa *gesaku* writers. However, the political climate of the time was not solely responsible for this sense of alienation, which was shared by other writers of Kafū's generation. A widespread and serious split between the conservative segment of society and the more progressive dissenters, or that between reformers and radicals, was another contributing factor. Deciding that fundamental social change was inconceivable, these writers turned their concern to their inner selves and chose to explore their internal experiences rather than external reality.

A combination of the Romantic School's rebellion and the French Naturalist School's method of a close examination of the self and its immediate environs characterizes the writings of the Naturalist School in Japan. The writers of this school were most concerned with the representation of authentic experiences, and they quickly reached the conclusion that technique — how skillfully stories were told — was secondary. The protagonist in their stories is almost always the author himself, thinly disguised, one who lives on the periphery of society and maintains an attitude of seeking ultimate truth; he is conflicted with feelings of inferiority as well as pride. The protagonist's self-centered behaviors, abundant in the stories written by these Naturalist School writers, are explained as a compensation for the self-sacrificing devotion to art by the protagonist, who is often a writer. For example, *Futon* ("The Quilt"), a short story written in 1907 by Tayama Katai, who is considered as one of the precursors of the school, tells of the anguish of a middle-aged writer, a married man, over his infatuation with his young female protégée. The story's aim is to examine the protagonist's conflicts between his romantic longings, mixed with sexual desire, and his inhibiting ego.[3]

Although the Naturalist School dominated the literary scene in Japan only for several years, ending in the early 1910s, its ideas and methods had a profound influence on young writers, as well as on major established authors such as Natsume Sōseki and Mori Ōgai. By bringing the sincerity of a philosopher into fiction writing, the writers of this school offered a new view of fiction — one that helped promote fiction as a somewhat more respectable art form. At the same time, however, the school involved the creation of a small, insulated community of writers — a guild, as it were.[4] In this community of artists (in which special mores and lifestyles were promoted), fiction was produced primarily for the eyes of fellow writers. Women were not welcome.

As witnessed by women discussed below, writers of the Naturalist School tended to trivialize women's attempts at literary careers; they rationalized their distrust of women writers by saying that women, unlike men, did not have to earn a living, and since they had nothing to lose by choosing a literary career, they could not be serious. This negative appraisal of women writers was related to the complex superior/inferior psychology developed by the mainstream Naturalist School writers. In the highly secular society at the end of the Meiji era, when ambitious men generally chose practical occupations, writing as an occupation was unrewarding financially as well as in terms of social status, and thus choosing it as a way to earn a living meant considerable sacrifice for the writer and his family. Viewing writing as a serious endeavor open only to chosen individuals was perhaps a counterbalance for these negative aspects they and society in general attached to a career as a writer. And this position affected their view of women's attempt at writing. The Naturalist School writers, in other words, refused to believe that women were as serious as they themselves were in their pursuit of "high art." Already on the periphery of society, women who aspired to write were made to feel even more marginalized.

The rise of the Naturalist School caused a shift in the pattern of mentor-student relationships as well; established writers were by and large less sympathetic to their disciples now, and they gave very little of their time to actually guiding and encouraging students. This was a logical conclusion of the school's professed approach that learning the craft was not essential, and that writing was a deeply personal and lonely endeavor. Although some writers, such as Tayama Katai and Tokuda Shūsei, might not have openly discouraged young women who wanted to become their protégées, the denial of membership in their club was made clear to them. The experience of Ojima Kikuko, who considered Shūsei to be her mentor, was therefore very different from that of Kitada Usurai to her mentor. Kikuko continued taking her manuscripts to Shūsei, knowing that he hardly read them, and when she attended informal gatherings at his house she encountered not merely discouragement

but hostility from her fellow students, such as Masamune Hakuchō.[5] Indeed, it took a great deal of persistence for her and other women writing under the influence of the Naturalist School to make her male colleagues see her serious intent to write.

And yet the Naturalist School's approach to fiction writing, with its professed goal of writing about the author's self candidly and truthfully, was attractive to the aspiring young women who needed an outlet. In an age when women's social and legal rights were much more restricted than those of men, and when very limited opportunities for self-expression existed (except for teaching, very few professional jobs were open to women), the idea of self-expression through writing had indeed a great deal of appeal for them. Remembering her younger years, Mizuno Senko, a woman who wrote under the influence of Tayama Katai and started publishing her work around 1909, stated that her effort to find a purpose in life led her to write fiction. Any woman awakened to herself could not blindly accept the submissive role given to her, she wrote; it was her "sense of homelessness" experienced as she grew up that drew her to writing. A few other women took similar steps and began writing under the influence of the Naturalist School.

Although women who wrote under the Naturalist School banner received little encouragement for their endeavor, the growth in the publishing industry, as mentioned earlier, worked favorably for them. The number of magazines and newspapers was increasing, and publishers sought out new talents. Writing contests, basically a tactic to increase circulation, were also introduced around this time. As mentioned earlier, there were also literary magazines specifically geared for women. It was in one of these magazines, *Women's Literary Circle*, that Mizuno Senko started publishing her work, first as a regular contributor, then by invitation. For Ojima Kikuko and Tamura Toshiko, winning a prize in a newspaper's fiction contest was the first step in becoming established as a writer. The old way of obtaining the influence of an established writer, however, still existed as an option; as we will see, Shiraki Shizu chose this path.

Mizuno Senko

Mizuno Senko (née Hattori Sadako, 1888–1919) was among the first women who wrote in response to the literary theory advocated by the Naturalist School. Her early stories, written in a flat tone and concentrating on life's gloomy and unexciting aspects, portray the life of a family in a small provincial town. Revealed there are a young woman's yearnings for a larger life, one that was freer, more meaningful, and with fewer constrictions.

The youngest daughter of a merchant-class family in the northern prefecture of Fukushima, with a poet-scholar brother and a sister who was to become a doctor, Sadako was a bright and studious girl who loved her schoolwork. However, after six years at the primary school, which she attended without missing a day, she was sent to an occupational school to learn sewing. An avid reader, she read indiscriminately, including popular fiction of the time: "When I was fourteen or fifteen," she tells in her memoir, "I fell in love with fiction, and that was the beginning of me as I am now. Until I reached nineteen years of age, however, I believed I would be a wife of a merchant, who would succeed my father's business." To ease her boredom, she also subscribed to various literary magazines, and soon she started writing stories as well as corresponding with other subscribers in circumstances similar to hers.

The narrator-protagonist of *Shijūyonichi* ("Forty-Some Days," 1910), one of her more successful pieces, describes her own experience. Oyoshi, a thinly disguised author, states:

> Having tasted the excitement of writing stories and having them published in magazines, Oyoshi yearned to eventually become a writer.... She made friends, whom she had never met before, and they all enticed her to Tokyo. In her letters to them, however, she often added a few lines about her aging parents and the circumstance of her family. She also wrote about what she had asked herself many times — how far she had to go denying herself; warming her frozen hand over a small fire, she developed in her mind her naive argument.

In 1908, Senko began receiving invitations to write for a few literary journals, including *Bunshō Sekai* (*Writing World*), a magazine whose chief editor was Tayama Katai. It was Katai's rave review of her story *Torō* ("Vain Efforts") that made her resolve to go to Tokyo and study writing more seriously. Knowing that her parents would strongly object to such a venture, she carefully planned her departure, preparing for it by taking a few clothes at a time to her friend's house, thus avoiding her parents' suspicions. In the spring of 1909 she left for Tokyo. Senko described her venture in her short story *Musume* ("Girls"), published a year later.

Once in Tokyo, Senko had no place to go but to Katai's house. She stayed there for a while, helping with the household chores in exchange for room and board. Katai was sympathetic to Senko's aspiration, but at the same time he had a great deal of doubt about her endeavor. "It is rare to find such a talent as hers; it is not easy to write a story like *Kurai ie* ["A Dark House"] and *Torō*," he wrote, claiming that Senko was able to come up with such bold expressions because she was sincere. Women "whose mind is

clouded by vanity," he added, cannot do what she did. One should take notice that Katai also wrote the following: "It is hard to become a writer; we had gone through many, many painful experiences. This is true with all male writers but for women ... I wonder if it is possible for them, whose constitution is unfit to be a writer, to persevere."[6]

By this time Senko's name had become better known within literary circle, as shown in the fact that she was invited to write for *Chūō Kōron* (*The Central Forum*), then one of the most respected general magazines. The arrangement at Katai's house, however, left Senko very little time to write, and soon she moved out and took an editing job for a small magazine, sharing a rented room with a woman who shared her interest in writing. The amount of money a woman could earn by any kind of work in those days was very small, and although she was able to sell her stories more readily, making a living by writing seemed impossible.

Senko married an aspiring writer who worked as a journalist in order to support himself. Not much is known about the circumstances of this marriage except that it was not a conventional arranged marriage. It is said, however, that Katai was against this marriage because he thought it would not be "conducive to writing." It was not possible to simultaneously manage household duties and work to become a good writer, in his opinion.[7] Senko joined the Seitō Society the same year that she married.

Senko was able to spend more time writing for a short while, but soon her husband fell ill and she had to go back to work, this time editing for the daily paper *Yomiuri*, until she herself contracted tuberculosis. At *Yomiuri* she was in charge of *minoue sōdan*, a column in which readers wrote for advice regarding their personal, mostly domestic, problems. Although she was good at this and is said to have worked hard at her job, she did not last more than six months. Her own writing also seemed to suffer from problems in her marriage to another writer. A literary critic wrote that her husband's jealousy was a problem, since he was unable to sell his work as successfully as she did. Katai's worry that marriage would "dry up her creative energy," this critic concluded, was well founded.[8]

Senko spent her last three years in various sanitariums and hospitals. At the end of 1917 she was too sick to leave her bed, and yet she continued writing until she died in April of the following year. She was thirty-two. She published altogether about seventy short stories, but except for one volume—a collection of her stories published to commemorate the first anniversary of her death—they are in magazines and other publications, most of which are available only in the National Diet Library in Tokyo and thus not readily available to readers now.

Senko's work can be grouped into three general categories: early stories

that deal with the life of her family and her hometown; those that sketch her marriage; and later work based on her days at the sanitarium. Compared to those written by women in earlier years, her stories are refreshing in their subject matter; they are also more modern in style. For example, one of her early stories, "Forty-some Days," provides a glimpse of the life of a provincial family at a time when a daughter develops a serious illness after having delivered a stillborn child. This crisis is presented in the story through the eyes of the patient's younger sister, Oyoshi, who describes her family members as they go through forty-some days of anxiety over the patient's condition. Instead of describing the internal dramas of each person acting and reacting during this family crisis, the author views the various shades of her characters' emotions through the scrutinizing eyes of Oyoshi, whose function is close to that of a camera. This story's deliberately flat tone and lack of drama are characteristics of the Naturalist School of writing. In another story, *Musume* ("Girls," 1910), Senko depicts a group of girls at their sewing lesson. Here again the narrator observes the girls, who are on the verge of becoming women, in a manner devoid of sentimentality. This story, narrated in the colloquial style rather than in the elegant style, lacks the lyrical quality that is seen, for instance, in Higuchi Ichiyō's story treating similar material, "Growing Up."

Kagurazaka no han'eri ("The Kimono Neckpiece at Kagurazaka"), a 1913 short story depicting a young couple going shopping, represents Senko's work of the second period. It is about a small disappointment the wife feels in her husband. This story attempts an analysis of the subtle shifts in the woman's mind and in her moods. Although Senko's stories at this stage deal with minor, even trifling, incidents — "a slice of life," as the Naturalist School writers were fond of saying — they afford the reader a glimpse into the female protagonist's internal landscape. These stories are rendered more subtly, if not fully, than most stories written by women discussed in earlier chapters.

Senko also wrote stories that do not fit the characteristics of the Naturalist School, those in which the protagonist is not the author in disguise. A 1913 piece entitled *Onna* ("A Woman"), for example, is about a housewife who accuses a workman of stealing money. "Women are a mystery, I say; so difficult to understand. Whether this one is clever or daft, I really can't tell": so this story begins with the remark of an attorney made to his wife. He is telling a story he has heard from his colleague, a case in which a man refuses to confess to a theft he did not commit. Although the supposedly stolen money turns up later in the woman's living room underneath a tray, the accusing woman remains convinced (or so she says) that the theft occurred. Although it includes no interpretations of the woman's mind or descriptions

of her behavior, this story nonetheless shows an innovative touch in storytelling, and the central theme — the mystery that exists in our daily lives — is successfully conveyed. Nothing is certain, the author seems to say in this story.

Several stories Senko wrote during the year immediately before her death show a definite step toward more sharply focused themes; they also reveal a deeper understanding of the complexity of life. *Michi* ("A Road"), for instance, published in *Yomiuri Shimbun* in 1917, tells the story of a couple, who, while desperately in need of each other's affection, somehow find themselves in an inharmonious relationship. The wife, who is in a sanitarium, meets a sympathetic man, her husband's friend, but she decides to keep her distance from him. She concludes that two people can come together to a certain point, but from there on the road will inevitably divide, with each going his or her own way. Comparing the woman in this story to, say, Ichiyō's young wife in "The Thirteenth Night," one can see how much further the woman protagonist of Senko's story has come in dictating her life as a free agent.

Kagayakeru asa ("A Glorious Morning," 1918) records the mental landscape of a terminally ill patient. The first-person narrator-protagonist of this story, a patient in a sanitarium, overhears a staff orderly talking about a woman he saw that night; this woman had a small child with her and appeared to be on her way to the nearby railroad track to kill herself. The narrator spends a sleepless night, but when she finds out the next morning that the woman did not die, she feels she has discovered a miraculous new beauty in the familiar landscape outside the sanitarium window. Because of her experience, the protagonist finds a serenity and quiet happiness within herself. This story has a certain dramatic force that is created by the internal tension in the protagonist's mind; it also gives an uplifting feeling that comes from the protagonist's belief in humanity, a quality absent in typical Naturalist writing. It transcends the kind of literary realism characteristic of Senko's earlier fiction and shows that the author has successfully described a life beyond its mundane details. It was Senko's last work.

Senko lived longer (though not much longer) than many of her literary predecessors, but, following a familiar pattern, her life ended prematurely. As with most women writers discussed in this book, we know very little of her life and thoughts. She had more opportunities (though not many more) than her predecessors, however, and the degree of freedom she managed to secure through determination and careful planning was considerably greater. She was able to make an independent living without depending on her parents for financial support, and thus was free from inevitable interferences that come with it. She earned her own income and chose her husband on her own,

things Tazawa Inafune, for example, was not able to do successfully. And yet, to make a living by writing was nearly impossible for Senko; she found out that being a wife and leading a creative life did not go together easily. Her life in essence demonstrated the plight of women who struggled to have a life of their own at the time when the Meiji era was approaching its closure. Shiraki Shizu, another woman who wrote under the influence of the Naturalist School, also led a short life, though it was different in kind. Revealed in her case, too, are the aspirations and frustrations of a woman determined to lead a more fulfilling life.

Shiraki Shizu

Shiraki Shizu (1895–1918) led a short and difficult life, which she tried to live as fully as possible despite a real limitation. Born in Hokkaidō, the northernmost of Japan's four major islands, she contracted tuberculosis the year she finished the middle school. She went to Tokyo for treatment, and at the end of 1912, when she was seventeen, she had her leg amputated above the knee. Six years later, she died of tubercular infection of her lungs. During those six years in which Shizu wrote and published stories, she became recognized within the literary circle of the Naturalist School as a unique writer; she also married a painter, had a child, and managed a poor but happy household.

Losing a leg and becoming a writer were related, in the minds of Shizu and her family. Shizu's mother is said to have told Morita Sōhei, author of Naturalist novels, that she wanted to let Shizu devote herself to writing in the hope that it would distract her from the grim reality of her situation. People in those days thought that physical anomalies, whether congenital or due to an accident, were something one should be ashamed of; a woman of Shizu's condition, in other words, could not hope to lead a normal life. It was this perception that Shizu had to fight against as she learned to accept her illness and her physical handicap.

With the help of a friend, Shizu obtained an introduction to Sōhei, whose name was familiar to her because of the widely reported scandal he had been involved in — a double suicide attempt with Hiratsuka Raichō (see Chapter 5). He had written a novel based on this incident that was serialized in *Asahi*. Sōhei agreed to give Shizu instruction in fiction writing as well as some English lessons. "Shizu's writing was created from her mind, which, unduly affected by her illness, was trying to find a narrow outlet," wrote Sōhei shortly after her death. Because of her illness and physical handicap, she

was able to see "the truth of life," and her work "revealed a side of herself she would not have seen were it not for her misfortune," he also stated.[9] This appraisal is reasonable, perhaps accurate as well. Shizu herself said that she had made many discoveries that are denied to physically normal people. In an essay entitled *Watashi hitori no koto* ("Only About Myself"), Shizu described her thoughts about having lost her leg and its relationship to her desire to write: "I've since become moved quite easily by the slightest emotion that came to stir up in my mind...; people's psychology, which is not visible to the observers as it is hidden deep inside, and the mystery of soul as well as our destiny are what I wanted to put down on paper." For Shizu, writing fiction involved, first, carefully observing the reality she was in — insensitive stares as well as sympathetic eyes noticing her anomaly — and then studying the reactions of her inner self.

But a unique perspective alone would not make Shizu a writer. Although little is known about her life beyond the most basic facts, it is said that her father encouraged her to become "like Lady Murasaki," an eleventh-century author who represents for the Japanese all great literary women. As in the cases of other literary women, the seed of literary aspiration might have been placed in her during her childhood, and in later years this seed grew into a desire to write. Shizu shared with other women discussed in this book an intense desire to accomplish something significant; she had an unyielding spirit as well. By living a very short life she also shared the destiny of Meiji's pioneering literary women.

Shizu's fiction, about twenty pieces altogether, renders the condition of women in Meiji Japan symbolically: her protagonist is someone who lacks full membership in the society in which she lives, one who is expected to react but not to act. *Matsubazue o tsuku onna* ("A Woman with a Crutch," 1913), for example, describes the mind of an adolescent girl who discovers that her view of life is altered after her leg has been amputated. Having returned from her venture out into a public place one day shortly after the amputation, she reflects: "As she lay down, exhausted and sweaty,... she thought of the freesia in a vase that was placed at a storefront on the main street; she then saw in her mind's eye those people walking like machines.... The flower for sure would wither and die if it were thrown into the street, she thought." Trying to find a hope for her future, this girl dreams of becoming a writer.

"Being convinced that I live in order to write, I wrote a piece of sixty or so pages," Shizu says, reflecting on the state of her mind at the time she composed "A Woman with a Crutch." She decided not to be bothered by the "possible ridicule and objections" of the people around her. The process in which the girl accepts her own physical anomaly is represented in this story

without sentimentality, a rather remarkable accomplishment for a person barely twenty years old. When the protagonist exclaims, "Look at all those people walking so freely, unrestrained," the reader cannot help but sense the protest — as well as the sadness — of a sensitive person overwhelmed by the discovery of her limitations. With this work, published in a small but important literary magazine called *Shin Shōsetsu* (*New Fiction*), Shizu was ushered into the literary world.

The protagonist of *Utsukushiki roya* (*A Beautiful Prison*), again the thinly disguised author, sees the world as a prison; in the end, she finds peace and happiness in her marriage to a painter. Lacking the intensity with which the protagonist of the Naturalist School writers described the sense of isolation and alienation, this novel, which was serialized in the *Yomiuri Shimbun* in 1917, reveals its author's considerable naiveté.

A year earlier, Shizu's work was discussed in an article entitled "On Some New Writers" published in the magazine *Writing World*. After admiring her *Sanjūsan no shi* ("Death at Thirty-three") for its "subtle emotions unique to women" and "the pathos that prevails in the entire work," the male author of this article described it as "very feminine" and "something only women can write." Evident in this review is an attitude toward *keishū* writers that was quite familiar during the Meiji period but is still being observed: namely, measuring women's work with a different yardstick from that used to judge the work of male writers. The same author also revealed his view of women authors in general in the following comment about Shizu: "She should avoid a folly of developing empty arguments of logic to cover up certain naiveté, a lamentable characteristic often seen among women writers. There is a sphere set aside for women to explore; bringing something new into that sphere is a much more meaningful and safe thing for a woman to do. In this sense we must agree that Ichiyō was a genius, even though she did not know exactly what she was doing."[10] This biased attitude toward women writers did not belong only to this critic but was shared by others in the literary establishment as well, and even in the Taishō era of the early twentieth century.

Shizu's literary progress during the six years she wrote was slow and limited. With the sensitivity and yearnings of a person who knows her own limitations, however, she wrote stories that impressed the reader who was looking for a realistic representation of "the essence of life." We might add here that the facts in the author's personal life (which were readily available in the small, insulated literary circle of the time) subtly affected critical responses. In this sense, too, Shizu epitomized the Meiji women writers, whose work was evaluated, positively or negatively, according to their gender, and with a standard different from the norm.

Had she been born two decades earlier, Shizu would not have become a writer; she would not have thought of writing and publishing fiction. The new view of fiction developed by the Naturalist School encouraged women like Shizu to see the new horizon, and they wrote with the understanding that living sincerely and analyzing the pain and joy they actually experienced were integral parts of fiction writing. A recognition that women could make writing a career came to be shared in turn by the general public. This understanding (or misunderstanding) is eloquently shown in a marvelous short story, *Kata-ashi no mondai* ("A Story of a Missing Leg"), written by Nogami Yaeko in 1931. It tells of an uneducated middle-aged woman who comes to visit the narrator, an author, mistaking her for another author with one leg missing (Yaeko most likely had Shizu in mind). This woman asks for advice for her crippled niece, believing that her niece, whose future happiness cannot be found in more ordinary ways (such as marriage), should become a writer. As shown in this woman's thinking, the idea of becoming a writer, even making a living by writing, was becoming less extraordinary. "Times have changed. Who would have imagined five years ago that a tinplate shop owner in Honjo and his wife would come up with the idea of training their niece to become a writer, just as they might think of apprenticing their son to some trade or sending their daughter to become a hair stylist?"[11] says the narrator-protagonist of this story.

Changes were also evident in the fact that women writers were now rarely called *keishū sakka*. Instead, they were now referred to as *joryū sakka*, or female school writers. Women writers, however, still existed at the periphery of the literary establishment, and if their work was included in magazines, it was to add "color." It was not easy for a woman to be taken seriously, and even if one were to gain financial independence, as Ojima Kikuko did, or to achieve a high level of demand by publishers, as Tamura Toshiko did, she still would not be welcomed as a full-fledged member of the male-dominated literary circle.

Ojima Kikuko

Like the two women discussed above, Ojima Kikuko (1884–1956) wrote fiction under the influence of the Naturalist School. The pattern of her career, however, was somewhat different from those of Mizuno Senko and Shiraki Shizu, as was her personal life. Although her goal was to write "pure," or highbrow and serious fiction, she also wrote stories for juvenile magazines in order to earn income. And although Kikuko did not experience the spectacular success Tamura Toshiko enjoyed, she wrote steadily and managed to

sustain a relatively consistent career with her characteristic tenacity. She also lived a much longer life than most other literary women of her time.

Born in Toyama, a northern province facing the Sea of Japan, Kikuko grew up in a large family full of complicated problems, such as suspicious business intrigues, greed, and other human follies. Her father, who had earlier lost an inherited pharmacy enterprise through speculation, got involved in a dubious business deal that resulted in his imprisonment. He and eight of his ten children died before Kikuko finished middle school. Her grandmother, who favored and indulged Kikuko, was a fanatical Buddhist and was partially responsible for the family's financial decline. Kikuko's mother experienced constant friction with this domineering, dogmatic woman. It was this family background that provided Kikuko with material for many of her stories.

When she turned seventeen, Kikuko left home and went to Tokyo, as Mizuno Senko had. There she lived with her cousin, who was married to a well-known socialist scholar. Kikuko benefited greatly from her exposure to the intellectual life of this home, and, as she recounted, she learned to enjoy reading and talking about literature while she was with them. Their extreme poverty was a problem, however, and soon Kikuko stopped attending high school. A few years later, she invited her mother and her surviving siblings to Tokyo, and then she got herself into a marriage, which lasted very briefly. After her divorce, she worked as a clerk until she was fired because of a love letter someone wrote to her: being the only woman in the office, she was expected to take the blame for disturbing the morale of the workplace. Kikuko subsequently began writing juvenile fiction for girls' magazines. Based in part on her own experiences, these stories were sentimental tales with the heroine in various adverse circumstances.

With the help of a small income from her inheritance and from writing, Kikuko managed to make a living for herself and her mother and sister. It is conceivable that being the head of a household encouraged Kikuko, as it did Higuchi Ichiyō, to see writing as an income-producing activity. Without a husband, a father, or any other authority figure to dictate her life, she was able to develop and sustain her career in writing with a degree of freedom rarely seen in women writers of the previous era. At the same time, Kikuko was keenly aware of the financial responsibility she had, and as she often wrote, it was quite a burden. Her tenacious nature, however, helped her stick to writing, and her literary commitment was not deterred even after her marriage, in 1914, to a painter.

While she wrote juvenile fiction to earn income, Kikuko's ambition was to write more serious fiction. She started going to see Tokuda Shūsei, one of the most respected Naturalist School writers of the time, in the hopes that

he would read her manuscripts and give her some advice. Characteristically, Shūsei neither encouraged nor discouraged her in her aspiration. The male writers with whom Kikuko associated at Shūsei's house gave her mixed signals: on one hand, they admired her commitment to literature; on the other hand, they let their skepticism be known to her because they felt she, a woman, could not be as serious as they were. The doctrine of the Naturalist School, which viewed literature as a means of personal liberation and as a way of reaching the truth about oneself, did not impress Kikuko as much as it did Mizuno Senko, but by listening to young writers discussing literature at Shūsei's house, she slowly absorbed their new literary theories.

Like mainstream Naturalist writers, Kikuko concentrated on the weaker and less praiseworthy human traits in her fiction, finding material from what she knew intimately. In doing so she tried to delve into the depths of human nature. *Chichi no tsumi* ("Father's Crime," 1910), her first autobiographical piece, depicts men who influence the life of the central character, Yukie: a young medical student, who shatters her by breaking their engagement; her father, who is serving a prison sentence; and the husband of her cousin, an irresponsible family man who seems genuinely interested in her. These men are represented as either insensitive to and unsupportive of women, or outright selfish. Toward the end of the story, Yukie finds herself plagued with a deep sense of futility in human endeavors, and she obtains a job in an orphanage where she discovers happiness and reward.

"I must not let myself believe what men would say for I have a responsibility to make a living for myself, I said to myself; I have a work for which I've decided to devote myself," Kikuko wrote in an essay,[12] remembering the time when she became serious about writing and started going to Shūsei's house. "A woman with an ambition of becoming a respectable writer cannot let herself fall in love and indulge herself," she had also reminded herself. Reading these essays and autobiographical stories informs us about the kind of bind Kikuko was in; her mind fluctuated between her resolve to write and her wanting to love a man and be loved, a situation of which she was more aware than, say, Higuchi Ichiyō. "I was drawn to the thinking of Schopenhauer then, and ... the dismay I've felt has led me close to the shadow of death with which I often had to struggle." Kikuko's work has elements that resemble those of the work of Shūsei, and she might have been influenced by his rather pessimistic view of life.

For "Father's Crime," Kikuko won the first prize of the new writers' contest sponsored by the *Asahi Shimbun*, sharing it with Tamura Toshiko. This was her turning point, and for the next four years Kikuko became very productive: she published twenty or so stories, including a few longer pieces, in such magazines as *Joshi Bundan* and *Seitō*. The main character in these stories

is a woman who, though no longer young, is financially independent. Characteristically, she is on a trip or staying at a resort: she has left home looking for stimulation, romance, or something that she cannot quite identify at the outset. Being outside the familiar boundaries of daily life, she is made to feel self-conscious and vulnerable.

In *Yogisha* ("The Night Train," 1913), for instance, the central character is a woman traveling alone at night in a third-class railroad car. She finds herself being stared at by a couple of male passengers seated nearby, and their rude gestures imply that she is the object of their lust. Kikuko's female protagonists (as Kikuko herself) have already gained freedom from the oppressive control of their families, but this does not mean that they do not feel helpless. Caught in another type of bind, which is more subtle and often takes the form of psychological pressure, the story tells us, the woman still feels victimized. Although she has the courage to engage in independent actions, such as taking a trip alone, she does not find anything worthwhile. An independent life has its pitfalls, the story seems to say.

The vulnerability felt by the protagonist of "The Night Train" exists symbolically in all women in a patriarchal society, where they receive little understanding and encouragement as they try to assert themselves. Among a few women writers who ventured into a new terrain, Kikuko, however, did not explore the issue deeply enough; she could not identify the exact nature of the problems faced by more independent women. Although her vulnerability is experienced as a real emotion, the protagonist in Kikuko's stories has little access to the core of what she is feeling — resentment, frustration, and ambivalence. These emotions are going to be delineated more clearly in the writing of the younger, less-known women who had just begun writing and publishing their work, primarily in *Seitō*.

Kikuko published a collection of short stories in 1913. "Under the Flames of Red Candles," a fairly long autobiographical piece included in the volume, is about a trip a woman makes with her aged mother in order to attend her grandmother's memorial service. "My parents were well off, but they did not let me have any childlike joy and instead insisted on hard work," states the narrator-protagonist. As story progresses, the reader slowly finds out about the grandmother: when she was brought to the temple to be cared for toward the end of her life, Kikuko wrote, her body, half paralyzed, is said to have given "a distinct odor characteristic of old people." Various ghosts of Kikuko's past are captured in this story in a more precise manner, giving a tone slightly different from those that describe the experience of a single woman:

> Mother is chanting her mantra while pressing her lower hip against the tombstone ... in such a manner as if one is putting something in a shed.

Kiyoko's urn was placed inside the opening underneath the stone. My older brother is there, and so is my father and grandfather; my younger brother and sisters, too, are there. As Yayoi saw those urns of her family lying in one place right in front of her eyes, all together, she felt strong attachment to her own life, undeniably existing inside of her; it was as if she could touch it with her hand. In that moment, something shifted inside of her, and in place of that familiar mood of rebellion mixed with strange detachment she always has when she is traveling, another emotion rose. You're back home, it said, and for the first time in many years she was pressed with an irresistible feeling, as real as it could be.

In this and other stories where Kikuko recounts memories of her childhood and her family, she always paints a grim picture. These are, however, the finer pieces among Kikuko's work and have a quality that touches the reader.

Kikuko was among the few Meiji women who were able to enjoy a long and active career, and in her later work her unhappy childhood continued to provide her with material. In 1930, Kikuko wrote another story about her grandmother. *Kanashiki sobo* ("Inconsolable Grandmother") delineates the drama of decline in an old family as seen through the eyes of the young narrator. With its characters more fully developed now, the story conveys the author's mature view of life: human beings are essentially selfish and obstinate. At this point, with nearly twenty years of writing behind her, Kikuko reached a stage where she was capable of not only representing reality objectively but also creating a contemplative tone that penetrates its surface.

"I have spent more than twenty years now, being drawn to the spell of fiction writing," Kikuko wrote when she published her second collection of short stories in 1927; "I will most likely continue to let this overpowering magic guide me till death catches up with me."[13] She also states here that her stories are all "born naturally out of [her] perception and understanding of life." Although Ojima Kikuko is not even mentioned in standard textbooks of modern literary history, she is certainly an important writer of the Naturalist School, one who recognized and was irresistibly drawn by the act of writing fiction. Despite the many obstacles she had to overcome, including her mistrust of men and her doubts about her own talent, she did not give up writing. By going through hardships, Kikuko once said, she learned to endure; "so long as your soul sits tightly with you, you do not need to worry, I kept telling myself." Despite many doubts and distractions, she did not stray from her original aspiration.

In her later years, Kikuko came to be looked upon with respect by younger women writers. Women writers became more prominent as their numbers increased, and some would follow the pattern set by Kikuko, starting their career by writing for the steadily growing market for juvenile fiction.

Tamura Toshiko

Because of their exceptional literary achievement, as well as the subsequent fame they reached at the peak of their career, Tamura Toshiko (1884–1945) and Higuchi Ichiyō are often discussed side by side. Similarities between the two include the fact that both were born and raised in Tokyo, were familiar with its "lowtown" (a section where traditional culture and lifestyle remained) neighborhood, and led their late adolescent years without a father or other authority figures, thus relatively free from constraints though financially precarious. Their mothers, however, were quite unlike in their upbringings and moral orientation. Although Toshiko lived much longer than Ichiyō, she was productive for barely five years, not much longer than the period during which Ichiyō wrote. Lastly, neither had a mentor to speak of.

Despite the disheartening way in which her career ended, Toshiko is an important figure among modern Japanese women writers for various reasons. First of all, her great success in the commercial publishing world was unprecedented among women. Second, her fiction introduced themes previously untouched, and her female protagonists are represented with a wider range of experiences — from exploration of their own sexuality to an attempt to liberate themselves in quite a radical way. Their claim for sexual freedom in fact extends to experimenting with adulterous affairs and lesbian involvements.

Toshiko is often made to represent women writers of the Taishō era, with its new sense of freedom, just as Ichiyō is for the Meiji period. Unlike Ichiyō, Toshiko published five collections of short stories in her lifetime, and she was able to make an independent living. While a large number of biographical and critical studies were produced (and still more coming) on Ichiyō, however, the same is not the case for Toshiko. Except for various memoirs and essays, only two book were written about her life. Hard as it is to believe, becoming acquainted with her entire work is not easy as there has not been a *zenshū*, or "complete works," published to this day.

In contrast to the subdued yet steady literary career of her contemporary Ojima Kikuko, that of Toshiko was colorful and tempestuous. She treated her personal experiences in many of her stories, though not directly as Mizuno Senko and Shiraki Shizu had done. Although she was influenced by the Naturalist School, her stories go beyond representing personal experiences and inner reflections; the way in which they are shaped with a wider range makes her stories more satisfying artistically.

Very little is known about Toshiko's early life. She grew up in a section of Tokyo where the ethos of old Japan persisted in people's sentiments and

lifestyle, and was raised by her mother, a woman with little education but a keen interest in traditional music, one who gave Toshiko little maternal affection. After her father had left the family, Toshiko, her younger sister, and her mother somehow managed, perhaps with the financial help from her maternal grandparents. The image of her mother is given in Toshiko's story *Eiga* ("Glory"), which is about a woman (and mother) infatuated with a male actor of Kabuki. As experienced by the small child depicted in this story, financial insecurity and the absence of a family was something Toshiko knew well as a child. An avid and early reader of popular fiction, such as those by Ozaki Kōyō, Toshiko became interested in writing during her teens, when she wrote a few sentimental stories.

In 1902, the year she left Japan Women's College after having attended for about a year, Toshiko started an apprenticeship in fiction writing with Kōda Rohan. She is said to have made her choice of teacher based on the fact that Rohan maintained a detached relationship with his students. Indeed, Rohan gave Toshiko little actual guidance except the advice not to read contemporary fiction. Her first work, *Tsuyu wake goromo* ("A Garment Damp with Dew"), was published in *Literary Club* in 1903 with Rohan's recommendation. Reminiscent of Ichiyō's fiction, this story portrays a self-sacrificing young heroine who eventually dies of tuberculosis. Characters are convincingly portrayed in this story, but there is no hint of a departure from the fiction written a decade earlier; it is written in a quasi-classical style that resembles the work of Rohan and Ichiyō. Toshiko continued writing for a few more years, producing several stories in a similar vein, none of which received critical attention.

Soon, Toshiko, now twenty-three years old, became discouraged and decided that writing was not a good way for her to express herself or to gain social recognition. She had been interested in acting for some time, and that seemed more promising, more glamorous. She joined a small theatrical group that staged traditional plays. Quickly becoming disappointed with this experience, however, she soon returned to writing, but meanwhile she married Tamura Shōgyo, a fellow student of Rohan's. It was Shōgyo who urged Toshiko to enter a new writers' contest. His failure to sell his own manuscripts prompted him to do this; he thought Toshiko would have a better chance. She did win the first prize, sharing it with Ojima Kikuko, and the work was published on *Asahi*.

The title of this story, *Akirame* ("Resignation"), refers to the heroine's decision to give up her future as a scriptwriter and a more stimulating life in Tokyo so that she can take care of her aged parents. Although "Resignation" is written in a colloquial style, its basic theme — surrendering — is similar to that in "A Garment Damp with Dew."

The year 1911, when "Resignation" ushered Toshiko into the literary world, is important in the history of Japanese women's consciousness from the feminist point of view. As discussed in the following chapter, *Seitō*, was started in September of this year by a group of young women, announcing the arrival of "New Women"; Arishima Takeo's *Aru Onna* (see Chapter 5 also), an epoch-making novel by a male author with a very new and independent-minded heroine, was out earlier, and an actress, Matsui Sumako, received rave reviews for her role of Nora in Ibsen's *A Doll's House*.

While writing "Resignation," Toshiko still had an interest in acting, and again she became involved in the theater, this time with a small group called *Shin Shakai Gekidan* (The New Society Theater). Along with another better-known group, *Bungei Kyōkai* (The Literature and Art Association), this group was trying to introduce Western theater to the Japanese audience. Although acquiring scripts for the plays was not a problem, it was hard for these theater companies to find actresses. Acting until then had always been done exclusively by men, as it is still in the Kabuki theater; furthermore, public opinion held the profession of acting in low esteem (since actors had long been considered similar to the entertainers in the demimonde), and young women involved in it, even in a new type of theater, had to be prepared for severe criticism. Toshiko was willing to take this risk, and the New Society Theater welcomed her, a woman not only with some previous experience but also intelligent and well educated. She played the leading role in *Nami* (*The Wave*), a play about the conflict a concert pianist experiences between love and career. The theme of the play, especially its conclusion (the heroine chooses her career over harmonious family life), foretells the coming of the new age for career women. The play was successful, and a few reviews even compared Toshiko's acting to that of Matsui Sumako, then an immensely popular actress. The production was a failure financially, however, and the group disbanded soon after. Toshiko had lost her enthusiasm for acting even before that, primarily because of her disillusionment with the other actors and actresses; she had decided that acting was not a worthwhile commitment.

"Resignation," which Toshiko had written supposedly under pressure from her husband, and in which she seemed to have little confidence, opened the door to a literary career for her. Within a year it was clear that Toshiko was a successful writer. In May 1912 her work appeared in the two leading magazines, *Chūō Kōron* (*Central Forum*) and *Shinchō* (*New Tide*), and that year she also published ten more stories in various magazines, including *Saitō*, *Bunshō Sekai* (*Writing World*), and *Waseda Bungaku* (*Waseda Literature*). This success set a pattern in her personal life, particularly in her marriage to Shōgyo, as she became a successful career woman who supported both herself and her husband. The resulting sense of power was accompanied, however,

by strong ambivalence, resentment, and fear, all of which she would examine in her stories. For the next two years, during which Toshiko wrote twenty more short stories, she was in high demand by the editors of literary and general magazines. In response to this popularity, *Chūō Kōron* published special feature articles about her.

Like other women discussed in this chapter, Toshiko started writing under the influence of the Naturalist School, seeing fiction writing as a means of self-realization. While she pushed herself toward the direction of independence and self-realization, however, more traditional sentiments about women's position in society were clearly pulling in the other direction. One can see this divided perception in "Resignation" through three female characters: the protagonist, her older sister (who has surrendered to the morality of the selfless wife, paragon of the sacred hearth of home), and her younger sister (whose licentious nature makes her look and act like a woman in the gay quarter, who in fact seduces her sister's husband). Held between these two sisters, Tomie, the protagonist, is attracted to neither approach to life; she is unsure of where she really stands. Her involvement with another young woman, therefore, points out yet another possibility: a lesbian relationship. "Resignation" is in fact about many things related to a woman's independence and sexual freedom, with all the accompanying conflicts, frustration, and ambivalence. The theme of lesbian relationship, which will be central in *Haru no Ban* ("A Spring Evening"), for example, is presented obliquely in this story:

> In the afternoon when the sun started to warm the room, the nurse told Someko that she could go outside to walk in the garden. Since she was no longer feverish, Tomie strolled with her. While walking, Someko said she wanted to go somewhere with Tomie.
> "I want to get well and go with you, sister; wherever that is," she said.... "I don't want anything else so long as you are always with me; I want only you."

The protagonist of "Resignation" is a young woman who, albeit with strong ambivalence, considers self-realization through writing, and she is somehow led to an exploration of her own sexuality in the end.

As Toshiko continued to write, she would explore the theme of women's sexuality more directly and in depth; these stories depict women who yearn for sexual freedom, ranging from romantic flirtations to adultery. *Ma* ("A Demon," 1912) and *Hōroku no kei* ("Enveloped by Fire," 1914), for example, treat a young wife's infidelity and adultery. For the protagonist in both stories, an affair presents a way out of her troubled marriage, a way to fulfill her longings for a freer, more stimulating and meaningful life.

Iki-chi ("Raw Blood"), a story Toshiko published in *Seitō*, shows yet

another aspect of her writing. A story of a young woman who spends a day with a man after having slept with him, it focuses on sensuous experiences: "As she slowly walked under the scorching sun in the morning afterward, she thought her body might give off a smell of a rotting fish. Yūko wished someone would pick her body up and throw it away somewhere." Earlier, while still at the inn, Yūko feels a strong urge, akin to that of a sadomasochism; she puts a needle into a goldfish's eye:

> Can't stand it, really can't, she uttered silently, feeling she'd want to confront somebody with a knife in her hand; she had been in this state since the night before. She put her hand in the fishbowl abruptly and grabbed a goldfish as if it was what she hated.... As she pushed the needle into the eye, which looked like a black sesame seed, the goldfish hit her wrist with its tail; water smelling of raw fish meat splashed around her waist.... She pricked the tip of her index finger with the pin. A small drop of blood like a ruby appeared.

No other women writers had earlier attempted a literary analysis of a woman's sense of self and sexuality as consistently as Toshiko did in these and other stories. Her protagonists, however, tend to act on impulse, and while seeking sexual freedom, they cannot get rid of strong inhibitions and self-loathing. Therefore, though their words and behaviors hint at possible changes in their dead-end relationships with men, they are still tied to their old-fashioned, unliberated selves as well; they do not fully comprehend their strong feelings other than as being "inexplicable," and are thus unable to acknowledge them as an impetus for real changes.

Two of Toshiko's best-known stories, *Miira no kuchibeni* ("Painted Lips of a Mummy") and *Onna sakusha* ("A Woman Writer," translated in *To Live and to Write*), were published in 1913, her most productive year. "Painted Lips" is about a troubled marital relationship: the protagonist's husband has given up writing, but he wants his wife to succeed, mainly for financial gain. The woman is uncertain about her ability as a writer, but she knows she cannot be content being just a wife and gradually accepts writing as a career, realizing that it is in the end up to her to make sense out of her life. The story ends with her strange dream about two mummies, one male and one female, lying in a copulating position: the dark gray body of the female mummy has lips painted in crimson, indicating her sexuality. The dream represents the grotesque passivity that the woman discovers in herself.

"Painted Lips" as a whole portrays the precarious psychological state of a woman who is reluctant, even fearful, to go further in her attempt to understand herself. Looking hard into the inner spheres of her life, she finds nothing substantial: what is there instead is "something which can be only

described as a light, glittering somewhere in the sky and inviting [her] from a distance," and this light "does not shine directly upon her." The protagonist of "A Woman Writer," a writer in great demand, likewise finds only an inexplicable anger and frustration when she tries to see where her sense of self-contempt comes from. This frustration in her ends again with an explosion of a sadomasochistic impulse rather than leading to a serious contemplation and insight:

> "Hey, you, hey," she said in a low voice, and grabbed his collar to pull him backwards. "Take this off, get undressed," she said pulling his kimono as hard as she could. When the husband pushed her hand away, she thrust her hand into his mouth and tore at his lips. As she felt the wet warmth of the interior of his mouth with her finger tips, a flash ran through her head: the memory of the moment when her body and mind had been loosened under the fingers of this man. The next moment, she pulled her hand out of his mouth and pinched his cheeks as if trying to wrench them out of his face.[14]

Difficulties in writing are superimposed in the mind of this writer-protagonist upon the problem of identifying and defining that for which she yearns. She does not know what she wants, therefore she has nothing to write about. No doubt bolstered by the fact that she can earn a living for herself and support a husband, her self-confidence nonetheless is not strong enough to help her initiate constructive action. Women in these two stories realize in the end that they have very little they can claim as their own outside the torpid relationship with their husbands.

In her autobiographical stories, Toshiko lacks a sufficient distance from her material, thus making it difficult for her to maintain a good control over it. In contrast, stories that deal with the sexual awakening of a teenage girl achieve a degree of objectivity, making them finer pieces of fiction. *Kuko no mi no yūwaku* ("The Seduction of Chinese Berries"), one such story, tells about a teenage girl who goes to collect berries and is seduced by a man; her family treats her badly, humiliating her and calling her a "cripple." One morning, the girl discovers her own "red berries"—menstruation. Feeling alone, she soon becomes aware of "a real seduction of red berries that comes to her," and behind the red shade of the berries she sees a man's hand; "the sensation of his hand awakened her senses with unmistakable clarity." Describing with poetic subtlety the girl's sexual awakening and her desire mixed with fear, this story ends with the girl's affirming her own sexuality, as well as her decision to ignore adults' narrow-mindedness. No writer in modern Japan before Toshiko had written about an adolescent girl's dawning awareness of her own sexuality so directly and with such insight.

In another, longer piece, *Eiga* ("Glory," 1916: in *To Live and to Write*), Toshiko tells a story of a woman with self-destructive impulses, written in a pessimistic tone. The protagonist, the widow of a wealthy merchant, has enjoyed doing exactly what her late husband had done — patronizing an actor and freely spending money in the company of people from the "floating world" of the theater. Although this gender role reversal is significant in view of Toshiko's thematic concern — a woman's yearnings for self-realization — the situation is not fully developed; instead, the story concentrates on the decline of the protagonist. With the exhaustion of her financial resources, the time of her glory is about to vanish and her lover has no interest in a patroness without money. Humiliated and without a plan for surviving the next day, she, however, does not regret her rebellious indulgence. Even though her undisciplined passion causes her defeat in the end, there is something remarkable about this woman; unhindered by the morality of common sense (she pays little attention to her young child, for instance), she pursues her own desires. At the end of the story, we find her consoling herself by trying to buy a present for her fickle, absent lover. Representing a woman who enjoys men's privileges, this story hints at a new power and authority that women are yet to achieve; it also suggests the predicament of a self-assertive woman.

"Glory" foretells the coming of a time when Toshiko's creative resources dry up and the life of extravagance she has led comes to an end with a pathetic conclusion. Earlier, Hiratsuka Raichō, who by this time has become the champion of the "New Women," called heroines in Toshiko's fiction "anti-intellectuals," its author "merely skillful in her craft." Toshiko was "not a woman with individuality and a sincere desire for an authentic life," she stated; "she is, in essence, a product of the old culture."[15] Toshiko's heroines, it is true, give the impression that they do not fully grasp the meaning of their longings. However, they intuitively sense that a key to self-understanding lies in the exploration of their own sexuality. The implicit message conveyed in such an approach probably evaded Raichō.

In response to Raichō's criticism that her work was devoid of a message that fit the new age, Toshiko wrote a piece entitled *Kanojo no seikatsu* ("Her Life") in 1915. it is more like an exposition than a fiction on the topic of women and creative life. Her life is like a "sewer blocked with rubbish," says the narrator-protagonist of this story: she is without a habit of deep thinking; she has no passion and raises her children with an "instinct of a dog"; and, having no sense of herself, she lives like a "ghost." Wanting a different kind of life, to be free and independent, the protagonist manages to establish herself with an income of her own, and by studying literature she has enriched her intellectual life. Falling in love, however, has changed the whole situation.

Although her husband neither restricts her freedom to work nor objects to her personal growth, her love and sensitivity to his needs force her to spend a great deal of time doing chores around the house. She soon realizes that she is limiting her own emotional life in order to adjust to her husband. Wanting to be a good wife, she concludes, is the "beginning of a frightening compromise with oneself." The arguments presented here have a certain ring of truth even to the readers today, and statements such as "the wife's subjugation is not a matter of personal morality but merely the practice in the manners of marriage" or "the doctrine of love teaches women to conquer with selfless love" have an ironic tone, as they are relevant to us. The analysis furthermore goes on to the issue of gender and creativity: as she became resentful of the demands placed upon her at home, the woman protagonist says, her creativity died and her rebellious spirit found release in self-destructive behavior. This analysis seems to accurately describe what happened to Toshiko in her own life.

At the end of 1916, eleven months after she wrote "Glory," Toshiko wrote a short story entitled *Hebi* ("The Snake"). Depicting an actress whose fading career has reduced her to going onstage half-naked with a snake wrapped around her body, it renders the despair and the sense of helplessness experienced by a woman who feels doomed. Shortly before writing this story, Toshiko's creative energy began to decline, and just as the actress-protagonist of *Hebi* yearns for "an ideal man" to appear and rescue her from her miserable life, Toshiko was looking for a way out of her situation, which was similarly desperate. After eight years, her marriage to Shōgyo was at a dead end, and her habit of impulsive spending had brought her many debts. Earlier, Shōgyo had opened a small antiques shop to support himself, and Toshiko found herself making and selling paper dolls, for which she had a special talent. Partly out of desperation, but also with hope, Toshiko then got herself involved in an affair with Suzuki Etsu, a writer and journalist who was two years her junior. She might have hoped that a new passion would revive her creative energy.

Accompanying Etsu to Vancouver, British Columbia, was partly a means of hiding herself from creditors, but there Toshiko began an entirely new life. Her subsequent marriage to Etsu, which took place in 1920, was a harmonious one, and Toshiko wrote essays and *tanka* poems for *Tairiku Nippō* (*The Continental Daily News*), a Japanese newspaper published in Vancouver, for which Etsu worked as an editor. Under her new husband's influence Toshiko also studied socialism and labor problems, and when Etsu started his own weekly paper, called *Minshu* (*People*), she became an invaluable assistant in his work. Although quite poor, the couple led a constructive life, and in a small community of immigrants Toshiko demonstrated an

aspect of herself that had not been revealed before. Although she refused to write fiction again, she was a good teacher for aspiring young immigrants; she also helped the women organize various cultural activities and taught them about birth control. All in all, she was happy in Vancouver until Etsu, who had returned to Japan alone in 1932 (they had money to buy only one ticket), fell ill and died.

Before she finally returned to Japan alone in 1936, Toshiko lived in southern California for nearly two years, trying to secure a living there by writing for a local Japanese newspaper. Earlier she had also made a few short trips to Seattle, San Francisco, and New York, hoping to find a job as a journalist. Being unsuccessful in these ventures, she went back to Japan after nearly twenty years' absence. In an attempt to support herself, she tried to reestablish herself as a writer. Although she desperately needed to earn income, however, she could not write, and when she managed to produce a few stories based on her experiences in California, they did not find an audience among those who had enjoyed her stories a few decades earlier. Her carelessness with money persisted, and soon she found herself heavily in debt again. Still, her selfish yet childlike straightforwardness and candor attracted various people from different backgrounds, including young women such as Miyamoto Yuriko and Sata Ineko, who would later establish themselves as writers. The tide had shifted since Toshiko's heyday; the new idea of feminism, a part of socialist ideology, was developed, and along with it a new group of literary women was emerging. Guilt over her involvement in an affair with Ineko's husband,[16] combined with money problems, precipitated another self-exile in 1938, this time to China.

Toshiko went to China with a positive outlook and on a royalty advance which she got on the promise of writing a full-length novel. The novel was never written, but instead she became involved with a small magazine called *Josei* (*Women's Voice*), published for Chinese women with the sponsorship of the Japanese occupational government there. She was hopeful and worked hard, writing essays and drama reviews as well as performing other chores related to magazine publishing. A few people who had seen Toshiko in these days later wrote memoirs of her, a woman in her fifties who was still the center of a small circle of men sent on a cultural mission by the military. As the war escalated, however, circumstances in general worsened and a paper shortage forced the termination of *Women's Voice*. In the spring of 1945, Toshiko died in a Shanghai hospital a few days after suffering a heart attack.

Complaints about Toshiko's fiction raised by the younger generation of women represented by Raichō reflect the ethos of the new era, but their opinions — that Toshiko's fictional characters are frivolous and that they remind the reader of the world of Tokugawa fiction rather than the spirit of modern

age—are shortsighted. Unfortunately, Toshiko gave an impression to those who knew her that she was capricious and lacked moral principles by freely borrowing money from friends and publishers, even from mere acquaintances, in order to support her extravagant habits.[17] Even though they appear to be limited in their intellectual resources, female characters in Toshiko's more successful stories are more complex than they are said to be. Like the protagonists in many works of the mainstream Naturalist writers, these characters struggle against the residues of the old mores and traditional sentiments within themselves, and they experience a real dilemma between the desire for autonomy and the need for dependence. Some stories that deal with a woman's sexuality, it is true, fail to communicate the tension between the sensual and the intellectual, giving an impression that it is mere decadence that is rendered. In her more skillfully written fiction, however, Toshiko is successful in conveying the fleeting nature of sensual experiences, an accomplishment no other writer has matched. With the more recent acceptance that sensual experiences are an essential part of women's sexuality, her fiction has been reevaluated. Moreover, the fact that she was able to compete with male writers and fared well during her short career should in itself be recognized as a great achievement for a woman. Two decades after her death, the Tamura Toshiko Literary Prize for Women Writers was established by her friends, using the royalty money her stories continued to earn.

Although the years in which the Naturalist School dominated the literary scene in Japan were not many, it influenced quite a few who were writing at the very end of the Meiji and the beginning of the Taishō periods. Attracted to its method and implied messages, women discussed in this chapter wrote with an intent and zeal similar to that of the mainstream Naturalist writers. Studying several women who wrote fiction at this time helps us see more clearly the relationship between writing and the conscious exploration of ways in which to achieve self-realization. That the theory of the Naturalist School writing did promote literary careers among women, however, went largely unrecognized by literary historians, and women discussed in this chapter are usually not included in the discussion of the Naturalist School. Except for Tamura Toshiko, their names are almost always mentioned in terms of their relationships to their male mentors, as if they were mere appendages, a severe irony in view of their scant relationship to their mentors.

The literary history of modern Japan tends to be organized around various literary schools and circles; women, who were not accorded full membership there, were then excluded from historical consideration. In the end, Tamura Toshiko, who had no real mentor or membership in any group, finds no place in literary history. Women discussed here are excluded altogether

from the discussion of the Naturalist School because historians (mostly male) see them as a part of *joryū*, the female school, a category defined solely by gender. Because the historical continuum of women writers is rarely discussed, women are doubly dislodged in a historical context. The result is the impression that women like Toshiko have created their fiction in a vacuum.

Women remained at the periphery of the literary establishment, but the number of those who attempted writing was increasing. As the publishing industry continued to expand and to invite more women to publish, women authors became no longer such a rare species as they had been a decade and a half earlier; they were no longer labeled as *keishū sakka*. Although creative activities of the women of this period would soon be overshadowed by a new wave of feminism focusing on social awareness and action, it is clear that the Naturalist School prepared — via women writers studied in this chapter — the emergence of *Seitō*, a magazine for women started by a group of young women. In fact, the original idea of *Seitō* was to encourage literary activity among women; it, in other words, had the position very similar to that of the Naturalist School writers, namely, using fiction writing as a means of self-exploration and liberation. Here we see a continuity, more than generally recognized, between women writers discussed in this chapter and the younger women discussed in the following chapter. Although *Seitō* tends to be discussed primarily as a manifestation of the feminist consciousness and women's social awareness in modern Japan, it is equally important to see it from the standpoint of fiction writing by women.

5

Taishō Liberalism and Women

During several years at the very end of the Meiji period and the beginning of the following Taishō period (1912–1926), Japanese women, now not only as individuals but as a group, began voicing their needs and their own perspectives more openly, demanding changes in various aspects of the social system and family practices. The decade that followed this era, the latter half of the Taishō period (roughly the 1920s), is characterized by a liberal climate that is generally referred to as *Taishō demokurashi* ("Taishō Democracy"). Polemic writing, such as was done by Kishida Toshiko and Shimizu Toyoko three decades earlier, was back, and some women, particularly the members of the Seitō Society, demonstrated their interest in this mode of expression. Along with the women discussed in the previous two chapters (who continued to publish fiction and poetry), these younger women wrote, sending similar messages in essays and treatises. Under the influence of the feminist movement in the West, these women, soon referred to as "New Women," urged others to take a step away from the periphery of the society as they did, and some began taking action on various sociopolitical issues. The mass media industry, which continued to grow, made the existence of these women more conspicuous, and there were a few daring ones who took advantage of the mass media development.

Hiratsuka Raichō and the Seitō Society

Women will no longer live "like the moon, sickly and pale, and reflecting a brightness that belongs to others — men." This feminist manifesto, laid down by Hiratsuka Raichō in an essay entitled *Genshi, onna wa taiyo de atta* ("In Antiquity Women Were the Sun"), urged Japanese women to have a free and independent life, that is, to become their own masters by regaining the

quality of the sun: "Come and express the brightness of the sun, our talent that has been long buried — this outcry is now steadily among us, resisting any means of suppression; such an expression is our instinct, authenticated by our wholeness, by that which transcends all of our minor and partial desires," the manifesto stated.

Reminding the reader of Japan's mythological past, when the sun goddess Amaterasu had been central to procreation, Raichō's writing, with its powerful images, evoked excitement among the young women who read it in *Seitō* ("Blue Shoes," a translation of "Blue Stockings"), Japan's first magazine published by women alone. It was in September 1911, at the very end of the Meiji period; Raichō was twenty-five years old at this time, totally unknown to the literary establishment. Her essay nonetheless gave a stimulus for those who were hoping to accomplish real changes in their lives, those who wanted to discover their own future. Their claims would reverberate through the poetry, fiction, essays, and polemical writing on the pages of *Seitō* and elsewhere.

Hiratsuka Raichō (1886–1971), called Haruko by her family, was said to have been extremely quiet and unsociable as a child. While she was growing into young adulthood, many changes were taking place in her family and immediate social surroundings as the sociocultural emphasis shifted from worshipping the West to making a return to traditional values and sentiments. Haruko quietly observed all of these changes with her keen eyes. Her father, a successful bureaucrat-scholar who had studied accounting in Germany, had once encouraged his wife to dress up in stylish Western dresses and take English lessons, but now he was a conservative member of society and felt that women should not be educated beyond middle school. Only with the help of her mother, and on the condition that she study home economics, was Haruko able to get her father's permission to enter a women's college.

Japan Women's College, where Haruko enrolled, was a private institution founded in 1901 as Japan's first college for women. The founder, Naruse Jinzō, was a Christian who was inspired to devote his life to women's education after having spent a few years in the United States. Although he was eager to influence his students with humanistic ideas, the college officially professed its primary objective as fostering "womanly virtue" according to the "unique philosophy of the state."[1] By the time Haruko entered, the doctrine of good wife/wise mother had been firmly adopted as a working guideline of the institutions for young women's education. Haruko was not happy with what the college offered. During the few years she remained there, she spent most of her time in the library, reading philosophy and history. She supplemented her studies by attending various public lectures and classes

offered at such places as Seibi English Academy, where Yosano Akiko was on the faculty. She also spent long hours with a friend peeking into theaters and other places of popular entertainment frequented mainly by working-class people. She intended to choose a career instead of marriage. Aiming at acquiring a skill to earn an income, she took classes in shorthand. It was around this time that Haruko began reading Nietzsche.

The intellectual climate in Japan during the first decade of the twentieth century, the time when Haruko was searching for a direction of her life, was characterized by spiritual uncertainty.[2] While many young people were aware of a vacuum in their educational training, intellectuals, suffering from a sense of alienation from society, were asking for a new philosophy. Christianity did not supply the answer, as it had for many young people a decade earlier; instead, Buddhism, for the first time in modern Japanese history, responded to this need. It was in this intellectual atmosphere that the Nietzschean doctrine of the superman gained support. Haruko was affected by Nietzsche's writings, as well as those of Tsunashima Ryōsen, a contemporary philosopher and scholar of Buddhism. In her manifesto for *Seitō*, which is written in highly abstract language, one sees the influence of Nietzsche and other philosophers. Haruko was also drawn to the practice of Zen around this time.[3] It was through the highly metaphysical yet pragmatic approach of Zen Buddhism that she learned how to understand the relationship between the world and the self; she also seems to have learned to channel her energy effectively into well-focused action.

Haruko's vague desire to do something significant was soon to have a clear direction with the help of two men: Morita Sōhei, a young writer and one of Natsume Sōseki's disciples; and Ikuta Chōkō, the literary critic who introduced Nietzsche to Japanese readers. Sōhei met Haruko first at Seibi English Academy, where he taught; he was intrigued by her, an attractive woman mysteriously different from any other woman he had known. Soon the two entered an affair that evolved into what appeared to be a double suicide attempt. In Haruko's mind it was merely an adventure through which she tried to put her philosophical and psychological theories into action, but the newspapers made the incident into a scandal, calling it the result of young women's excessive freedom. Sōhei wrote a novel, *Baien* (*Soot*), based on this experience, but Haruko's parents sent her away to the country in order to protect her, and themselves, from the curious eyes of the people. Haruko spent nearly a year there alone, reading, writing, and thinking. When she returned to Tokyo, uninjured by either the notoriety or the exile, she was ready to pursue more worthwhile activities.

If Sōhei contributed to the launching of *Seitō* in an oblique way, Chōkō gave her the idea of publishing a magazine for women and encouraged her

with specific instructions.⁴ He is said to have told Haruko that a capable individual ought to perform some work for the sake of others. Haruko's mother supported her again, this time with the one hundred yen she had set aside for her daughter's marriage. The manifesto Haruko wrote for the first issue of the magazine, which she signed "Raichō" (the name of birds that live in the Japanese Alps), had as its central theme the idea that the quest for identity must occur not outside one's self, but inside. This thinking and her dedication to a life with a sense of independence and self-sufficiency immediately attracted some young women, for whom Raichō would become the guiding spirit. It is clear that the successful launching of *Seitō* was inseparable from the strength of her personality, and therein also lie the limitations we will discuss below.

When *Seitō* appeared in a few Tokyo bookstores, it was as one of the *dōjin zasshi*, coterie magazines published by a group of writers (both aspiring and the established) and generally supported by membership fees. Writing for these noncommercial publications was a practice known to aspiring writers, mainly of fiction but also of essays and criticism, as a way to be recognized by the literary establishment. They served an important role in the history of modern Japanese literature. Both *Bungakkai* (*The Literary World*), in which Higuchi Ichiyō's "Growing Up" first appeared, and *Yoshiashigusa* (*Reeds*), where Yosano Akiko started publishing her poems, were *dōjin zasshi*. Sometimes they became commercially successful so that publishing houses took over their management.

The publication of a *dōjin zasshi* was what Raichō and the four other original members of the society had in mind. Its primary goal was to promote women's literary endeavor: the "unknown talent" that was to be "discovered" (as Raichō put it in her essay "In Antiquity Women Were the Sun") was literary talent. In "The Rules" of the Seitō Society given in the first issue, in fact, this goal is clearly stated: "The Society is to promote women's literary activity as well as to help them develop their natural talent; it is hoped that some geniuses will emerge in later years." In other words, the original intention of the Seitō Society was not to advocate the social and political advancement of women, a cause with which it would later became associated. This point is not made sufficiently clear by social and literary historians.

The nature of *Seitō* in the beginning stage of its publication as a literary magazine is also clear when one looks at another rule of the society, which states that its membership is for "women writers and those who aspire to be one, as well as earnest readers of literature." That they took the name *Seitō*, which came from "Blue Stockings," a group of women who were a part of a semi-literary salon, also reflects the original interest of the founding

members. And, the inaugural issue had the following verse from Yosano Akiko's "A Rambling Talk":

> The mountain-moving day has come.
> I say this but they did not believe me.
> Though the mountains have been merely dormant,
> And, they in fact danced many years ago with fire, all of them.
> No matter if this fact has been forgotten.
> But you, my friends, must believe that
> All women who're in their slumber are awake now, ready to move.

The poem then stated that women ought to write in the "first person," implying women's need to gain confidence in expressing themselves more directly. In other words, Akiko, who understood the symbolic meaning of the event and its broader social significance, expresses her hope for women to "move" through writing. Pointing out the strength of women in the metaphor of a volcanic mountain, the poem's first line would later be taken up as the dictum of the international feminist movement.

Except for Raichō's manifesto, the work that appeared in the first few issues was mostly of the published authors of fiction and poetry, and except for "A Rambling Talk," they did not convey the same message of new life for women. Tamura Toshiko's story, entitled *Ikichi* ("Fresh Blood"), for example, treats, characteristically, the theme of a dead-end relationship between a man and a woman; the young woman experiences only frustration and dread. Ojima Kikuko writes about the loneliness of a single working woman approaching middle age. Thirty years old and still single, she cannot remain calm when she hears about the marriage of a close friend; she walks outside aimlessly, envying the friend and cursing her parents and her unsympathetic siblings. Kayano Masako's poem "A Woman's Song" compares the cheerful singing of a carefree man with a woman's "heavy, black burden" of responsibility: "You still sing, like a summer bird, joyously and heartlessly; you do not know my pains and tears, not even my cheek that has turned pale." Clearly there is a discrepancy between what is said in these stories and the general image of the Seitō women, particularly as the media came to associate them with the "New Women."

Raichō's idea that creative writing can be a way for a woman to free herself and acquire authenticity, however, was logical. First of all, in an age when opportunities for women to engage in public activities were greatly limited, creative writing was one of the few acceptable activities in which women's talents could be openly recognized. Her essay, in other words, can be read as

a rephrasing of the motto of the Naturalist School writers, whose theory was taking hold in the literary establishment of the time. She knew that writing was a way for women to become more aware of themselves.

The Taishō era, which began six months after the publication of *Seitō*, was characterized by a diminishing influence of the traditional authorities over the Japanese people and by more open attitudes toward the West. Industrial and commercial developments had removed many women from their homes by this time, making them socially more conspicuous than ever. An increasing number of people began embracing the ideology of individualism, which began to spread beyond the small segment of intellectuals; some used this concept as a tool to combat the old morality and subjugation to the patriarchy. In her essay, Raichō demonstrated that she was an heiress of this new trend. Not only because *Seitō* was published by women for women (although it had supporters among male writers and poets, "The Rule" stated that male membership was limited to those who "deserve our respect") but also because it would quickly shift its focus from creative writing to other areas of women's life, the magazine was a pivotal event in the history of feminist consciousness in Japan.

Having started with a thousand copies for its first issue, *Seitō* at its peak sold between two and three thousand copies per issue. As it became more widely known, subscription increased, and so did the supporting membership (from a dozen to over two hundred). Women of the Seitō Society now included schoolteachers, college students (besides Japan Women's College, there were by now a few private institutions for professional training), and wives of the upper and upper-middle classes. These women and their followers would soon find themselves being referred to as the "New Women." They were, in fact, a new type of woman. Better educated than their mothers, they considered the official educational doctrine of the good wife/wise mother unattractive. Some were working women. Although not all of them can be called feminists, these women either openly or secretly wished to be free from the yoke of the traditional morality and the family system.

The intellectuals of this time were aware of the situation on the other side of the ocean, both in terms of literary and other artistic activities and in terms of social accomplishments, including that of the suffragettes. *Seitō*'s interest in emulating Western thoughts and practices was evidenced visually on its front covers (the first issue printed a stylized drawing of a woman who looks more Western than Japanese); the magazine's content also revealed a keen awareness of intellectual and literary activities of their contemporaries, particularly women, in the West. Along with other literary and general magazines, *Seitō* published translations of Western authors such as Ibsen, Suderman, Poe, and Chekhov.

It is true that *Seitō* did not produce a single professional writer despite its original intention, a point that can be made more clear upon comparing it to *Shirakaba* (*White Birch*),[5] which began publication a year before *Seitō*. A *dōjin zasshi* like *Seitō*, *Shirakaba* served a very different function by actually assisting most of its members in developing successful literary careers; in contrast, *Seitō* quickly shifted its main interest from fiction and poetry to theater,[6] and eventually to social and economic issues. Although the more immediate cause of this shift was the reaction of the general public to the women of the Seitō Society, it was also because of the influence of current social and cultural movements in the Western countries. In the beginning of its third year, *Seitō* began actively introducing translations of the works of various feminist writers and activists, such as Olive Schreiner, Emma Goldman, and Ellen Kay.

Seitō and the "New Women"

In the fall of 1912, a year after the Seitō Society was founded, a few newspapers reported on the "New Women," pointing a finger at Seitō women among others and alleging that they idolized Nora (of Ibsen's *A Doll's House*) and Magda (of Suderman's *Die Heimat*). Although it continued to publish fiction by both established and unknown women writers, *Seitō*, in its second year of publication, introduced works by European authors, and indeed Ibsen's play was reviewed and debated there. Although the views of Seitō women were similar to that of the general audience, namely, that Nora was selfish and undeserving of sympathy, journalists decided at this time to call the members of the Seitō Society "worshipers of Ibsen's women" and the society itself "the hatchery of Japanese Noras."[7] The same newspaper reported on militant suffragettes overseas at about the same time, calling them "those jaded women." *Seitō*'s quick transformation from a literary magazine to a forum for the discussion of women's social and political issues was, in part, a reflection of the time and the result of this journalistic attention on the "New Women."

Having decided that the "New Women" were "poisoning" Japan's innocent girls and young women, journalists went on reporting on the wrongdoings of Seitō women. More fabrication than facts,[8] these "reports" were based on two minor incidents. In one, Ōtake Benikichi, an enthusiastic editorial staff writer still in her teens, went to a bar to obtain an advertisement and was treated to a new type of cocktail just then introduced to fashionable city people. In the other, a few Seitō women visited a teahouse at the invitation of Benikichi's prominent artist uncle (who reportedly urged them

to get firsthand knowledge of the women there — the geisha — who needed liberation more than any other women).

There is no denying that the young, unmarried women of the Seitō Society, with Raichō at the center, were evoking an atmosphere of freedom through their innocent but rebellious challenges of the norm. Benikichi, for instance, openly exhibited her unconventional taste by wearing a type of cloak usually worn by male university students, and Raichō published letters in which she acknowledged a personal interest in this young follower of hers, resulting in an accusation of lesbianism. The Seitō women, mostly from the upper-middle-class families, could spend a few free years before marriage and were enjoying themselves at this stage — studying, debating, and providing mutual stimuli — rather than making conscious attempts to unite behind a cause. Journalists, with their curiosity about and overall criticism of this new social phenomenon, however, helped create the public image of the Seitō women as "dangerous." Natsume Sōseki wrote a novel in which the central character resembles Hedda Gabler of Ibsen's play, a self-centered woman. The conservative segment of the society was afraid that the educated Japanese women were being modified into Noras and Heddas — in their view, selfish and bad women.

Then, the Home Ministry, having seen the Imperial Theater filled for successive performances of Suderman's *Die Heimat*, intervened. A newspaper article reported on "the round-up of the new women": "A recent increase in the number of women who call themselves 'New Women' precipitated the Ministry of Education to urge the Home Ministry to take an appropriate action. These women are said to be creating a rebellious mood as they write in magazines and newspapers indecent words of loose morals; the concern is that it is adversely affecting the nation's students, both male and female, in their thinking and behavior." The play, the Home Ministry argued, contradicted the spirit of the Educational Rescript and would interfere with the practices of filial piety and of loyalty to the male head of the house. Permission to continue performances was granted only after a new scene was added in which the heroine, Magda, repented of her selfish behavior and confessed that she was to blame for her father's death. (This change, of course, destroyed the unity of Magda's character and altered the meaning of the play.) Incidents related earlier by newspaper reporters as examples of shockingly unwomanly conduct now provided officials with a convenient focus in accusing *Seitō*, and a member of the Ministry reportedly called the Seitō women "a group of imps seized with lust."[9] The magazine suffered a loss in subscriptions, and Raichō had to endure personal attacks such as threatening letters and rock-throwing outside her house. Another contributing member, Kamichika Ichiko, lost her teaching job in a small rural community.

In the beginning of 1913, *Seitō* decided to respond to the journalists' charges by publishing feature articles and holding public lectures on the "New Women." Except for *tanka* poetry, creative work practically disappeared from the magazine; instead, it printed translations of feminist writings, such as Ellen Key's *Love and Marriage* (done by Raichō) and Emma Goldman's *Tragedy of Women's Liberation* (a partial translation by Itō Noe, to whom Raichō would soon transfer the responsibility of publication). Articles by women whose backgrounds were very different from those of the original members of the society also appeared. Fukuda (née Kageyama) Hideko wrote an article, for instance, insisting that only a classless society would solve women's problems, and Raichō herself wrote a piece attacking the laws and practices that treated women inequitably. These articles caused the official banning of the magazine on several occasions.

Stimulated by public debates around the controversial stage production of *A Doll's House*, as well as by *Seitō*'s articles, two leading magazines of general interest, *Chūō Kōron* (*The Central Forum*) and *Taiyō* (*The Sun*), published feature articles on the "New Women." Direct borrowing from pseudo-scientific theories being developed in the West was obvious in some of these articles, one of which is entitled "The New Women and Their Ovarian Cells."[10] Hatoyama Haruko, who had by this time modified her original position as a supporter of women's emancipation, now gave warning in her essay: the social conditions in Japan were different from those in the West, where women had the right to property and could stay single, she stated. What Japanese women should strive for, she wrote, was to become "pillars of society" through their contributions in the area of childbearing.[11]

Raichō, too, published articles in *The Central Forum*, defending the position of the "New Women." "I am a New Woman, and the New Woman seeks to destroy the old morality and the laws created for male advantage," she wrote, developing her basic stance as an advocate of individualism into broader issues of male oppression: "The New Women do not live thinking of yesterday. The New Women no longer consent to walk the same path taken by the Old Women, oppressed and mistreated; they are no longer content with a life of a person who is, left with ignorance like a slave, mere flesh. The New Women long for breaking the old moral doctrines and laws that were made to serve men." Raichō then went on to declare that she was not satisfied with simply rejecting the old conventions and laws made by men, but wanted to create a new society, an alternative. Written in her characteristic style but with less abstract language, this article concluded that women needed to learn self-discipline and to preserve their personal integrity.

Other members of the Seitō Society were also determined to counteract the criticism that held them to be merely rebellious, proud, and unrestrained.

In a more concrete manner than that of Raichō, Iwano Kiyoko and Itō Noe, for example, expressed their thoughts. In her article entitled "Men and Women Are Equal Members of the Human Race," Kiyoko (then the wife of Naturalist School novelist Iwano Hōmei) equated Japanese men's treatment of women as an inferior "race" with the way the European powers had been forcing Japan into unfair treaties. Kiyoko touched a tender spot with this remark, for the Japanese had considered the unfair treaty an inexcusable affront. Noe wrote an article entitled "The Way of New Women" in a peculiar blend of unsophisticated style and strong conviction. The "New Women" were the leaders of all women, she stated; in exchange for their glory as pioneers, they "must be prepared for danger, as well as fear and pain," and equip themselves with "confidence, strength, and courage." Noe was eighteen when she joined the Seitō Society and wrote this article.[12] A strong personality shone through Noe's spirited writing, which was a valuable addition to the magazine. At the end of this year she wrote, introducing the work of Emma Goldman: "Women's liberation must ultimately help us to become human beings in the true sense. All the obstacles ... have been created by men, every trace of subjugation and enslavement ... must be wiped out." In these articles, as well as in other pieces published in *Seitō* throughout 1913, Raichō and women around her were conscious of their link to international feminism.

The more severe the criticism was, however, the more active the core members of the society became. Responding the Home Ministry's official denouncement of their leaders for allegedly corrupting the virtue of Japanese women, they wrote more militant articles while expanding their protest to new areas. The January 1914 issue included feature articles on George Bernard Shaw's play *Mrs. Warren's Profession*, introducing arguments on chastity and prostitution. Then, in February, Raichō published a letter to her parents in which she announced her decision to leave home and marry Okumura Hiroshi, an art student who was a few years her junior. She would not legalize her marriage, she stated, because she objected to the existing laws, which considered marriage not a union of two individuals but an arrangement made for two families. Having declared her financial independence from her parents, Raichō was now pressed by the necessity to make her own living; she had little time to spend in publishing and managing the magazine. Her marriage to Okumura also disrupted the unity of the society, the core of which was composed of several young women who joined because they were attracted to Raichō's personality. Having strayed from its original position as a literary vanguard, the group was now experiencing difficulty in existing as a coherent unit. Increases in the price of paper, repeated banning, and the loss of membership caused financial difficulty as well.

The shift of emphasis had been obvious for some time, but when Noe

took over the editorial and managing responsibilities from Raichō in January 1915 the magazine took a decisive turn. Noe wanted *Seitō* to be a forum for women's liberation and announced that it was to be open to every woman writer in the country. Under the influence of Ōsugi Sakae, an anarchist and her common-law husband, she wanted it to have "no rules, no policies, no principles, and no ideology." *Seitō* now served as a forum for debate on such issues as prostitution and abortion. While Noe argued that any discussion of chastity that did not talk about the obvious double standard espoused by men was useless, Harada Satsuki discussed the issue of abortion in *Gokuchū no onna yori otoko e* ("From a Woman in Prison to a Man"), presenting it in the epistolary form. Writing from prison (she was imprisoned since abortion was a punishable crime), she argued in her letter that women should make their own decision about abortion, even if it violates the law. Nishizaki Hanayo wrote a piece entitled *Taberu-koto to teisō to* ("Securing Food and Women's Chastity") in which she described a young woman's struggle to make a living. Intending it as a protest against the arguments made by the Seitō women, most of whom were of middle-class background, Hanayo argued that chastity was a luxury that women with real economic hardship could not afford; she represented in this article the predicament of women in her situation, those born into a poor family. Already twenty-six when she joined the society, she had gone through her earlier life working as a maid and in other odd jobs.

Along with their polemical writing, core Seitō women at this stage also wrote fiction, or, more accurately, fictionalized accounts of their experiences and thoughts. Noe published a piece based on her romantic involvement with a young, aspiring writer. Iwano Kiyoko wrote about her own marriage in the manner of the Naturalist School: the husband in this story, who has married the protagonist because he likes an "awakened woman," treats her very differently afterwards, making many egotistical demands upon her. Using the form of fiction to argue about various sociopolitical issues and deliver the points more succinctly is a part of the literary tradition of modern Japan; this practice has been observed by such women as Kishida Toshiko and Shimizu Toyoko, both of whom were involved in a political movement before they started writing. Going back and forth between polemical writings and the fictional treatment of their own lives and opinions, each of the core Seitō women wrote about half a dozen stories.

Confusion between a personal concern and a public issue sometimes occurred, as it did in the experience of Nshizaki Hanayo. Her public confession in the article she published in *Seitō* moved a poet, Ikuta Shungetsu, who responded in another minor literary magazine, praising Ikuyo's courage of confession, and in effect proposing marriage. Hanayo made her interest in Shungetsu known, also in public. In the act of writing, publishing, and

reading these responses in print, a distinction between reality and literary representation seemed to have been obliterated. By the time Hanayo and Shungetsu actually met, Hanayo was convinced that their union was inevitable.[13]

Although their voices were not heard as loudly as those of the polemicists, there were a few women who published stories and poems consistently in *Seitō*. Having been encouraged by the approach of the Naturalist School, these women chose creative writing as their means of self-expression and wrote fiction based on their experiences. Katō Midori, one of the original members of the society and a regular contributor of fiction, wrote stories about the predicament of a young woman who let herself believe in the persistent wooing of a man: "Under the dim light Hisako opened the old letters sent by her husband. Stars will forever cast upon my mind a light of conviction of true love, it said in the color of a pale violet. Such a good time that was, she thought. He was quite forceful in wooing her even though Hisako was hesitant. So they were married four years ago, and a child arrived. It was after she became a wife that she came to know the cold heart of his." Midori's stories tell, with characteristic subtlety, of a young woman's sexual awakening after marriage and her conflicts over the choice she now has to make. While she feels that her husband (as well as her parents) is among the external agents of oppression, she cannot ignore her own inhibiting nature as similarly responsible for her problems. Filled with deep sighs, the protagonist is at least lucid in identifying the nature of her difficulties. Being aware of her discontentment, she sees reality with a more rational and critical eye than did the protagonists of the Naturalist School fiction.

Problems of so-called love marriages — the topic dealt with in Midori's stories — were now not so unfamiliar in real life, too. Compared to their predecessors, the young women of the Taishō era in general were less willing to accept the marriage arranged by their parents; they would rather take their life in their own hands, and sometimes they enter a marriage believing in the statements of a man who professed, privately and publicly, his sympathy for women's emancipation. Three *tanka* poets who regularly contributed to *Seitō*— Okamoto Kanoko, Migashima Yoshiko, and Hara Asao — all went through ordeals of disastrous marriages into which they had entered on their own initiative. Marriages at this time were no longer like those described by *keishū* writers (discussed in Chapter 3), but unlike those women who entered a more conventional marriage with the built-in safeguard of the matchmakers' intervention, these women had to struggle more or less by themselves. In their published work, women like these three poets candidly expressed their thoughts and emotions about their predicaments, some of which were overpowering.

While many women suffered, following the pattern similar to that

described in Midori's story, a few who took advantage of the new freedom and fared well. Kanoko, for example, survived her marriage and eventually gained enough personal strength, as well as creative impetus, to flourish as a novelist in the 1930s. Others reaped the benefit of the liberal climate and demanded what they needed with a force, as well as an openness, hitherto unknown to women in Japan.

Women and Mass Culture

Judging from the content of letters sent by readers, Japanese women were seeking a way out of the traditional lifestyle, reported *Yomiuri Shimbun* (*Yomiuri Daily*) in January 1918. It also said that more women were recognizing the need to get out of the home, as well as to receive higher education and occupational training. Although parental authority and male dominance remained the salient features of Japanese society during the two decades of the Taishō period, the younger generations, particularly the city dwellers, became more aware of what was going on in the West and questioned their own society's customs and values. How the new values were penetrating the thoughts of younger people is shown in a survey in which roughly half of the female students considered *ren'ai* acceptable. Small changes in legal procedures had also taken place, favoring women in divorce.[14] Thus an increasing number of young women were attempting, as Hiratsuka Raichō and Itō Noe did, to liberate themselves from the authority of the family. The idea that marriage is a union of two individuals rather than two families was no longer just the philosophical or literary concern it had been earlier. An unwillingness to accept the loose sexual behavior of men was also spreading.

And, on some occasions, conflicts over love and submission to parental authority caused head-on collisions, offering a subject for news reports.[15] One might say that women involved in these incidents were now putting into action the thoughts entertained a few years earlier by the *Seitō* women and the writers of the Naturalist School. Although they were reported as scandals, such incidents in effect made other women become keenly aware of the changing morality of family and marriage.

The well-known case of Yanagihara Akiko exemplifies women's revolt against the hypocrisy and degradation of the arranged marriage system under patriarchal dictate.[16] Akiko took a daring approach in order to achieve her aim: in *Asahi Shimbun* she published an open letter addressed to her second husband, a wealthy man she was forced to marry, in which she demanded a divorce. In the scandal she planned and carried out, she was the heroine who demonstrated the strength of will to take charge of her own life. Akiko in

effect took advantage of the mass media and the rising sentiment of sympathy toward rebellion against the patriarchy. Though her drastic approach provoked disapproval even among feminist women, she was successful. She later pursued a relationship with a young man, an aspiring writer, and advocated "true love" and living one's life "according to the dictates of conscience." Akiko played her role well. Unharmed in the end, she was able to develop a more secure sense of self and grew into a fine poet in the latter half of her life.

The emergence of a woman like Yanagihara Akiko points to the changes taking place among Japanese women in the liberal sociopolitical climate of the mid–Taishō period. A woman's attempt to revolt in rejecting a life of passivity and to follow the dictates of her heart had been immortalized a few years earlier, in 1911, in a novel entitled *Aru Onna (A Certain Woman)*. Written by Arishima Takeo, a member of the *Shirakaba* group, the novel presents the willful young heroine, Yōko, who is radically different from the conventional heroines previously created by men. It is said that this character was based, at least in part, on a woman's real-life experiences.[17] Unlike Akiko, however, Yōko is defeated and destroyed in the end, and this ending was interpreted by most readers of the time as a punishment for this "arrogant, self-centered, extravagant, and vain" woman.[18] It is difficult, however, not to be impressed by her energy as she fights a losing battle alone; her faith in herself and her strength in pursuing what she wants do not fail to arouse sympathy. In one of his letters, the author himself expressed his support of the plight of women in general. Most Japanese women, Arishima stated, were "the slaves of men" because they were socially and economically deprived, and since such a situation would prevent women from fully cultivating their capacity to love, it is the men who have made the women "instinctively hostile" toward them.[19]

As the mass-oriented culture continued to proliferate, the issue of women's liberation became a central one, and magazines and newspapers reported more and more on women's actions and opinions. On April 3, 1914, *Yomiuri Shimbun*, then one of the more popular national papers, announced that "considering the current trend," it was going to start a regular column for women as its "contribution to the women's cause." A woman was assigned as the column's editor in chief, and in addition to inviting established writers such as Yosano Akiko and Tamura Toshiko to write regularly, it devoted a full page to women's issues, printing announcements of public lectures and meetings, happenings at girls' schools, and letters from readers.

Responding to the needs of an increasing number of women readers, *Yomiuri* also started a *minoue sōdan* column, a Japanese version of "Dear Abby." This turned out to be the most popular feature of the women's page,

and many readers found themselves writing in for advice on problems in their own lives. Following this example, the women's magazine *Shufu no Tomo* (*Housewife's Friend*) started to include a *jitsuwa* (true story) section as a regular feature, with the result that the magazine experienced a dramatic increase in subscriptions (to 300,000). Other newspapers and magazines followed this practice, coincidentally creating additional jobs for women in journalism.

Though primarily a promotional strategy, these columns nonetheless gave women encouragement, and opportunities, to write and express themselves. Although the advice given in the *minoue sōdan* column was almost always along the lines of recommending resignation and endurance, the fact that women's doubts and discontents were expressed in widely circulated newspapers and publications was a new phenomenon. It would have been inconceivable in the days of the Meiji pioneering women, nearly three decades earlier.

An integral part of the proliferation of mass culture in the Taishō era was the emergence and rapid growth of *taishū shōsetsu*, or popular novels, which were usually serialized in daily newspapers. In the decade following the emergence of the "New Women," between 1915 and 1925, the more self-reflective type of writing by women stayed dormant, and after Tamura Toshiko stopped writing there were only a few women who produced serious fiction. But now, as the demand for popular novels grew dramatically, women joined in writing them. It was in these serialized popular fiction novels that the ethos of the time, including the new recognition of the role of women, can be most clearly seen.

Written without much concern for artistic quality but concentrating instead on the plot and an easy-to-read style, popular novels were authored by a variety of writers and were produced quickly and in large quantities, allowing its authors to reap great financial return. And this type of fiction now presented women in a radically different way from their portrayals in widely read novels (such as *Hototogisu*) of earlier days. Ruriko, the heroine of *Shinju Fujin* (*The Pearl Lady*), for example, is totally undaunted by criticism and lives her life the way she sees fit. An attractive widow of a man who had become rich quickly by hoarding during World War I, she in fact makes several young men compete with each other to be her lover. Responding to the accusation that she is fickle and dangerous, Ruriko says that men have always taken a selfish pleasure in trifling with women: "And so, what's wrong with women trying to do the same thing?" Motivated by a desire for revenge against her late husband, who had married her simply to show off his wealth, Ruriko not only plays the role she has given herself well but seem to enjoys it. It is a story of a woman who successfully manipulates and controls various men, all of whom are the elite of the society.[20]

The Pearl Lady bases its story on the first half of the life of Yanagihara Akiko, and although it is about a woman's victory in a man's world, few features were added to make the work more palatable for the mass audience. Ruriko, for example, decides to refuse the marriage proposal of Aoki, one of her admirers, when she finds out that her stepdaughter loves him; Aoki kills himself after stabbing Ruriko. "While badly treating her admirers to satisfy her own needs, she held deep in her bosom her chastity toward the man she loved, and it shone brilliantly like a pure pearl," the author adds at the end of the novel. Ruriko dies in the arms of her true lover, Sugino, and she has his picture sewn into her undergarment.

The heroine of *The Pearl Lady* is given too many roles — a beautiful maiden turned revengeful woman, a sexually liberated scheming widow, a stepmother as a protector of her daughter — and they are not integrated well. In spite of this weakness, the novel was enormously popular, making its author, Kikuchi Kan, one of the most successful popular fiction writers of the time.

The Pearl Lady was refreshing in the sense that it had elements not found in other popular novels, particularly those published in women's magazines. Instead of telling about a woman's destiny and the inevitable course of her life, it presents a heroine who dictates her life's direction and makes her own decisions. "A daughter sacrifices herself for the sake of her parents, lets herself be sold in order to save them — that sort of thing belongs to the feudal age," Kikuchi lets one of his male characters declare.[21] Following society's moral dictates rather than being adventurous and looking for a new future had been the basic recommendation made in the fiction fed to the readers of women's magazines. This type of fiction was no longer so popular as readers began looking for something else. Though women were yet to be liberated from the confines of the patriarchal family system, they no longer sought a catharsis in the stories they read; they looked for a vision of a different and freer life.

Women participated in producing popular novels, and sometimes, as in the case of Yoshiya Nobuko (1896–1973), they had a great deal of success. Nobuko is a product of the newly developing mass-oriented culture of the late 1910s and early 1920s. Like most women writers studied in this book, she started writing at a young age and sent her stories to various magazines. One of them, *Shōjo kai* (*The Girls' World*), chose her piece as the best among the readers' contributions. Nobuko at this time was in the third year of a higher school for girls in the provincial town of Tochigi. Greatly encouraged, and again following the pattern set by the Naturalist School women, she went to Tokyo to pursue writing. In 1917, Nobuko began writing a series of short stories under the title *Hana Monogatari* (*The Flower Tales*). When this was

compiled into a book it became enormously popular, making her an important writer of juvenile fiction. Two years later she won the first prize in the *Tokyo Asahi* competition for new writers (the same competition won earlier by Tamura Toshiko and Ojima Kikuko). Unlike the work of her predecessors, her novel *Chi no hate made* (*Until the End of the Earth*) was based not on her experiences in real life but on her observation of the lives of several Christians with whom she became acquainted while she was living in the YWCA dormitory when she first came to Tokyo.

Reading both Japanese and Western fiction on her own (she was said to have been particularly impressed by Louisa May Alcott's *Little Women*, which she read in translation), Nobuko had no one to teach her the craft of fiction writing and no author whose work she would follow as her model — a departure from the common practice among her literary predecessors. Unlike the Naturalist School women, furthermore, she did not approach fiction writing as a means of self-realization or of examining her awakening sense of self. Her primary interest was in writing fiction that would appeal to a wide, particularly female, audience. *Sora no hate made* (*To the End of the Sky*) treats a woman's devotion to her younger sisters, and *Onna no Yūjō* (*Women's Friendship*) is about three young women who help each other.

The female characters in Nobuko's novels are quite ordinary, but they are distinctly modern nonetheless; quite different from the tragic heroines in Meiji fiction, they are women who have experienced the new wave of feminism and Taishō liberalism. Later, in 1936, Nobuko would publish a novel entitled *Otto no teisō* (*A Husband's Chastity*), an astonishing title considering that "chastity" in those days was thought to belong to women alone. Treating a triangle with two women and a man, a pattern exploited by Meiji writers, Nobuko focuses in this novel on the double standard practiced in the morality of marriage. The conflicts in the triangle situation ends with a constructive solution arrived at through the efforts and mutual understanding of the two women. Presenting two women who were supposedly competing but actually firmly tied by each other's trust, the story can be read as a feminist revision of earlier, more conventional treatments of the triangle theme. Nobuko introduced early on in her career a lesbian theme while exploring different ways of life for women. Her female characters' opinions and choices are often so new and revolutionary that one must consider her a feminist writer. Often described as a female version of Kikuchi Kan, she is among a few women who not only had a successful career writing popular fiction but also reaped enormous financial rewards.

Although she was not uninterested in women's emancipation (she had acquaintances among members of the Seitō Society), Nobuko nonetheless did not join the group of "New Women." In real life she never married, instead

living an uneventful, harmonious life with a woman (a high school teacher) who accepted the role of managing the household and assisting her with research. In the days when remaining unmarried was extremely rare for Japanese women, such a lifestyle was radically new and unconventional. Nobuko remained productive throughout her life. In her later years she wrote historical fiction — again focusing on several remarkable women in the court of the Shōguns — in which women's lives are overshadowed by those of their fathers, their husbands, and their masters. Her memoirs of various women she had known in her life are quite interesting, revealing her talent as a fine nonfiction writer as well. Despite the wealth of materials available on her work and life, only a few biographies have been published so far.

A New Era for Women

World War I, which broke out in the second year of the Taishō period (when *Seitō* began shifting its focus to social and political issues related to women), brought many far-reaching changes in the political and economic lives of the Japanese. One such change, the expansion of the economy, meant an increase in the size of the middle class, which in turn supported political changes. It was women of this expanding middle class (doubled between 1903 and 1917) who read women's magazines, which were numerous by now. Since agriculture had already reached the limit of its potential for absorbing manpower, younger men and women left the rural areas in great numbers to find work in the cities.[22] Industrial progress helped enhance the standard of living, at least in the urban areas, and the technology introduced from the West, such as in printing and transportation, enabled the average citizen to enjoy various cultural activities inexpensively. As new industries began targeting their products to the taste of the masses, culture became no longer the possession of the privileged.[23] Free primary education, begun in 1903, contributed considerably in raising the level of school attendance, preparing students to enjoy more sophisticated cultural activities. The number of secondary schools for girls increased more than twofold, and the number of students more than threefold, during the 1920s.

The emergence of several new monthly magazines for women — some for general interest, others with specific focuses — was one result of an increase in disposable household income, enhancement in higher education, and more vibrant cultural activities. Stimulated by the commercial success of *Housewife's Friends*, the publisher of *The Central Forum*, who had earlier issued a special on women, decided to start a new monthly publication for women, *Fujin Koron* (*Women's Forum*). Other publishers followed this trend,[24]

and in 1917 two literary magazines, *Saien Bundan* (*Literary World for Talented Women*) and *Shōjo Bundan* (*Literary World for Maidens*), were started with women readers in mind. A magazine called *Woman Karento* (*Women's Current*) was started several years later by Miyake Yasuko, a writer-essayist and Tanabe Kaho's daughter-in-law.

Increased activities in the publishing world were no doubt supported by the growth of the middle class and the enhancement of their economic lives, as well as by new awareness of the changing needs of women. These were the same socioeconomic circumstances that helped the "New Women" emerge, but now women demanded not only to be free from patriarchy but also to have opportunities to speak out, to have and enjoy their own version of life. When we hear Ruriko state at the end of *The Pearl Lady* that it is not her late husband (who took advantage of her) that she rebelled against, but rather the injustice in the society that has shaped a man like him and the idea that men can trifle with women, we see a sign of a different type of social consciousness emerging among women.

As industries expanded rapidly, during and after World War I, the economic distance between the capitalists, who had most profited from this expansion, and the laborers widened. To make matters worse, the trade recession that occurred in the postwar years had a sudden and severe impact on many industries. The workers in these industries now resorted to strikes in an attempt to retain their employment; they were also encouraged by the heightened interest in the left-wing activism among the intellectuals. Women workers also developed their consciousness as laborites at this time, and a national labor organization, *Yuaikai*, began admitting women to membership.[25] In the rural areas, farmers organized themselves in frequent tenancy disputes. In 1918, protests referred to as *kome sōdō* ("rice riots") involved thousands of unorganized angry citizens assembled in the streets, attacking the establishments of rice dealers and moneylenders. The first mass protests in the history of modern Japan, these are said to have been ignited by a group of housewives in a small fishing village facing the Sea of Japan.[26]

The rice riots helped the Japanese see the political process close at hand. They also had a major impact on the psychology of the people, particularly of the housewives and younger women who felt insecure about their own precarious situations at home, and some of these women started thinking of going out to work and earning their own income. Unlike their European counterparts, Japanese women did not enter the labor market while their boyfriends and husbands were away in the battlefield, but their numbers steadily increased as new jobs and occupations were created. While general economic hardship was the primary reason for the increase in the number of working women, many took employment to gain a sense of independence or to avoid boredom.[27]

And, women outside the factories also began organizing themselves in order to have their voices heard. In early 1919, *Shin Fujin Kyōkai* (The New Women's Association) was established with the membership of various small groups of working women, such as the YWCA, the typists' union, and labor organizations. Individual housewives and students also joined the association to promote their causes. Hiratsuka Raichō, now the mother of two children, was once again a chief organizer.

The association took up two issues as its targets of petitioning: first, amending the Peace Preservation Law by revoking its Fifth Article (which prohibited women from organizing and participating in political meetings, the issue Shimizu Toyoko had worked more than two decades earlier); and second, introducing a law that would protect women from contracting venereal disease from their husbands. At the forefront in launching the women's suffrage movement in Japan, the association would soon introduce legislation for women's suffrage and work.[28] Women were becoming politically aware to a degree unknown in earlier years.

A decade after the Great Treason Trial and the subsequent political repression, leftist movements in general once again grew significantly. During the 1920s, in the turbulent atmosphere of the years following the rice riots, the Japanese Socialist Party and the Japanese Communist Party were founded. Lack of unity among their members and strong police intervention caused the both parties to fail in securing popular support, but here again we find some women who were interested in joining the men. In early 1921, at the first May Day demonstration held in Japan, the members of *Sekiran Kai* (the Red Wave Society) — mainly the wives, daughters, and sisters of revolutionary activists — made their presence known. Originally gathered together to study about socialist-communist ideologies, this group dissolved rather promptly because of the split between two factions — the anarchists and the Marxists. They did, however, educate a numbers of female college students through organized lectures.

Enthusiasm for sociopolitical activities was definitely growing among women. College students joined left-wing activists while other liberal intellectuals participated in various types of campaigns, such as raising funds for the starving Russians in the post–Bolshevik Revolution era. A celebration for International Women's Day (started in New York a decade earlier) was held in Tokyo in March 1923, and lectures by Margaret Sanger and Jane Adams were organized. Although the Women's Day celebration was attended mostly by men and was dispersed by police within forty minutes, Japanese women were now free to attend political gatherings. Slow, steady efforts to abolish the practice of licensed *kōshō* prostitution had been made by various groups, and now prostitutes themselves protested, appealing for better treatment. In

one such protest, which took place in Okayama, five women stated: "In the time when liberation is taking place everywhere, we cannot remain in our slumber; our appeal is not just for ourselves but for those thousands throughout the country, and we are prepared to go on a hunger strike if necessary." These women got what they wanted — freedom to go out on their day off, public facilities to treat venereal diseases, and organized help for those who leave the prostitution houses.[29]

Left-wing activities, however, were almost always disrupted by large-scale police forces. In June 1923, many activists, including the majority of the Communist Party, were arrested. A few months later, a terrible earthquake shook the Tokyo-Yokohama region, disrupting the lives of people of the area and provoking nationwide economic confusion; it gave the police a convenient rationale for exerting further control. The government, having been prepared by the experience with the rice riots, took the upper hand this time and arrested all those it considered dangerous. Itō Noe, with Ōsugi Sakae, her common-law husband (an anarchist), were killed for allegedly plotting a revolution. This atrocity forecast the coming of military control, with which the government would enforce its reactionary policies at an increasing pace over the next twenty years.

No doubt encouraged by the ferment of women's social activities, as well as the examples set by *Seitō* and *Women's Current*, two women, Hasegawa Shigure and Okada Yachiyo, tried to start a literary magazine geared for women in 1923. After an interruption caused by the Great Earthquake, it was finally launched in 1928, this time by Shigure alone. This magazine, named *Nyonin Geijutsu* (*Women and Art*), would play a vital role in promoting creative writing among aspiring young women. Having left their native towns and villages with a single-minded determination to become writers, many of the women who gathered around Shigure in Tokyo were penniless. Reflecting on the turbulence around them, as well their own state of mind, they wrote stories that transmitted a message of rebellion, sometime outright hostility and anger. Their opinions, moreover, are clearly laid out. Nakamoto Takako's *Suzumushi no Mesu* ("The Female Bell Cricket," included in *To Live and to Write*), for instance, is about a young woman who takes advantage of her weak lover. Like the female cricket, which is said to kill the male at the end of summer, she destroys her lover after using him to avenge her unfaithful ex-lover. The departure from the old theme of women's victimization is more than clear in this story. The leftist approach to literature was soon to be introduced to take the lead in the literary world, and *Women and Art* would publish pieces with highly political contents.

The earlier life of Hasegawa Shigure (1879–1941) reads like an early Meiji story; what she made out of her life later, therefore, gives us a glimpse

of many changes made by women of modern Japan in general. As her autobiographical writings reveal, her early experiences strongly remind us of those of the heroines created by the pioneer literary women. Born into a family with a strict and autocratic father and a traditional mother, she was raised to become, above anything else, an obedient wife. Because education would not help Shigure reach this goal, her mother prohibited her from reading books, for example. When she finished the primary school, she was sent to live with a prominent family to receive training in domestic work. From Shigure's description, one gets the impression that this family was living the reality of the feudal era. Then, at age eighteen, she was made to marry the immature, indolent, and prodigal son of a wealthy merchant. After eight years of marriage, Shigure was set free because she had contracted tuberculosis. It was this marriage that provided her with material when she first started writing fiction.

Shigure published her first work of fiction in 1902. Describing a young wife in a small local town who is ridiculed for her efforts to read books and to write, this story, entitled *Uzumibi* ("Buried Fire"), poignantly portrays a woman whose desire for self-expression is dampened by the ridicule she encounters and her own hesitation. This protagonist's motivation in attempting to write is very similar to that of women authors of the Naturalist School.

Having found the approach she took in her short story to be limiting, however, Shigure abandoned fiction and instead wrote stage plays. *Sakura Fubuki* (*Storm of Cherry Blossoms,* 1910) won her wide recognition and established her as a playwright. A historical drama that takes place in Japan's feudal time, it treats the main character's conflicts over the womanly virtues prescribed by society and her sense of autonomy. Many of Shigure's plays, like this one, present sentiments that seem to belong to the premodern era; they are akin to those seen in the stories of Kitada Usurai and, to a degree, of Higuchi Ichiyō. Shigure's contribution to the enhancement of women's writing, therefore, was through publishing *Women and Art* (the funding for which came from her second husband, a popular fiction writer), thus supporting a group of very poor young women financially and otherwise.

Within a few years after *Women and Art* was launched, the Marxist theory of literature began gripping the Japanese writers, affecting their choice of themes and approaches. This theory maintained that fiction writing should aim not only at eradicating the internal oppression experienced by individuals but also at exposing the more obvious forms of social exploitation. Reflecting the social and political climate of the late 1920s, this position was also a reaction to the dogma of the Naturalist School, which in the end sees individuals in isolation.

Encouraged by the leftist theory that self-representation was a measure

open to everyone, women with an ever wider range of backgrounds, including those of the working class, now tried to write and express themselves. *Women and Art*, in fact, published stories written by factory workers and prostitutes at one point. One such story, naive and poorly executed, narrated an attempt of a woman, the thinly disguised author, to escape from a house of prostitution. Popular fiction was now expected to convey leftist ideology also, and some had a heroine involved in labor disputes. "There once were new women, and they were called *seito*, blue stockings, but now we have a different kind of new women," Kume Masao, a popular fiction writer, has his character, a writer, tell a woman in his 1927 novel: "and I call them 'blue brows'; they don't simply talk about theories and logic but act; they represent our time through their body."[30] Unlike Ruriko, whose freedom was secured by the money her husband left her, a "blue brow" woman has a profession. The protagonist works for a publishing house, and aided only by her wit and beauty, she survives various battles she faces as she moves in the world of men.

Many of women represented in *Women and Art* would soon abandon writing for more direct means and engage in various leftist activities, but others, such as Hayashi Fumiko, Sata Ineko, and Uno Chiyo, would emerge with fine pieces of fiction several years later, preparing a new era for women writers. Highly autobiographical in nature, the stories by these emerging women of the proletariat school did not portray their female protagonists dwelling on the experience of victimization; nor is a precarious sense of self the focus, as it was in the work of the Naturalist School women. Characteristically, they are unafraid to pursue their often daring goals; they successfully shape their own destinies in the end. After World War II, many of these authors would establish themselves and pursue successful writing careers.[31]

Shigure herself did not receive much critical attention for her fiction and plays. She is remembered rather as the publisher of *Women and Art*, a woman who advocated and financially supported young aspiring women in their attempts at writing. Born during the years when Japan first tried to follow the Western examples, Shigure lived through the era of conservative backlash and then became involved in literary activities that aimed at women's mutual support. She lived through the multitude of changes Japan underwent during the Meiji, Taishō, and Shōwa periods. Although Shigure's early years revealed very little that would foretell her future path, her life seems to summarize the story of literary women discussed in this book.

Epilogue
Toward the New Era of Literary Women: Nogami Yaeko

The long and productive career of Nogami Yaeko (1885–1985), a novelist and short story writer, was quite different from that of other women writers studied in this volume. She died in 1985, shortly after the representatives of the Japanese literary establishment had given a party to honor her one hundredth birthday. Yaeko had lived through the latter half of the Meiji period, all of the turbulent years of the Taishō era, and most of the Shōwa period, which had witnessed the rise of militarism, the defeat in World War II, and a recovery from the economic and spiritual devastation people had endured. At the time of her death, she was trying to finish, slowly but steadily, an autobiographical novel entitled *Mori* (*The Wood*). Since the publication of her first work in 1907, her career had lasted for nearly eight decades, during which time she wrote without major breaks except for several difficult years during the war. Considering the distance she covered in her life, it is possible to say that Yaeko personally embodied the history of women writers in modern Japan.

Yaeko was a product of Meiji Japan as much as any other woman discussed in this book. Her approach to life and writing, however, was quite different from that of other women writers, and perhaps it is in this uniqueness that one learns why she was able to sustain such a remarkably long career. Thus, at the end of this book, it is worthwhile to briefly examine her life and career.

Although she had personal acquaintances among writers and other intellectuals, Yaeko chose to keep a distance from the literary establishment, particularly from its core. This distance enabled her to see herself as neither a follower of the trend set by male writers nor as an imitator of a male model. As a consequence, she did not have to see herself leading a marginal existence,

as other women writers did; she could remain basically indifferent to the critics and other members of the literary world, mostly male. This was actually a deliberate strategy, which she referred to as remaining "an amateur."[1] This deliberateness also separates her from other women writers studied in this book. Although she was a faithful supporter of the Seitō Society,[2] she did not join this group or want to be directly involved in its activities.

Yaeko's sense of commitment to herself as a free and totally independent agent can be seen also in the choices she made in her personal life, particularly regarding marriage. She was unyielding not only to the traditional practice of arranged marriage, but to a romantic involvement, which might have brought — as it did to some women writers of the Naturalist School and the Seitō Society — a disastrous result. Deciding that her priority was to remain in Tokyo (where she had been sent for her education) so that she could secure freedom as well as opportunities to pursue her aspirations, she chose to marry a man from her hometown, a student at the University of Tokyo, someone her parents would approve of. Considering the many cases in which marriage prevented women writers from further developing their career, this was a wise decision, and it produced a good result: in sharp contrast to the experience of Shimizu Toyoko, Yaeko's husband was not just understanding but uncommonly cooperative with her literary pursuit. In fact, he helped her launch her literary career by introducing her to Natsume Sōseki, and later, when she was established as a writer, he performed many of the necessary chores for her, including dealing with editors and publishers.

Family background and educational experience are other areas where we can see how Yaeko was able to develop her unique strength as a person and a writer. The eldest daughter of an established, prosperous sake-making family in a small port town on the southern island of Kyūshū, Yaeko led a stable and happy childhood with a liberal-minded father and an old-fashioned but strong mother. Like many other Meiji literary women, Yaeko was an exceptionally studious girl, and by the time she was fifteen she had learned the Japanese and Chinese classics.[3] Since there was no middle school for girls in her hometown, she was then sent to Tokyo in 1900 for further study. Sending their young daughter away to the nation's capital (a three-day trip by ship and rail in those days) was not such an unusual idea for her parents. Unlike another port city, Sakai, where Yosano Akiko grew up, Yaeko's native town was, according to her, made up of people who were open-minded and eager to see beyond the boundaries of their limited experience. Through the recommendation of a family friend in Tokyo, Yaeko entered Meiji Jogakkō and stayed there for nearly seven years. At a time when conservative trends prevailed in the educational milieu of girls' school in general, this choice was a fortunate one. The educational environment of Meiji Jogakkō, as Yaeko herself

described in her novel *The Wood*, was markedly different from that in public secondary schools for girls and that of Japan Women's College, where Hiratsuka Raichō (also Tamura Toshiko very briefly) attended. Although it was not the same as it had been in its heyday, the school gave Yaeko a solid liberal education with the emphasis on independence and self-sufficiency; it also gave her a propensity not to put trust in conventions and formalities, but to think freely without readily submitting to authority.

Yaeko's first published work was a short story entitled *Enishi* ("Bonds," 1907); it appeared in a haiku magazine called *Hototogisu* (*The Cuckoo*) with a recommendation from Natsume Sōseki, already an influential literary figure: the story was a "refreshing piece" and "distinctly a woman's work ... revealing a certain passion that Meiji women writers had not expressed previously," stated Sōseki.[4] Yaeko was twenty-two years old at this time, and her husband, Nogami Toyoichiro, was a part of the literary circle founded around Sōseki. Despite Sōseki's sympathetic encouragement and kind invitation, Yaeko did not join Sōseki's literary salon; instead, she made her husband take her manuscripts to him, expecting him to report back to her what Sōseki had said about them. Not only was she uninterested in becoming Sōseki's disciple, but she had no desire to seek help from him. It was nonetheless fortunate for Yaeko to be introduced, through her association with Sōseki and the *Hototogisu* group, to a literary theory that advocated objective depiction of the details of an everyday life. For a person who led a sheltered middle-class life, as Yaeko did, this theory made writing quite approachable; her first dozen or so pieces of fiction are characterized by the narrator's sensitive observations of her undramatic family life.

By 1915, Yaeko was the mother of two boys. With her husband holding a university position and domestic help being readily available, Yaeko managed to combine a career in writing with the raising of her children. They were, in fact, the objects of her close observation, providing her with material for her stories, and one of her collections, *Atarashiki inochi* (*New Lives*, 1916), deals exclusively with children. Rather than describing them from outside, however, Yaeko uses their point of view in examining adult affairs, an approach rarely attempted by women writers before (with an exception of Wakamatsu Shizuko in "The Sailor Boy"). This collection gained her recognition as a writer who successfully treated motherhood in fiction. Revealing the stereotypical view generally held about women as being anti-intellectual, one critic called her "a writer with breasts as well as intellect."

Choosing to write fiction about many things she saw, heard, and thought about, Yaeko went on writing while she constantly expanded her horizons. Several years after *New Lives*, Yaeko published *Kaijinmaru* (*The Neptune*, 1922), a gruesome drama that takes place on a small fishing boat as it drifts away

from the shore. Narrating an extraordinary circumstance in which men are tempted into cannibalism, *The Neptune* created a world miles away from that of her earlier stories. Based on a real incident, which she had heard from a fisherman of her native village, this novella poses an ethical and philosophical question — whether human beings are basically good or evil. With this novella Yaeko showed the literary world that, against the popular notion of the time, a woman could write fine fiction on a topic, and in a style, that is not particularly "feminine." By asking difficult moral questions, it also proved that a woman was capable of dealing with abstract ideas, not just the narrowly confined experiences of daily life. It also showed that she had learned a great deal about writing and had developed skill in constructing a story.

A remarkable characteristic of Yaeko as a writer is the diversity of her fiction writing, as well as the variety of themes she explored. At the end of the 1920s, when the central interest of many women was social and political activism, Yaeko wrote a novel entitled *Machiko*, which was serialized in a leading general magazine of the time, *Kaizō (Reconstruction)*. By this time her sons were in the university, and the primary question she asked in this novel was why so many bright young people were attracted to leftist ideology. The protagonist, Machiko, is an educated young woman who rejects the petite bourgeois conventions carefully followed by her mother. She is seriously concerned with her personal morality, and her sense of social responsibility leads her to become involved with a group of Marxist activists. This novel presents a full and convincing picture of a liberated young woman of the 1920s, depicting her internally as well as in various social interactions. Eventually, Machiko sees the selfishness and hypocrisy of her activist lover, and in the end she leaves him. In a conclusion that is typical for Yaeko, the novel emphasizes the victory of reason over passion. This ending made the novel unpopular at a time when the intellectual climate was strongly sympathetic to Marxist ideology, causing reviewers to complain that the author's own political loyalties were unclear.

By writing *Machiko*, Yaeko proved that, against the common notion of the time, a woman could produce a full-length novel with a well-developed plot, rounded characters, and a clearly defined theme. Yaeko at this point was most certainly not called a *keishū sakka*, a woman who wrote about the sad predicaments of her sex and rendered women's victimization with pathos and feminine sensitivity. Yaeko published a few more full-length novels during the 1930s, and these are now recognized as masterpieces of modern Japanese fiction.[5]

Unlike most other women discussed in this book, Nogami Yaeko had a long and productive career, writing most actively during the 1930s and after World War II. Having engaged in a new type of relationship with the literary establishment, she demonstrated new ways for Japanese women to embark

CONTRIBUTIONS TO SOUTHERN APPALACHIAN STUDIES, 6

John Fox, Jr., was one of the first writers to use the mountains of southwestern Virginia and eastern Kentucky as a backdrop for his stories and novels about a people whose culture faced extinction. Writing was not a profession he chose quickly or painlessly—he was well into middle age when he made the decision and he struggled with his choice for a long time after—but he made quite a name for himself through his work.

This work is a biography of Fox. It draws from personal and family correspondence and covers his entire life, from his birth in Stony Point, Kentucky, in 1862, to his death from pneumonia in Big Stone Gap, Virginia, in 1919. It documents his early life and education at his father's school, his two years at Transylvania University in Lexington, his transfer to Harvard and graduation in 1883, his work for the New York *Sun* and *Times* and smaller newspapers, and return home in the mid–1880s to work with his half-brother in the coal mines. It was also around this time that he began his first novel, *A Mountain Europa*. Over the next thirty years he wrote dozens of short stories and nine novels from the family home in Big Stone Gap, including *Little Shepherd of Kingdom Come* (his first to gain the status of bestseller) and *The Trail of the Lonesome Pine*.

Bill York is a high school social studies teacher and lives in London, Kentucky.

ISBN 978-0-7864-1372-0

Cover photograph: John Fox, Jr., 1894
(courtesy of the University of Kentucky)

Background image ©2002 Art Today

on writing careers. She had no mentor or male model to follow, nor did she approach fiction writing as a means of personal and social emancipation; instead, writing was an intellectual challenge for her. She may have been a woman whom Arishima Takeo hoped to see, a woman who "would look afresh at contemporary culture with truly liberated eyes."[6] Although she did not identify herself with any particular group, she associated with a large number of literary women personally and professionally — a sharp contrast with the social isolation experienced by many Meiji literary women of the earlier period.

In her liberated view of literary endeavors and gender roles, Yaeko is the forerunner of the generation of women writers emerging toward the very end of the Taishō period. In greater numbers, these women writers would continue to write after World War II, extending the years of active writing beyond that of most literary women studied in this book. They would also gain far greater financial rewards. And in the late 1950s we saw the beginning of the trend toward the prominent participation of women writers in the Japanese literary establishment. Although it is questionable if men's perception of women as their subordinates was substantially altered, Japanese women by then acquired many rights and opportunities that had been denied in earlier times. It was also around this time that Japan finally introduced a new approach toward prostitution by passing (after a great deal of controversy) a law that put a stop to the *kōshō* system of prostitution.

In 1988, two women writers, Kōno Taeko and Ohba Minako, were included among the judges for the Akutagawa Prize, the oldest and most important literary award for new writers of "high" (serious) fiction. This decision symbolically told the public that women had gained full membership in the literary establishment, which more or less had excluded women writers altogether. Although the term *joryū sakka* persists, the other term, *keishū sakka*, has been obliterated not only from the mind of critics but from that of common readers as well.

Notes

Preface

1. Egusa, Mitsuko, *Tatakau "chichi no musume"* ("A Father's Daughter, a Warrior"), *Onna ga yomu nihon kinndai bungaku: feminisumu hihyō no kokoromi* (*Modern Japanese Literature Read by Women: An Approach of Feminist Criticism*), Shinchosha, 1992, p. 143.

Introduction

1. Mori Ōgai, *Keishū shōsetsu o yomite* ("Reading Women's Fiction"), *Bungakkai* (*Literary World*), January 1896. See *Meiji joryū bungaku shū* (*Collection of Writings by Women in the Meiji Period*), vol. 1, Chikuma-shobō, 1966, p. 395.

2. Subgrouping of women writers is still observed in the scholarly research today. The number of research papers and critical studies on individual women writers (with the exceptions of Higuchi Ichiyō and Yosano Akiko) has been conspicuously small, but when attention is paid to these less well known literary women and their work, it is almost always in a special issue on *joryū*, where a group of women writers with diverse characteristics are assembled simply because of their gender. Such a title as *Joryū sakka no saizensen: Higuchi Ichiyō kara hachijūnen dai no joryū* ("The Front Line of Women Writers: From Higuchi Ichiyō to the Women Writers of the 80s") is illustrative. Women writers themselves (and some feminist scholars) have started objecting to the term *joryū* in recent years. In 1992 a book entitled *Danryū bungaku ron* (*On Male School Literature*, by Ueno Chizuko, Ogura Chikako, and Tomioka Taeko, Chikuma-shobō, 1922) appeared. See also Kirschnereit, Irmela, *Joryū bungaku ga bungaku ni naru hi* ("The Day When Women's School Literature Becomes Literature"), *Asahi Shimbun*, 2 September 1986.

3. See "Biographical Appendix," Showalter, Elaine, *A Literature of Their Own: British Women Novelists from Brontë to Lessing*, Princeton, Princeton University Press, 1977.

4. See Gilbert, Sandra M., and Gubar, Susan, *The Madwoman in the Attic: The Woman Writer and the Nineteenth-Century Literary Imagination*, New Haven, Yale University Press, 1979.

5. Ibid., p. 73.
6. Showalter, p. 17.

Chapter 1

1. This book was used as a textbook at Kyōritsu Jogakkō. See *Autobiograph* by Hatoyama Haruko (*Jijoden*), collected in Saeki Shoichi, ed., *Nihonjin no Jiden* (*Autobiographies by the Japanese*), Heibonsha, 1980–1983, a twenty-five-volume collection in which only five are those of women. Tokyo Jogakkō was originally called Kyōritsu Jogakkō (when Hatoyama Haruko was a student). When it closed, the students were transferred to the women's section of the normal school as it was established in 1874. See Takamure Itsue, *Josei no Rekishi* (*History of Women*), vol. 2, Kōdansha, 1972.
2. *Jogaku Zasshi*, June 1888.
3. Shioda Ryōhei, *Meiji joryū sakka ron* (*The Female School Writers of the Meiji Period*), Narashobō, 1965, p. 98.
4. Tanabe Kaho, *Sono hi sono hi* ("Day by Day"), quoted in Shioda, p. 93.
5. Shioda, p. 97. Muramatsu Sadataka is another scholar who emphasizes Kaho's self-effacing statements about her publication of *Yabu no uguisu*. See Muramatsu Sadataka, *Kindai joryū sakka no shōzō* (*Portraits of Modern Female School Writers*), Tokyo Shoseki, 1980.
6. Yanagida Izumi, *Zoku zuihitsu Meiji bunkaku* (*Essays on Meiji Literature Vol. 2*), quoted in Shioda, p. 106.
7. *Sono hi sono hi,* Shioda, p. 94.
8. Typical of Kaho's fictional themes, also seen in Tokugawa popular fiction, *Hagikikyō* involves a triangle of a man and two young women who are sympathetic and filled with pathos, rather than confrontational. It received favorable reviews for its quiet feminine sensitivity.
9. Honma Hisao, *Meiji bungaku sakka ron* (*Writers of the Meiji Period*), Waseda Daigaku Shuppan, 1951, p. 166.
10. A native of Shikoku, Kusunose had been to various political rallies organized by the Popular Rights Movement and was known as *minken bāsan*, or "Popular Rights matron." The letter was presented not only to prefectural but to the national government as well. Wakita Haruko, Hayashi Reiko, and Nagahara Kazuko, *Nihon josei shi* (*History of Japanese Women*), Yoshikawa Kōbunkan, 1987, p. 196.
11. Reported, for example, in *Hōchi Shimbun* (19, 28 April 1882) and *Chyoya Shimbun* (16 December 1882), Murakami Nobuhiko, *Meiji josei shi* (*History of Meiji Women*), Kōdansha, 1977, vol. 2, p. 93.
12. Kageyama's *Warawa no hanshō* (*The First Half of My Life*) was published in 1904. She also published, in 1905, *Warawa no omoide* (*Accounts of My Life*). Later, Kageyama advocated socialism and in 1907 started a women's magazine called *Sekai Fujin* (*Women of the World*).
13. This was true in Kageyama's experience as well. Men she worked with allowed her to assume important, even dangerous, roles, but in the end they ignored

her as their true partner. Looking back in her later years, Kageyama wrote that her male partners thought nothing of spending the political contributions she and another woman had collected to buy drinks and the services of geisha.

14. Murakami, p. 99.

15. Also published in *Jiyū no tomoshibi* in ten installments, Murakami, p. 100.

16. *Yo no otto ni nozomu* ("A Request I Make to Husbands"), *Jogaku Zasshi*, 25 July–25 August 1886.

17. Shioda Ryōhei is among them. He quotes a few of Shōen's Chinese poems in his book.

18. The fact that the topic of heterosexual love was uncommon in serious fiction is evident in the translator's preface. Oda Jun'ichirō, the translator of *Ernest Maltravers*, felt the need to justify himself for introducing a story not of lofty ambition but of tender emotion, and explained his choice of this work by stating that his intention was to "edify women and children." Generally, political novels were written in a style that mixed Japanese and Chinese; the authors often were former *gesaku* writers who had resumed their writing for newspapers, but under a newly established government countering with anti-press laws, they turned to a new genre.

19. Quoted in Shioda, p. 87.

20. The plan was proposed by Kuroda Kiyoteru, then the head of the Hokkaido Land Development Bureau, under the pretext that exceptionally capable individuals would be needed to develop the uncultivated region and that only educated women could raise such individuals; the real reason, however, was to impress Westerners with the fluent English and social manners that these girls were expected to be trained in. Out of five girls sent, the two oldest became ill and went right back to Japan, but the others stayed on for nearly ten years. Upon their return, they joined the wives and daughters of upper-class families at various governmental diplomatic functions, such as Western-style balls and charity bazaars. The government plan of sending girls to the United States, unlike in the conclusion of *Mirror of Womanhood*, did not take into account how the experience of these women would best serve the nation and enhance the lives of other women. As a result, the three young women felt displaced in their own society after their long sojourn.

21. In the year *Mirror of Womanhood* was published, about three hundred women in a textile factory in Osaka went on strike — Japan's first success for women strikers.

22. When the reactionary conservatives began voicing their objections to secondary education for girls in an attempt to restrict women's roles to reproduction and homemaking, Iwamoto immediately published oppositionary articles. He encouraged his readers — specifically, the students of girls' schools — to confront the reactionary backlash and to overcome it rather than avoid it. When the newspapers reported incidents of hostile attacks on female students (in order to discourage them from attending school), he even advised the students to carry knives to protect themselves.

23. Kishida Toshiko offered a course in Chinese classics; Shimizu Toyoko taught writing; Tanabe Ryūko studied and taught there briefly; and Otsuka Kusuoko also spent some time as a student. Nogami Yaeko was among the students during the

final years of the school's existence, and she described student life at Meiji Jogakkō in her autobiographical novel *Mori* (*The Wood*), Shinchosha, 1985.

24. Sōma Kokkō, *Mokui* (*Silent Passing*), Towado, 1936, quoted in Kosaka Masaaki, *Meiji Nihon Shisō Shi* (*Japanese Thoughts in the Meiji Era*), Tōyō Bunko, 1958, pp. 163, 164.

25. It was not until 1901 that the first women's college, a private institution, was founded, offering three areas of study: home economics, Japanese, and English literature. The national universities did not open their doors to women until 1913.

26. The strength of the Ferris Seminary was that students were encouraged to stay until they felt they had learned all that the school could offer; another advantage was its relatively low tuition compared to other private and missionary schools. The school continues to exist now as Fuerisu Jogakuin (both high school and college). For the history of Ferris Seminary, see *Fuerisu Jogakuin Hyakunen Shi* (*The Hundred Years of Ferris Girls School*), Fuerisu Jogakuin, 1970. See also Murakami, vol. 1, pp. 394–399.

27. "The Condition of Women in Japan," written in English in February 1888.

28. Published in *Jogaku Zasshi*, no. 172 (July 1889).

29. See Futabatei Shimei, *Yo ga honyaku no hyōjun* ("Standards of My Translation"), published in 1906, in Yamaguchi, p. 166.

30. Yamaguchi, p. 166.

31. By 1930, *Shōkōshi*, now published in a book form, had been through forty-two editions. The mother of Katayama Tetsu, a socialist philosopher, is said to have clipped pages from *Jogaku Zasshi* and made it into a book to read to her own and neighborhood children. See Yamaguchi, p. 172. Nogami Yaeko tells in her *Mori* (*The Wood*) about her encounter with the book and states that she can recall vividly its "refreshing impression" upon her.

32. Ueda Bin's review, quoted in Yamaguchi Reiko, *Toku to ware o mitamae* (*Look on Me Closely: The Life of Wakamatsu Shizuko*), Shinchosha, 1980, p. 138.

33. *Jogaku Zasshi*, no. 207 (April 1890).

34. In 1889, Shizuko published three short stories, her only works of fiction. Translations other than those mentioned in the text are "A Psalm of Life" by Longfellow, "A Doubting Heart" by Proctor, and "Enoch Arden" by Tennyson.

35. "The issue of the nineteenth century is that of women, and the history of this century is that of women's emancipation," Toyoko's preface begins. It goes on to encourage women readers to do what they can to reach the goal of emancipation. Quoted in Yamaguchi Reiko, *Naite aisuru shimai ni tsugu: Kozai Shikin no shōgai* (*I Plead with You, My Beloved Sisters: The Life of Kozai Shikin*), Sodo Bunka, 1977, p. 76. Kozai is Toyoko's married name.

36. Under the new version, all women (not just teachers and students as in the earlier law) were prohibited from becoming members of political organizations or attending political meetings. This situation, which denied women's political participation, did not change (though it was partially improved in 1922) until the end of World War II.

37. Contrary to common impression, divorces were not uncommon in early Meiji years. According to one study, approximately one-third of marriages ended in divorces

in 1888, the year Shikin got her divorce. Although certainly not all divorces were requested by wives, 5,447 marriages were registered in 1890 in Aomori Prefecture, but in the same year there were 2,429 divorces. These figures are given in *Jogaku Zasshi*, Yamaguchi, p. 101.

38. Shikin was among women involved in appealing against polygamous practice, referred to as *ippu ippu kempaku,* or an "appeal for one wife for one husband." In 1889 she presented an appeal (published in *Jogaku Zasshi,* 15 June 1889) to change Article 311 of the Penal Code, which punished the wife but not the husband for an adulterous act.

39. It is true that some contemporary readers interpreted "The Broken Ring" as a story of the sadness of being a woman rather than that of an awakened woman's attempt at an autonomous life. Imai Yasuko also argues that the story was well received because of the more traditional sentiment of sadness in the protagonist, who fails to have the kind of marriage promoted by Iwamoto, based on the model of Victorian marriages. See Imai Yasuko, Yabu Teiko, and Watanabe Sumiko, *Tampen Josei Bungaku: Kindai* (*Women's Literature: Short Stories of the Modern Era*), Ofusha, 1987, pp. 15–20.

40. Sōma Kokkō, *Meiji shoki no san josei* (*Three Women in the Early Meiji Era*), Koseikaku, 1940. *Jogaku Zasshi,* which published "The Broken Ring" (1 January 1891), was sold out. Some of the favorable reviews of the story include ones by Kōda Rohan (published in *Kokumin no Tomo*), Yamada Bimyo (in *Kaishin Shimbun*), and Uchida Roan (*Jogaku Zasshi*). Tanabe Kaho also wrote a favorable review.

41. Yamaguchi, p. 280.

42. Yoshinao met Toyoko through her brother, who was his teaching assistant at that time. Yoshinao's letters were discovered after his death in 1934, a year after Toyoko's death.

43. Shikin's depression accompanied severe migraines which required hospitalization. They were primarily the result of becoming pregnant and having a child by Ōi Kentaro, a leading figure in the Popular Rights Movement whom she had associated with after her divorce. Kageyama Hideko, with whom Shikin had earlier formed a friendship through their involvement in the movement, also had a child by Ōi. Hideko was angry, broke the friendship one-sidedly, and later publicly denounced Shikin in her book *Warawa no hanshōgai* (*The First Half of My Life*), published in 1904.

44. Kawai Michio, *Shimizu Toyoko to Sangetsushi,* quoted in Yamaguchi, p. 160.

45. In fact, a negative image of her during her lifetime contributed to the suppression of her name until the 1970s, when, through the efforts of mainly female historians, her life and work were rediscovered. The rumor of Yoshinao's control over Toyoko's writing was unquestioned until recently, even by scholars.

46. Yoshinao was known for childlike inattentiveness in his daily life. For instance, he needed daily reminding from his wife to take a bath. Imai, Yabu, and Watanabe, p. 17.

47. *Naite aisuru shimai ni tsugu, Jogaku Zasshi,* 11 October 1890.

Chapter 2

1. *Kōtō-jogakkō seito kyōdōho yōkō* ("Essential Points of Guidance in Higher School for Girls"). See Mitsui Reiko, *Gendai nihon fujin undo shi nenpyō* (*History of Women's Movement in Modern Japan: A Timetable*), Sanichi Shobo, 1963, p. 29.

2. In another example, an accusation brought by a local newspaper led to the resignation of a teacher at a missionary school in Kumamoto; this teacher, who used in his speech the word *hakuai* (philanthropy), referring to the spirit of education, was accused because the word implied negation of the state. These actions were taken in the name of the Emperor, who was now being elevated by extreme nationalists to the object of supreme worship.

3. The number of students at the Ferris Seminary, for instance, decreased from 185 in 1888 to 38 in 1896.

4. Even during the period when the role of women was being rapidly redefined to that of mere domestic work, there were some efforts made by the women themselves to maintain the initial impetus of the early Meiji years to improve their own position. Among those who tried to do this through education was Tsuda Umeko, whom the government had sent to study in the United States in 1871, when she was five. In 1900 Umeko, using funds collected largely by her friends in the United States, opened a school for women who were planning careers as English teachers. That same year, Japan's first medical school for women was founded by Yoshioka Yayoi, who was convinced that the only way for women to receive medical training was to secure an institution of their own. With her husband as her sole collaborator, she opened her Tokyo Women's Medical School in her home, with four students. As seen in these examples, the pioneering work in training professional women received very little support, and their struggles epitomize the difficulties Meiji women confronted during the decades of the conservative backlash. Being aware of society's criticism of their "impertinence," these women repeatedly urged their students to be not only sincere and persevering but also humble in their aspirations. Only a few women followed in the footsteps of the pioneers in medical practice because the situation became increasingly difficult throughout the rest of the Meiji period and later. This situation did not significantly change until the end of World War II.

5. The preparations for writing the Meiji Civil Codes started in 1879 and were completed in 1890. Before the codes were put into effect, some scholars and members of the Lower House disputed several points, mainly on the rights of women. They objected, for instance, to a mother's being given custody upon the death of the father, to a widow's having the right to manage property, and to the fact that a child born outside marriage could not be legitimized even with the father's recognizing the child as his.

6. There were six such districts in Tokyo, and Yoshiwara, one of the oldest and largest districts in Tokyo, had about one hundred quarters and a total of three thousand *kōshō* prostitutes in 1898. The estimated number of annual visits made by patrons was well above the entire population of the city at that time. Murakami, vol. 4, pp. 31, 32.

7. In this incident, some Chinese workers escaped from a Peruvian ship while they were being shipped to South America, and the governer of Yokohama refused to give them back to the ship on the grounds that the workers were sold, thus slaves. When this incident was brought to an international court, the Japanese government had to declare that there were "no slaves" in Japan, thus the decree.

8. *Teikoku Bungaku* (*Literature of the Empire*), January 1902.

9. *Keishū shōsetsu o yomite* ("Reading Fiction by Women Writers"), a review in *Bungakkai*, January 1986, reprinted in *Meiji joryū bungaku shu* (*Collection of Writings by Women in the Meiji Period*), Chikumashobō, 1966, vol. 1, p. 395.

10. Hiratsuka Raichō, for example, was critical of Ichiyō for this reason. See Vernon, Victoria, *Daughters of the Moon,* University of California Press, Berkeley, 1988, pp. 39, 40.

11. The words of Baba Kochō, one of the *Bungakkai* group who frequently visited Ichiyō.

12. With the Restoration, the dream Noriyoshi had managed to bring to reality suddenly became meaningless. Because he worked hard to acquire the status of samurai, Noriyoshi was perhaps quite self-conscious about the Confucian ideology that formed the ethical guidelines for the class, and he might have handed them down to his bright daughter. Ichiyō's perception of reality and her attitude toward life were in a way prepared before she was born. It is interesting to note that some of her characters — for example, Irie Raizō, an idealistic artisan in "The Buried Tree," and Oriki, the articulate heroine of *Nigorie* ("Troubled Water") — interpret their personalities and destinies as "inherited."

13. Translation is from Keene, Donald, *Dawn to the West: Japanese Literature of the Modern Era: Fiction,* Holt, Rinehart and Winston, New York, 1984, p. 158.

14. *Nihon Gendai Bungaku Zenshū* (hereafter, NGBZ), vol. 10, Kodansha, 1962, p. 163.

15. Translations of Ichiyō's stories are all from Danly, Robert Lyons, *In the Shade of Spring Leaves: The Life and Writings of Higuchi Ichiyō,* W. W. Norton, 1992.

16. Shimazaki Tōson's *Haru* (*Spring*), for example, delineates aspiring young writers (the thinly disguised author and his friends) in their romantic involvements with women.

17. Itō Seiko, *Honoo no joryūsakka Tazawa Inafune* (*A Woman Writer of Passion: Tazawa Inafune*), Sokyō Shoin, 1979, p. 192.

18. This book was discussed by young Meiji writers as a story of rebellion against society. In their eyes, Raskolnikov's madness was a reaction to a society unsympathetic to the spiritual needs of young people.

19. NGBZ, pp. 185, 186.

20. Ibid., p. 185.

21. Ibid., p. 129.

22. "A Question to the Reading of *Takekurabe,*" *Gunzō,* May 1975.

23. This special quarter remained basically unchanged during the Meiji period as the system of *kōshō,* licensed prostitution, continued to be practiced. Inside the gate and the Ohaguro ditch, as described in *Takekurabe,* prostitutes are still indentured, often for life.

24. Quoted in Keene, p. 180.
25. Remarks of cautioning are seen in her journal, especially during October 1895 and January 1896.
26. NBGZ, p. 213.
27. There were good reasons for Ichiyō's caution in dealing with critics and readers, as we see partially revealed in *Godai-dō* ("Temple of Godai") by Tazawa Inafune. In the words of its heroine, Inafune expresses her feelings about the problematic situation faced by women writers of her time: "It's not easy to be a woman writer; when she writes what she really thinks, people call her bad-mannered and gruff." A woman holds back from what she wants to write, this character continues, both from her desire for praise and from her lack of courage to withstand the critics' views. This character in "Temple of Godai," a thinly disguised Inafune, is talking about another character, Ms. Hanazono, a writer and acquaintance. It is quite possible that Inafune had Ichiyō in mind in creating the character of Ms. Hanazono, who is described as frank and straightfoward, not a coward. Inafune had never met Ichiyō, but she was certainly aware of her fame. See Itō, p. 194.
28. Frequent entries mentioning Saitō Ryokuu, referred to as Shōtarō, are found in mid–1896 through the end of the journal.
29. Danly, for example, dismisses both works because they are "inconsistent" and "incomplete." See Danly, p. 306.
30. Quoted in Vernon, p. 39.
31. Ibid., p. 68.
32. Quoted in Shioda, p. 182.
33. Takayama Chyogyū, *Teikoku Bungaku* (*Imperial Literature*), February 1896, quoted in Itō, p. 257.
34. Ohaguro Dobu (ditch) is the small moat surrounding the Yoshiwara district of licensed prostitution; it is also referred to in the opening line of Higuchi Ichiyō's *Takekurabe*.
35. Amachi Kenichi, *Tōka* (*The Eastern Flower*), January 1896, quoted in Itō, p. 258. Amachi also used such expressions as "filthy" and "vomiting."
36. There was a private medical school that accepted women, but the difficulties one had to go through to receive training there, as witnessed by a few pioneering women, was so great that one of them, Yoshioka Yayoi, established a medical school for women. See note 4.
37. *Gidaiyū* was enjoying renewed popularity around the time Inafune published this story.
38. Shioda, p. 184.
39. These debates began in 1889, when Yamada Bimyō published a book with the drawing of a nude woman on the front page, and continued in 1895, when the work of Kuroda Kiyoteru, a painter who helped introduce the Western style of painting to Japan, was shown in a Tokyo museum.
40. When Bimyō's betrayal of one woman (a former geisha who had borne his child) grew into a scandal involving legal action, Tsubouchi Shōyō, an influential literary figure, wrote an article entitled "Do Writers Have a Right to be Immoral in the Name of Literary Experiment?" Bimyō had earlier tried to defend his womanizing

as artistically motivated and as an experiment to use in his fiction writing. Following Shōyō's essay, various newspapers wrote articles denouncing Bimyō.

41. Shioda, p. 186.

42. A review of *Godai-dō*. Shioda, p. 190.

Chapter 3

1. Indignant over the West's contempt for the East, Tenshin argued that in the visual arts, if not in religion and literature, Japan should be recognized for its unique contribution to the world.

2. When Russia, France, and Germany intervened in Japanese negotiations with China at the end of the Sino-Japanese War and forced Japan to relinquish all the territorial rights it had gained in China, the Japanese public began to rally for another war.

3. The word *ren'ai*, first used by Tōkoku, is meant to convey platonic love, not carnal desire or filial affection; it was a concept that had not existed in pre–Meiji Japan.

4. Translation is by Keene, p. 16.

5. Her father's abuse of authority is demonstrated, for instance, in his practice of locking the door to Akiko's room from the outside so that she could not go out at night without his knowledge.

6. Danly, p. 162.

7. Keene, p. 24

8. Hinatsu Akinosuke, "Romantic Sentiment in *The Tangled Hair*," *Meiji Joryū Bungakuzenshū* (*Women's Work of Literature in the Meiji Period*), vol. 2, p. 371.

9. Keene, p. 23.

10. Brawer, Robert, and Miner, Earl, *Japanese Court Poetry*, Stanford University Press, Stanford, 1961, pp. 425–473.

11. She helped finance his trip by undertaking an additional project of copying one hundred of her poems by hand on folding screens. She spent many hours on this work, and with the help of her publisher she sold them to her patrons for a good price. This was at the end of 1911, right after she had given birth to her fifth child.

12. For the debates, see Irie Haruyuki, *Akiko no shūhen* (*Akiko and Her Surroundings*), Yoyosha, 1984, pp. 183–236.

13. *Yosano Akiko Zenshū* (*Complete Works of Yosano Akiko*), Ōtsuki Shoten, 1933, vol. 9, pp. 154, 155.

14. Ibid., pp. 204, 205.

15. Yamamoto Chie, *Yama no ugoku hi kitaru: Hyōden Yosano Akiko* (*A Mountain Moving Day Has Come: Biography of Yosano Akiko*), Ōtsuki Shoten, 1986, p. 93.

16. *Yosano Akiko Zenshū*, vol. 9, p. 132.

17. *Sanya Monogatari* ("Voices from a Delivery Room"), quoted in Nagahata Michiko, *Yume no kakehashi* (*A Bridge of Dreams*), Shinhyoron sha, 1985, pp. 179, 180.

18. *Yosano Akiko Zenshū*, vol. 9, p. 351.

Chapter 4

1. Personal accounts of Kusuoko are found, for example, in *Mokui* (*Silent Passing* by Sōma Kokkō), quoted in Shioda, pp. 261, 262; also in *Kusuoko joshi no tsuikai* ("Remembering Kusuoko" by Mine Yuriko). See Shioda, p. 266.

2. Many Japanese resented the government's failure to obtain greater returns from the victory over Russia. Moreover, the rate of increase in the standard of living, which people had just begun to enjoy, was now frustrated because of the continuous military expenditures necessary to fortify the country.

3. "The Quilt" shows two types of women, representing the role of woman split into two: the wife and the lover. The wife is depicted as a passive and subservient woman who has nothing to say about her husband's relationship with his female student. She exists in her husband's life like a piece of furniture sitting in the family room. His lover, on the other hand, is an educated young woman, a modern woman who has been taught to be in charge of her own life, one who feels that her sexual conduct is her own affair.

4. The term *guild* is used by Itō Sei in *Tōbō dorei to kamen shinshi* ("Runaway Slaves and Masked Gentlemen"), *Shinbungaku* (*New Literature*), August 1948.

5. Shimajiri Etsuko, *Hyōden: Odera Kikuko* ("Biography of Odera Kikuko"), *Gakuen* (*Literary Garden*), September 1965. Odera is Kikuko's name by her second marriage. Hakuchō's view of women in general can be seen in many of his stories, for instance, *Doro ningyō* ("A Clay Doll").

6. Quoted in Shioda, p. 366.

7. Ibid.

8. Igarashi Rantei, *Hyōden: Mizuno Senko* ("Mizuno Senko: A Biographical Sketch") *Gakuen*, no. 294, 1 June 1964. pp. 51, 52.

9. Shioda, p. 367.

10. Okifuji Noriko, *Hakumei no sakka: Shiraki Shizu no shōgai* (*The Life of Shiraki Shizu*), Shinchōsha, 1988, pp. 112, 113.

11. Tanaka Yukiko, *To Live and to Write: Selections of Stories by Japanese Women Writers, 1913–1938*, The Seal Press, Seattle, 1987, p. 156.

12. *Koitoienumono* ("Don't Call It Love").

13. Preface to *Jōnetsu no Haru* (*Spring of Passion*), 1927.

14. Tanaka, pp. 14, 15.

15. Hiratsuka Raichō, *Tamura Toshiko ron* ("On Tamura Toshiko"), *Chūō Kōron* (*Central Forum*), August 1914.

16. Sata Ineko wrote a novella, *Haiiro no gogo* (*Grey Afternoons*), based on her and her husband's involvement with Toshiko.

17. Raichō's evaluation also reveals a certain limitation on the part of the critics of her time: although Toshiko's personality is certainly reflected in her work, the critics sometimes confused Toshiko, the author, with the characters in her writing.

Chapter 5

1. In a speech he made in 1913, Jinzō stated that it was a grave mistake for Japanese women to emulate Western women. Mitsui, *History of Women's Movement in Modern Japan*, p. 57.
2. The skepticism of contemporary youth was symbolized, for example, by an increase in suicide, the first publicized occurrence of which was a famous one by a high school student who jumped into Kegon Waterfall in 1903, leaving a note that life was incomprehensible.
3. Raichō stated that the time of this intense involvement in the study of Zen, when she started her day at dawn and walked several miles to her practice, was the happiest time in her life. She is said to have reached the stage of enlightenment by having solved the koan given to her by her teacher before she reached twenty.
4. Chōkō had probably conceived of the idea of a literary magazine for women by observing the success of *Joshi Bundan* (*The Women's Literary Circle*), which had been started in 1905 and was receiving the attention of established literary circles.
5. Emerging from the liberal climate of the time, with the similar intention of offering a launching base for unknown writers, *Shirakaba*, unlike *Seitō*, maintained its basic stance as a literary magazine. It helped to launch the careers of several aspiring writers who later became important and influential authors. The members of the *Shirakaba* group, all male and from upper-class families in Tokyo, enjoyed freedom, self-confidence, and financial guarantees that were absent in their female counterparts. Believing in their innate potentials and opportunities, their characters are without a trace of the victim consciousness seen in the work of the Naturalist School writers. These writers, however, treated women not as their equal partners but their inferiors; this is evidenced, for example, in an autobiographical novel of Mushakōji Saneatsu, *Omedetaki Hito* (*An Innocent Man*, 1910). In *Anya Kōro* (*Dark Night Passing*, 1921–1937), a highly acclaimed novel by Shiga Naoya, another *Shirakaba* writer, the central character's personal relationships with women are treated as peripheral to his consciousness. The age-old view of women as existing to serve men's needs is revealed in these male characters, who go to the red-light district to indulge their sexual obsession.
6. *A Doll's House*, for example, was translated into Japanese in 1901, and the play was produced by the theater group *Bungei Kyōkai* (Literary Art Association) in September 1911.
7. *Yomiuri Shimbun*, 5 May 1912.
8. *Kokumin Shimbun* also fabricated articles based on other newspaper articles. See *Joseigaku Kenkyū Kai* (Women's Study Group), ed., *Onna no imēji* (*Images of Women*), Keiso Shobo, 1984, p. 216.
9. Raichō and Kiyoko protested to the bureau chief of the Ministry of Internal Affairs for his comment reported in *Asahi Shimbun*.
10. On the basis of physiological differences which are claimed to exist between males and females—including the differing amount of blood in a woman, the weight of her brain, and the fact of menstruation—this article denounced the "New Women" for their presumptuous behavior.
11. *Chūō Kōron*, January 1913.

12. The eldest daughter of an exceptionally talented man who had lost a once prosperous business, Noe grew up in extreme poverty. While her mother worked hard as a hired hand in order to support her family of seven, Noe spent most of her time reading; she considered herself special and thought of nothing but herself, her future, and her aspirations. Through her aggressive pursuit of her goals, she succeeded in going to Tokyo and enrolling at Ueno Girls' Middle School. Tsuji Jun, one of her teachers, whose initial pedagogical interest in her gradually developed into a romantic and sexual involvement, taught her revolutionary Western thoughts and introduced her to *Seitō*. Once she discovered *Seitō*, Noe quickly identified with Raichō in her sincere desire to elevate herself, to be faithful only to herself and disregard conventional opinions. Filled with passion and eager to talk, to learn, and to work, Noe was a welcome member, bringing fresh air to the Seitō Society.

13. Their marriage turned out to be a disaster. Hanayo found herself serving as her husband's housekeeper and secretary as well as a breadwinner, while Shungetsu had multiple affairs.

14. See Nagahata Michiko, *Honoo no onna: Taishō josei seikatsu shi* (*Women with Passion: History of Taishō Women and Their Lives*), Shin Hyōron Sha, 1980, p. 143.

15. Among the most scandalous incidents was a suicide attempt by Yoshikawa Kamako and her lover, her father's chauffeur. Kamako, an undaunted young woman, was dissatisfied with her husband, whose involvement with a geisha was common knowledge. Perhaps Kamako's attraction to a younger man who drove an automobile, a symbol of the new age, was based mainly on infatuation, but their double suicide attempt was made into a scandal since Kamako was a young, attractive woman of the upper class. A few days before her suicide attempt, another drama, this time involving a love triangle, was played out. It involved two Seitō women — Itō Noe and Kamichika Ichiko, an established reporter at this time — and Ōsugi Sakae, the leader of an anarchist group. Ichiko was unwilling to accept the male egoism revealed in Ōsugi's self-serving lifestyle and stabbed him.

16. Akiko was forced to marry a man she had grown up believing to be her brother, and for six years she was the wife of this proud but dull man, who considered her merely a tool to satisfy his sexual needs. In order to help her real brother, who needed money for his election campaign, Akiko got a divorce and entered a second marriage, this time with a coal-mining millionaire twenty-five years her senior, a man whose sole interest in Akiko was her tie to the royal family. Shortly after this second marriage, Akiko met a young student at the University of Tokyo. He was also the editor of a literary magazine, and through their mutual interest in writing they became lovers. Akiko eloped with this man but was forced to return, and for two years she was kept under strict family supervison.

17. Having left her first husband sometime before, Yōko in the beginning of the novel is on her way to the United States, where another man, whom her family has arranged for her to marry, is waiting. Yōko does not love this man and refuses to get off the ship. She has fallen in love with Kurachi, the ship's purser, to whom she felt sexually attracted the moment she saw him.

18. Honda Shūgo, *Shirakaba ha no sakka to sakuhin* (*The Shirakaba Writers and Their Work*), quoted in Keene, p. 488.

19. Strong, Kenneth, "Introduction" to *A Certain Woman*, University of Tokyo, 1971, p. 19.

20. *The Pearl Lady* has all the ingredients needed to succeed as popular fiction: an extremely wealthy man who has risen from the bottom of society, a beautiful and proud woman from a declining aristocratic family who indulges in many love affairs, an automobile, and a luxurious mansion.

21. Mayeda, Ai, *Taishōkōki tsuzōkushosetsu no tennkai* ("Development of Popular Fiction in the Latter Half of the Taishō Period"); *Kindai dokusha no seiritsu* (*Birth of Modern Readers*), Yūseido, 1977, p. 209.

22. The first national census, taken in 1920, showed about one-fifth of the entire working population in Japan engaged in service industries, including retail sales and transportation, much of which utilized women.

23. Japanese people learned to enjoy coffee, beer, and ice cream around this time, and waitressing became a new occupation for women.

24. Quite a few women's magazines started in 1916, including *Ryōsai Kembo* (*Good Wife, Wise Mother*), *Otome* (*Maiden*), *Shin Katei* (*New Home*), and *Tairiku Fujinkai* (*Continental Women's World*).

25. While the total number of women working in factories, mainly in textiles, doubled between 1914 and 1919, the jobs of typist, sales clerk, telephone operator, and bus conductor came to be considered primarily women's occupations.

26. In the spring of 1918 the price of rice increased nearly twofold over the prewar price, and then, due to poor crops and hoarding, it doubled again in the summer of the same year. This meant that a typical family of five had to spend about half of its monthly income on rice.

27. Esashi Akiko and Ide Fumiko, *Taishō demokurashī to josei* (*Taishō Democracy and Women*), Gōdō Shuppan, 1977, p. 74.

28. Although women's suffrage was beyond the group's capability, repealing the Fifth Article did succeed after repeated petitioning. *Shin Fujin Kyōkai* was disbanded, however, shortly after this achievement, with only its first goal achieved. Because it was an umbrella organization and was also supported in part by contributions from sympathizers, mostly men, the association had found it difficult to maintain a unified front. The obvious differences between those with a socialist orientation, representing the working-class women, and those of the middle class with a broader perspective became too great to be resolved.

29. Mitsui, p. 105

30. This novel, *Seibi* (*Blue Brows*), was serialized in *Yomiuri Shinbun*.

31. Works of these women writers are collected in Tanaka, *To Live and to Write*.

Epilogue

1. Yaeko used this word to refer to herself in an interview by Okuno Takeo, a literary critic. Okuno Takeo, *Joryū sakka ron* (*Essays on Female School Writers*), Daisanbunmeisha, 1974, pp. 20, 25.

2. She first contributed to their magazine with her translation of the autobiography of Sonya Kovalevsky, a nineteenth-century Polish mathematician whose successful attempt to release herself from the old morality of family and marriage reminded the Japanese readers of their own situation.

3. Yaeko's love of learning, self-discipline, and determination were demonstrated in her routine of leaving home at five in the morning to take lessons before school. These traits stayed with her all her life: she read many English novels, particularly those by Jane Austen, George Eliot, and Charlotte Brontë (in English); in her later years, she took private lessons from a prominent philosopher and also studied the traditional arts, such as the tea ceremony and *utai*, the songs that accompany the Noh play.

4. Quoted in Shioda, p. 330. Sōseki was a professor of English literature then.

5. *Meiro* (*The Labyrinth*, 1937–1956) and *Hideyoshi to Rikyū* (1962) are Yaeko's major works after *Machiko*.

6. Strong, p. 19.

Selected Bibliography

Aoyama, Nao. *Meiji Jogakkō no kennkyū* (*Meiji Middle School for Girls*). Tokyo, Keiō Tsushin, 1970.
Fukuda, Hideko. *Warawa no Han-shogai* (*My Life: The First Half*). Tokyo: Iwanami bunnko, 1958.
Gilbert, Sandra M., and Susan Gubar. *The Madwoman in the Attic: The Woman Writer and the Nineteenth Century Imagination*, New Haven: Yale University Press, 1979.
_____. *No Man's Land: The Place of the Woman Writer in the Twentieth Century.* New Haven: Yale University Press, 1988.
Hiratsuka, Raichō. *Hiratsuka Raichō jiden: Genshi josei wa taiyō de atta* (*Autobiography: In Antiquity, Women Were the Sun*). Tokyo: Ōtsuki Shoten, 1971.
Ide, Fumiko. *Hiratsuka Raichō: kindai to shimpi* (*Hiratsuka Raicho: Modernity and Mystery*). Tokyo: Shinchōsha, 1987.
_____, and Esashi, Akiko. *Taishō demokurashī to josei* (*Taishō Liberalism and Women*). Tokyo: Gōdō Shuppan, 1977.
Imai, Motoko, and Watanabe, Sumiko. *Tampen josei bungaku: Kindai, gendai* (*Short Stories by Women: Modern and Contemporary Era*). Tokyo: Ōtosha, 1983.
Itagaki, Naoko. *Fujin sakka hyōden* (*Critical Biographies of Women Writers*). Tokyo: Kadokawa bunko, 1956.
Iwabuchi, Hiroko, Kitada, Sachie, and Kōra, Yumiko. *Feminizumu hihyōe no shōtai* (*An Invitation to Feminist Criticism*). Tokyo: Gakurin schbo, 1995.
Keen, Donald. *Some Japanese Portraits.* Tokyo: Kōdansha, 1978.
Komashaku, Kimi. *Mujo no ronri* (*Logics of Witches*). Tokyo: Fuji shuppan, 1984.
_____. *Yoshiya Nobuko: Kakure feminisuto* (*Yoshiya Nobuko: A Quiet Feminist*). Tokyo: Riburopōto, 1994.
Kozai, Yoshishige (ed.). *Shikin zenshu* (*Complete Work of Shikin*). Tokyo: Seidō sha, 1983.
Maeda, Ai. *Higuchi Ichiyō no sekai* (*The World of Higuchi Ichiyō*). Tokyo: Chikuma shōbo, 1989.
Matsuzaka, Toshio. *Higuchi Ichiyō kenkyu* (*Study of Higuchi Ichiyō*). Tokyo: Kyōiku shuppan senta, 1970.
Moi, Toril. *Sexual/Texual Politics: Feminist Literary Theory.* London: Methea, 1985.
Murakami, Nobuhiko. *Meiji josei shi* (*History of Meiji Women*). Tokyo: Riron sha, 1973.

Muramatsu, Sadataka. *Kindai Joryūsakka no shōzō* (*Portraits of Modern Female-School Writers*). Tokyo: Tokyo shoseki, 1980.
Nagahata, Michiko. *Honoo no onna: Taishō josei seikatsu shi* (*Women with Flames: Lives of Taishō Women*). Tokyo: Shinhyōron sha, 1971.
Seki, Reiko. *Ane no chikara* (*Power of Elder Sisters*). Tokyo: Chikuma shobo, 1993.
Setouchi, Harumi. *Kanoko ryōran* (*Flowering of Okamoto Kanoko*). Tokyo: Kōdansha, 1971.
———. *Tamura Toshiko* (*Tamura Toshiko*). Tokyo: Bungei shunjū sha, 1961.
Shioda, Ryōhei. Meiji joryūsakka ron (*On Female-School Writers of Meiji*). Tokyo: Nara Shobo, 1965.
Showalter, Elaine. *A Literature of Their Own: British Women Novelists from Brontë to Lessing*. Princeton: Princeton University Press, 1977.
Tsukada, Mitsue. *Gokai to henken: Higuchi Ichiyō no bungaku* (*Misunderstanding and Prejudice: Works of Ichiyo Higuchi*). Tokyo: Chūōkōron sha, 1967.
Urushida, Kazuyo (ed.). *Onna ga yomu nihon kinndai bunngaku* (*Japanese Modern Literature Read by Women*). Tokyo: Shinyō sha, 1992.
Wada, Yoshie. *Higuchi Ichiyō no nikki* (*Journals of Higuchi Ichiyō*). Tokyo: Fukutake shoten, 1983.
———. *Higuchi Ichiyō kenkyū* (*A Study of Higuchi Ichiyō*). Tokyo: Chūōkōron sha, 1956.
Yamaguchi, Reiko. *Tokuto ware o mitamae* (*Carefully Look at Me: Life of Wakamatsu Shizuko*). Tokyo: Shincho sha, 1980.
Yamamoto, Chie. *Yama no ugoku hi kitaru: Hyōden Yosano Akiko* (*Mountain-Moving Day Has Come: Life of Yosano Akiko*). Tokyo: Otsuki shobo, 1976.
Yazger, Patricia. *Honey-Mad Women: Emancipatory Strategies in Women's Writing*. New York: Columbia University Press, 1988.

Index

"Accusation" 58
Adams, Jane 156
Akutagawa Prize 165
Amaterasu 9, 138
Arishima, Takeo 150, 165
Aru Onna 128

A Beautiful Prison 120
Beauvoir, Simone de 101
"Black Lizard" 103
Blue Stockings 2, 140
"Bonds" 163
The Book of Tea 89
"The Bridal Veil" 37
Broken Commandment 47
"The Broken Ring" 42, 43, 44, 47
Buddhism 139
Bulwer-Lytton, Edward 15, 26, 27
"Buried Fire" 158
"The Buried Tree" 68
"A Bushclover and a Bellflower" 20
"Butterfly" 84

The Central Forum (*Chūō Kúron*) 115, 128, 129, 145, 154
China 134
Christianity 34, 35, 52, 53, 90, 138, 139
"Civilization and Enlightenment" (*Bunmeikaika*) 13, 16, 25, 35, 52, 54, 66
The Cuckoo (*Hototogisu*) 60–62
Confucianism 1, 10, 29, 31, 35, 39, 43, 51, 56, 63, 72, 77, 90, 95
The Continental Daily News (*Tairiku Nippo*) 133
Crime and Punishment 69
"The Crossroads of Good and Evil" 26

Daily Yomiuri (*Yomiuri Shimbun*) 53, 85, 149, 150
"A Dark House" 114
"Dark Nights" 59, 70, 71
"Dark Spectacles" 6, 58, 61, 62
David Copperfield 39
"Death at Thirty-three" 120
"Deepening Autumn" 105
"A Demon" 129
"Demon in the Heart" 44, 60
Dickens, Charles 10
"Do Not Die, My Beloved Brother" 97
dōjin zasshi (coterie magazines) 140, 143
"Double-Petaled Cherry Blossoms" 19, 29, 55
A Doll's House 44, 128, 143, 145

"Enveloped by Fire" 129
essence of life 120
eta 46, 47

"A Faint Tune" 85, 105
"Father's Crime" 123
"The Female Bell Cricket" 157
feminism 153
feminist consciousness 136, 142
Ferris Seminary 24, 35, 36, 38
"The Five-Storied Pagoda" 68
The Flower Tales 152
"Forty-Some Days" 114, 116
Fragrance in the Sky 106, 107, 109
"Fresh Blood" 141
From a Certain Corner 99
Fujiwara, Shunzei 91

"A Garment Damp with Dew" 127
"Garment of Love" 97

geisha 104, 105, 144
gesaku 27, 111
gidaiyū 83
giri 31, 58
"Girls" 114, 116
"A Glorious Morning" 117
"Glory" 127, 132, 133
Goldman, Emma 146
"good wife, wise mother" 42, 52, 87, 102, 137, 142
Great Treason Trial 111, 156
"Growing Up" 62, 69, 70, 72–74, 78, 79, 116

Haginoya 64–67, 70
haiku 97
"Hair Dye" 60
haishō undō 55, 56
Hasegawa, Shigure 157–159
Hatoyama, Haruko 145
"Her Life" 132
heterosexual love 27, 33, 68
Higuchi, Ichiyō 2, 3, 6, 9–11, 18, 61–80, 86, 89, 92, 108–22, 126
Hiratsuka, Raicho 80, 98, 99, 118, 132, 134, 137, 140–42, 144–46, 149, 156
Hirotsu, Ryūro 103, 106
Home Ministry 144
A Husband's Chastity 153

ie 4, 7, 20, 53, 54, 56, 61
Ihara, Saikaku 70–72
"The Immigrant School" 46
Imperial Rescript on Education (1890) 52, 53
"The Inafune Story" 85
"Inconsolable Grandmother" 125
individualism 90, 145
International Women's Day 156
Itō, Noe 145–47, 149, 157
Iwamoto, Kiyoko 146
Izumi, Kyōka 103, 104

Japan Salvation Army 55
Japan Women's College 127, 137
The Japanese (*Nihonjin*) 19
jitsuwa 151
Jogaku Zasshi 15, 18, 25, 26, 33, 34, 38, 41, 42, 48, 68
joryū 2, 8, 21, 136, 165
juvenile fiction 122, 153

kabuki 126
Kageyama, Hideko 23, 40, 41, 145
Kamichika, Ichiko 144
Kanno, Suga 111
Kawai, Suimei 110
Kawakami, Bizan 69, 75
keishū sakka 5
Kenyūsha 57, 105, 108, 110
Kikuchi, Kan 152, 153
"The Kimono Neckpiece at Kagurazaka" 116
Kimura, Akebono 17, 21, 28–32
Kishida, Toshiko 21–28, 40, 42, 100
Kitada, Usurai 6, 44, 56–62, 80, 81, 109
Kitamura, Tōkoku 33, 34, 90
Kōda, Rohan 68, 70, 74, 79, 127
"Komachi Bathhouse" 83
kome sōdō 155, 156
Kōno, Taeko 165
kōsho 10, 33, 55, 56, 156, 165
Kyōfukai (Women's Reform Society) 54

Lady Murasaki 110
"The Last Day of the Year" 70, 72
lesbianism 144, 153
Literary Club (*Bungei Kurabu*) 5, 13, 26, 45, 46, 56, 62, 74, 80, 82, 105, 127
Literary World (*Bungakkai*) 33, 34, 62, 68–70, 71, 91, 92, 140
Literary World (*Bunshō Sekai*) 114
The Literature and Art Association (*Bungei Kyōkai*) 128
A Literature of Their Own (Elaine Showalter) 2
Little Lord Fauntleroy 38, 74
love triangle 105

Machiko 164
The Madwoman in the Attic (Sandra Gilbert and Susan Gubar) 2
Marie Louise Incident 55
Mary Kidder ("Miss Kidder") 35, 36
Masamune, Hakuchō 113
Masaoka, Shiki 97
mass culture 157
Matsui, Sumako 128
Matsuo, Bashō 76, 91
"Medical Training" 82–83
Meiji Bungaku Zenshū 3
Meiji Civil Codes 53, 55, 56

Meiji Jogakkō 33–35, 39, 40, 68, 74, 108, 162
Michi 39
Mill, John Stuart 15
minoue sōdan 150
Mirror of Womanhood 17, 28, 29–32
Miyakonohana 18
Miyamoto, Yuriko 134
Mizuno, Senko 110, 113–18, 123
Mori, Ōgai 42, 61, 62, 74, 80–83, 91, 112, 118
The Morning Star (Myōjō) 91, 94, 96
Myōjō School 92, 96, 102
Myōjō style 97

Nagai, Kafū 111
Nakajima, Nobuyuki 24
Nakajima, Utako 67
Nakarai, Tōsui 67, 68, 70
nationalism 89
Natsume, Sōseki 106–10, 112, 139, 144, 162, 163
Naturalist School 7, 21, 47, 99, 103, 103, 109–13, 116, 121, 122, 125, 126, 129, 135, 141, 148, 149, 152, 158, 159, 162
The Neptune 7, 163, 164
New Lives 163
New Society Theater 128
New Women 2, 106, 107, 128, 132, 137, 141, 143, 144–46, 162, 163
The New Women's Association 156
Nietzsche, Friedrich 139
"Night of Hazy Moon" 75
"The Night Train" 124
Nihonjin 19
Nippon Dendō Shimpō (Japan Evangelical News) 36
Nogami, Yaeko 161–65

Ohba, Minako 165
Ōi, Kentaro 40, 41, 47
Ojima, Kikuko 112, 113, 121–25, 141
Okakura, Tenshin 89
Okamoto, Kanoko 148, 149
"An Orphan" 33, 38
Ōsugi, Sakae 146, 157
Ōtake, Benikichi 143
Ōtsuka, Kusuoko 105

"Painted Lips of a Mummy" 130–131
"Pale Purple" 63, 78–79

patriarchy 10, 54, 86, 150, 152, 155
Peace Preservation Law 156
The Pearl Lady 151, 152, 155
penal code 40
People (Minshū) 133
Pilgrimage to Yushima 104
Pillars of Fire 104, 105
The Pillow Book 1
Plum Blossoms in the Snow 27
polygamy 6, 20, 43, 44
Popular Rights Movement 15, 21, 22–26, 28, 30, 40, 51, 57, 90, 100
Proctor, Adelaide 33, 42
prostitution 44

"The Quilt" 111

rabu (love) 28
"A Rambling Talk" 141
"Raw Blood" 129, 130
A Red Poppy 106
The Reed (Yoshiashigusa) 94
ren'ai 90, 104, 105, 149
"Repentance Uttered to the Moon" 85
"Resignation" 127, 128, 129
Restoration 13, 35, 89, 90
"A Road" 117
Rokumeikan era 14, 29
Romantic movement 69, 75, 89, 110
Romanticism 90, 91
Romantics (European) 94, 102
"The Rumbling Talk" 98, 101
Russo-Japanese War 90, 97, 105, 111

"The Sailor Boy" 42
Saitō, Ryokuu 77
Sanger, Margaret 156
Sanshiro 106
Sata, Ineko 73, 159
Schopenhauer 123
"The Seduction of Chinese Berries" 131
Seedlings 91
seiji shōsetsu 21, 27
Seito 1, 7, 98, 123, 124, 128, 136, 137, 140, 142, 144, 146, 157, 159
Seito Society 8, 115, 137, 140, 142, 143, 145, 153, 154, 162
"Self-Conceit" 85, 86
Self Help 15
Sekirankai 156
"Separate Ways" 78

sexuality 129–31
Shimazaki, Toson 34, 47, 91, 94, 110
Shimizu, Toyoko 20, 23, 26, 32, 40–49, 60, 100, 156
Shin Fujin Kyōkai 156
Shin Shakai Gekidan 128
shinju 105
shinkoku shōsetsu 103, 104
Shino-Japanese War 90
Shinshi sha 91, 94
shintai-shi 91, 94, 97–99, 110
Shiraki, Shizu 113, 118–21
shishō 10, 55
Shōkoshi 38, 39
"Skeleton of a Shrimp" 63, 78
Smiles, Samuel 15
"The Snake" 133
"A Snowy Day" 68–69
Songbirds in the Grove 13–19, 21, 28, 64
Soot 139
Splendid Flowers of the Valley 21
"A Spring Evening" 129
Storm of Cherry Blossoms 158
"A Story of a Missing Leg" 121
The Subjugation of Women 15
Submerging and Floating 26
Suderman 142–44
suffragette 100, 142, 156
The Sun (Taiyō) 145

Taishō democracy 137
taishū shōsetsu 151
Takayama, Chogyū 81, 82
The Tale of Genji (Genji Monogatari) 1, 18, 19, 71
The Tale of Heike (Heike Monogatari) 84
Tamura, Shōgyo 127, 128
Tamura, Toshiko 113, 121, 123, 126–36, 150, 151
Tanabe, Kaho 15–21, 28, 29, 40, 42, 55, 59, 64, 66, 81, 109
Tangled Hair 89, 92, 96, 101
tanka poetry 91, 92, 94, 95, 97, 108, 110, 145
Tayama, Katai 111–15
Tazawa, Inafune 6, 66, 107–15
"Temple of Godai" 85, 86
"The Thirteenth Night" 6, 62, 75–76, 78, 117
"This Child" 78
"Three Singles" 57–58

Three Wives 54
"To My Young Friends" 99
To the End of the Sky 153
Tokuda, Shūsei 112, 122, 123
Tokugawa fiction 39, 134
Tokutomi, Sohō 89
Tolstoy, Leo 93
Toward the Light 98
Tōyō no Fujo (Women of the Orient) 40
"Troubled Water" 70, 72, 74–75, 79
Tsubouchi, Shōyō 15, 16, 66
Tsuda, Umeko 30, 32

Uchimura, Kanzō 52
Ueki, Emori 40
"Under the Flames of Red Candles" 124
Uno, Chiyo 159
Until the End of the Earth 153
"Unusual Confession of a Young Man" 45–46
Utopian socialism 90

"Vain Efforts" 114

waka poetry 18, 63, 64, 66, 70, 79, 89–92
Wakamatsu, Shizuko 33–40, 42, 66, 78
"A Wet Nurse" 59
White Birch (*Shirakaba*) 150
"The White Rose" 6, 62, 80–82, 107
"A Woman" 116
"A Woman's Song" 141
Women and Art (Nyonin Geijitsu) 157–59
The Women's Forum (Fujin Koron) 99
Women's Friendship 153
Women's Voice (Josei) 134
The Wood 161, 163
World War I 154

Yamada, Bimyō 21, 84–86
Yamakawa, Kikue 99
Yamakawa, Tomiko 92, 94
Yanagihara, Akiko 149–150
Yomiuri Shimbun 28
Yosano, Akiko 2, 6, 9, 10, 80, 87, 89–102, 110, 139, 141
Yosano, Tekkan 91, 92, 94, 96–8, 101
Yoshiwara 55, 69, 73, 74, 81
Yoshiya, Nobuko 110, 153, 154
"The Young Pine" 31

www.ingramcontent.com/pod-product-compliance
Lightning Source LLC
Chambersburg PA
CBHW020859020526
44116CB00029B/866